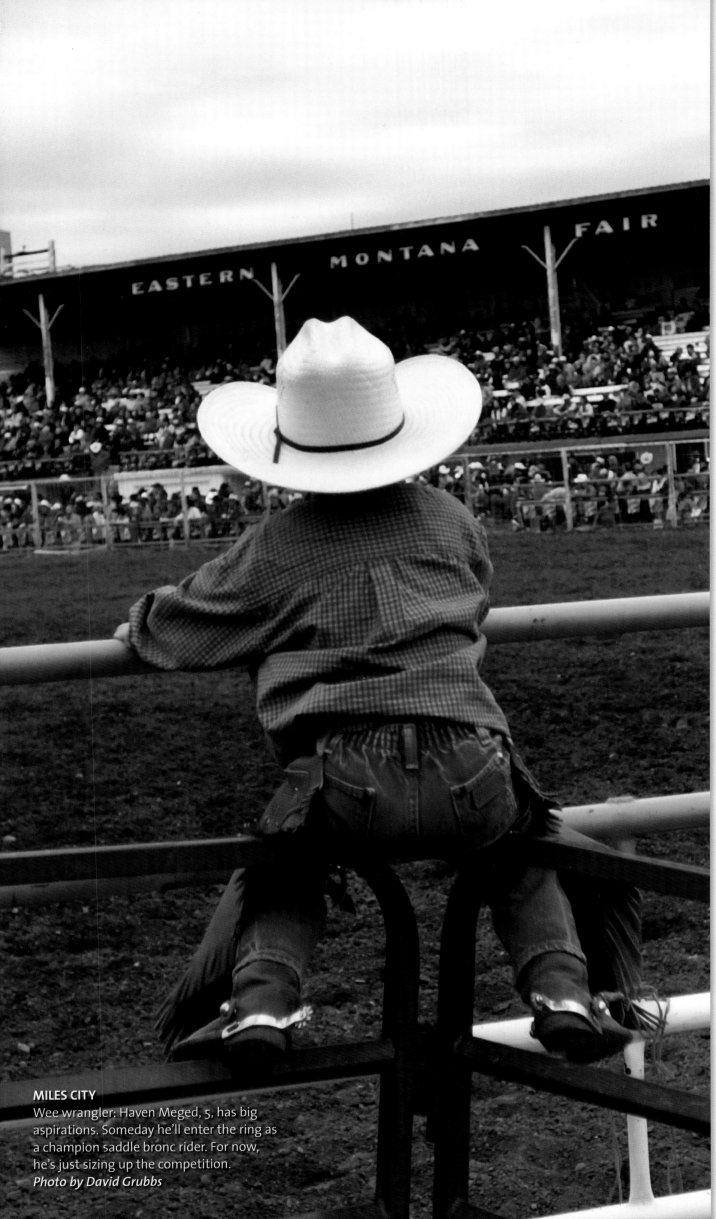

MILES CITY
Wee wrangler: Haven Meged, 5, has big aspirations. Someday he'll enter the ring as a champion saddle bronc rider. For now, he's just sizing up the competition.
Photo by David Grubbs

Montana 24/7 is the sequel to *The New York Times* bestseller *America 24/7* shot by tens of thousands of digital photographers across America over the course of a single week. We would like to thank the following sponsors, the wonderful people of Montana, and the talented photojournalists who made this book possible.

LONDON, NEW YORK, MUNICH, MELBOURNE, and DELHI

Created by Rick Smolan and David Elliot Cohen

24/7 Media, LLC
PO Box 1189
Sausalito, CA 94966-1189
www.america24-7.com

First Edition, 2004
04 05 06 07 08 10 9 8 7 6 5 4 3 2 1

Published in the United States by
DK Publishing, Inc.
375 Hudson Street
New York, NY 10014

DK Publishing, Inc. offers special discounts for bulk purchases for sales promo-
tions or premiums. Specific, large-quantity needs can be met with special
editions, personalized covers, excerpts of existing guides, and corporate
imprints. For more information, contact:

Special Markets Department
DK Publishing, Inc.
375 Hudson Street
New York, NY 10014
Fax: 212-689-5254

Cataloging-in-Publication data is available
from the Library of Congress
ISBN 0-7566-0066-9

Printed in the UK by Butler & Tanner Limited

First printing, October 2004

PRYOR MOUNTAINS RANGE
Home on the range: The country's first
nationally designated sanctuary for wild
horses, created in 1968 by Interior Secretary
Stewart Udall, reversed earlier federal
policy to round up the horses and kill them.
Pryor Mountain Wild Horse Range spreads
over 38,000 rugged acres and supports 200
wild horses.
Photo by Steven G. Smith

MONTANA 24/7

24 Hours. 7 Days.
Extraordinary Images of
One Week in Montana.

Created by Rick Smolan and David Elliot Cohen

DK Publishing

About the America 24/7 Project

A hundred years hence, historians may pose questions such as: What was America like at the beginning of the third millennium? How did life change after 9/11 and the ensuing war on terrorism? How was America affected by its corporate scandals and the high-tech boom and bust? Could Americans still express themselves freely?

To address these questions, we created *America 24/7*, the largest collaborative photography event in history. We invited Americans to tell their stories with digital pictures. We asked them to shoot a visual memoir of their lives, families, and communities.

During one week in May 2003, more than 25,000 professionals and amateurs shot more than a million pictures. These images, sent to us via the Internet, compose a panoramic yet highly intimate view of Americans in celebration and sadness; in action and contemplation; at work, home, and school. The best of these photographs, more than 6,000, are collected in 51 volumes that make up the *America 24/7* series: the landmark national volume *America 24/7*, published to critical acclaim in 2003, and the 50 state books published in 2004.

Our decision to make *America 24/7* an all-digital project was prompted by the fact that in 2003 digital camera sales overtook film camera sales. This techno-logical evolution allowed us to extend the project to a huge pool of photographers. We were thrilled by the response to our challenge and moved by the insight offered into American life. Sometimes, the amateurs outshot the pros—even the Pulitzer Prize winners.

The exuberant democracy of images visible throughout these books is a revela-tion. The message that emerges is that now, more than ever, America is a supersized idea. A dreamspace, where individuals and families from around the world are free to govern themselves, worship, read, and speak as they wish. Within its wide margins, the polyglot American nation manages to encompass an inexplicably complex yet workable whole. The pictures in this book are dedicated to that idea.

—*Rick Smolan and David Elliot Cohen*

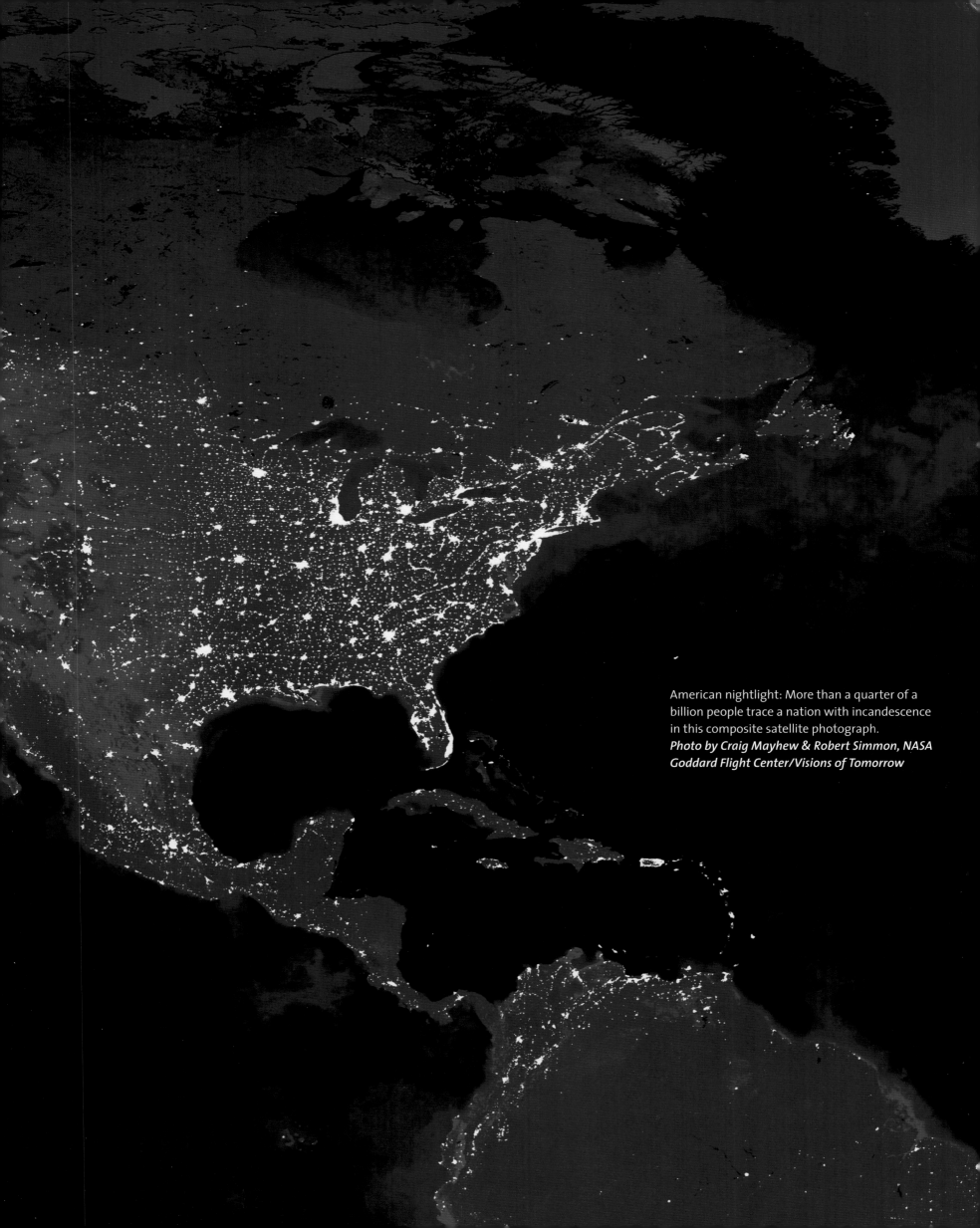

American nightlight: More than a quarter of a billion people trace a nation with incandescence in this composite satellite photograph.
Photo by Craig Mayhew & Robert Simmon, NASA Goddard Flight Center/Visions of Tomorrow

It's Not for the Meek

By Charles S. Johnson

Two centuries ago, Meriwether Lewis and William Clark burned up more expedition hours in what became Montana than in any other state. Gary Cooper learned to saddle up in his hometown of Helena before heading off to become king of Hollywood. Montana sent the first woman to Congress in 1916. Her name was Jeanette Rankin, and she was a pacifist who voted against both world wars. The French government made the late Blackfeet novelist James Welch, born on the reservation in Browning, a Chevalier de l'Ordre des Arts et des Lettres.

These are some of the epic names of the human figures that have dotted the immense Montana landscape, names remembered like an old song when it's 20 below and snow has buried the road.

This big, bold state, as seen in the frank and tender photos contained in this book, affects most everybody who has spent any time here. Actually living here, however...well, it isn't for the meek. Surviving the elements, much less the economy, people tend to end up with what we call an independent character. Many Montanans are strong, silent types, restless for brute adventure, and not afraid of the road less traveled. Cusses who insist on doing their own thinking make the state tough to govern—despite a few visionary leaders, Montana's government has failed to live up to its model 1972 state constitution—but most Montanans wouldn't have it any other way.

Even the hardiest Montanans struggle to eke out a living in one of the nation's poorest states. As usual, out-of-control forces—the weather, distant corporate boardrooms, and world market prices—dictate Montana's fortunes. Mining, which produced the jobs that kept Montana's economy

GREAT FALLS
Farmer Glen MacDonald's range of wheat and barley silos just north of the Missouri River echo the Rocky Mountains farther west.
Photo by John W. Liston, Great Falls Tribune

booming for decades but left some awful environmental messes, has seen better days. The timber industry faces major hurdles to continued logging on public lands.

Out in the drought-stricken fields and grazing lands, things aren't much better. Grain farmers can make more money from federal subsidies by leaving their land unplowed. Cattle and sheep ranchers can often make more in the short term by selling their families' historic spreads to developers, who subdivide them into tiny ranchettes. On the upside, some state officials have high hopes that university towns and natural beauty will lure clean, high-paying, high-tech jobs to western Montana. Tourism remains a bright spot.

Montana's isolation has always attracted more than its share of writers, artists, and musicians. The space, it is said, forces them to fill it—to reflect and think and create. Celebrities come here for big spreads and long roads where they can be left alone; likewise, society's rebels and outlaws— the Freemen, the Militia of Montana, and Unabomber Ted Kaczynski. This same vastness also requires Montanans to help each other—the way they raised barns together in the past. Farmers join to harvest a sick neighbor's crop, and drivers jump out of their vehicles to push a stranger's stalled car out of a snowdrift.

With such huge and magnificent spaces, with so much potential to fill in around them, Montanans still tend to be optimists. Montana is, as farmers put it, "next year country."

Great Falls native CHARLES S. JOHNSON has covered Montana politics for 33 years. He is currently the state capitol bureau chief for Lee Enterprises newspapers, which include The Billings Gazette, The Montana Standard, and Independent Record.

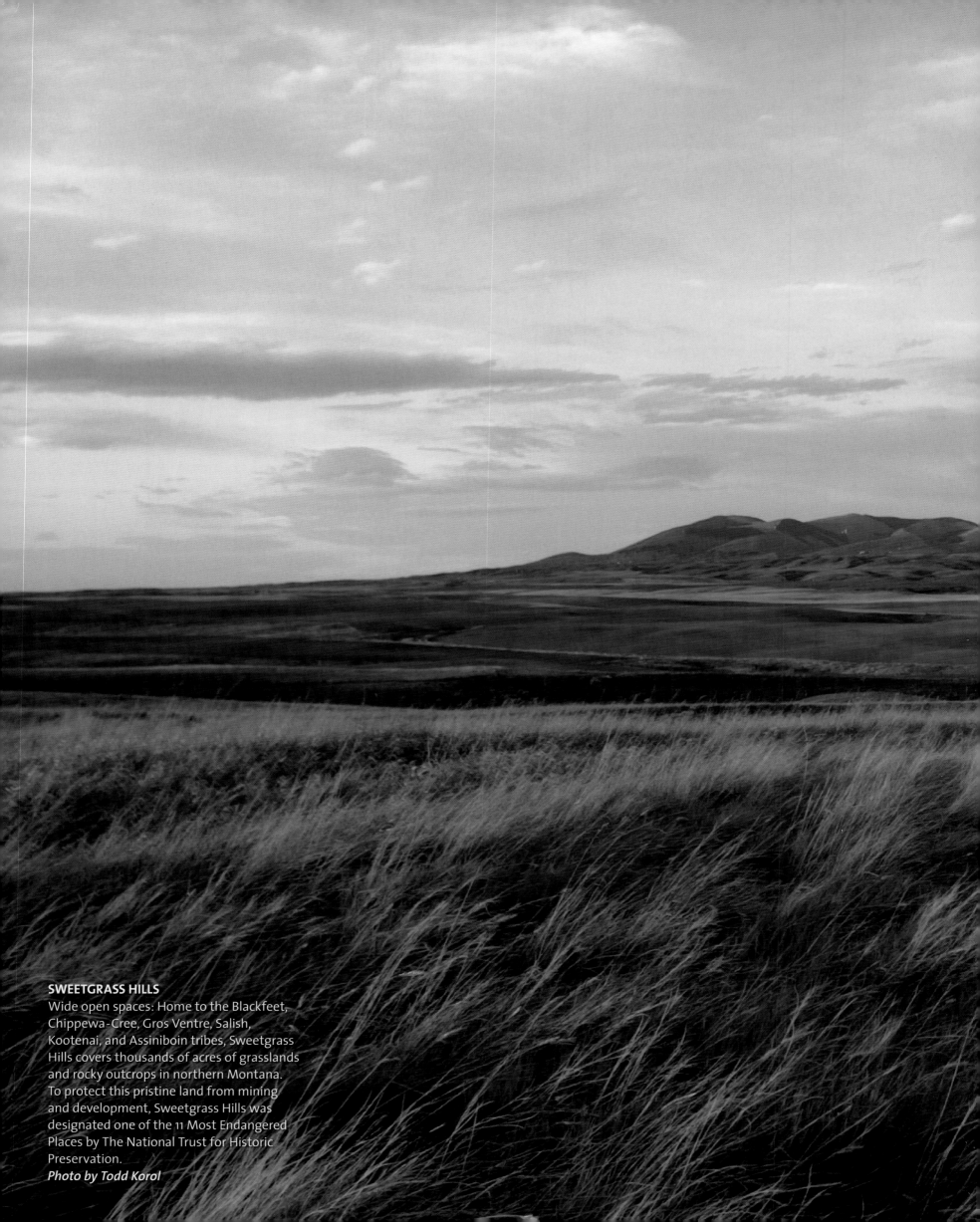

SWEETGRASS HILLS
Wide open spaces: Home to the Blackfeet,
Chippewa-Cree, Gros Ventre, Salish,
Kootenai, and Assiniboin tribes, Sweetgrass
Hills covers thousands of acres of grasslands
and rocky outcrops in northern Montana.
To protect this pristine land from mining
and development, Sweetgrass Hills was
designated one of the 11 Most Endangered
Places by The National Trust for Historic
Preservation.
Photo by Todd Korol

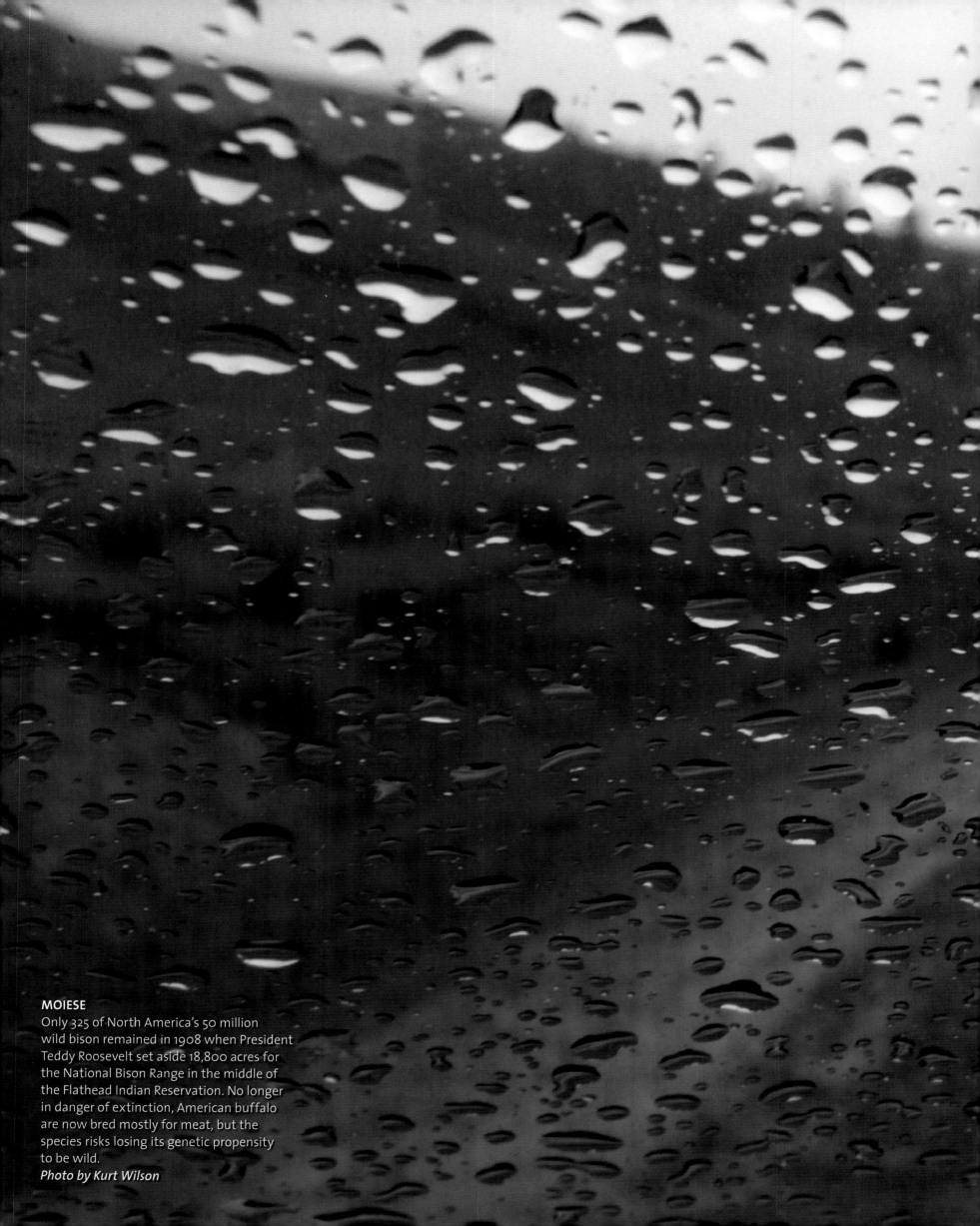

MOIESE
Only 325 of North America's 50 million
wild bison remained in 1908 when President
Teddy Roosevelt set aside 18,800 acres for
the National Bison Range in the middle of
the Flathead Indian Reservation. No longer
in danger of extinction, American buffalo
are now bred mostly for meat, but the
species risks losing its genetic propensity
to be wild.
Photo by Kurt Wilson

PRAY
Chico Hot Springs got its commercial start when miners stopped to bathe and "wash their duds" in the 112-degree water. Since 1900, it's been a luxurious hotel, respected medical facility, and dude ranch. Listed on the National Register of Historic Places, the resort appeals to all ages, as Terry Ferestad and 17-month-old daughter Morgan can attest.
Photo by William Campbell

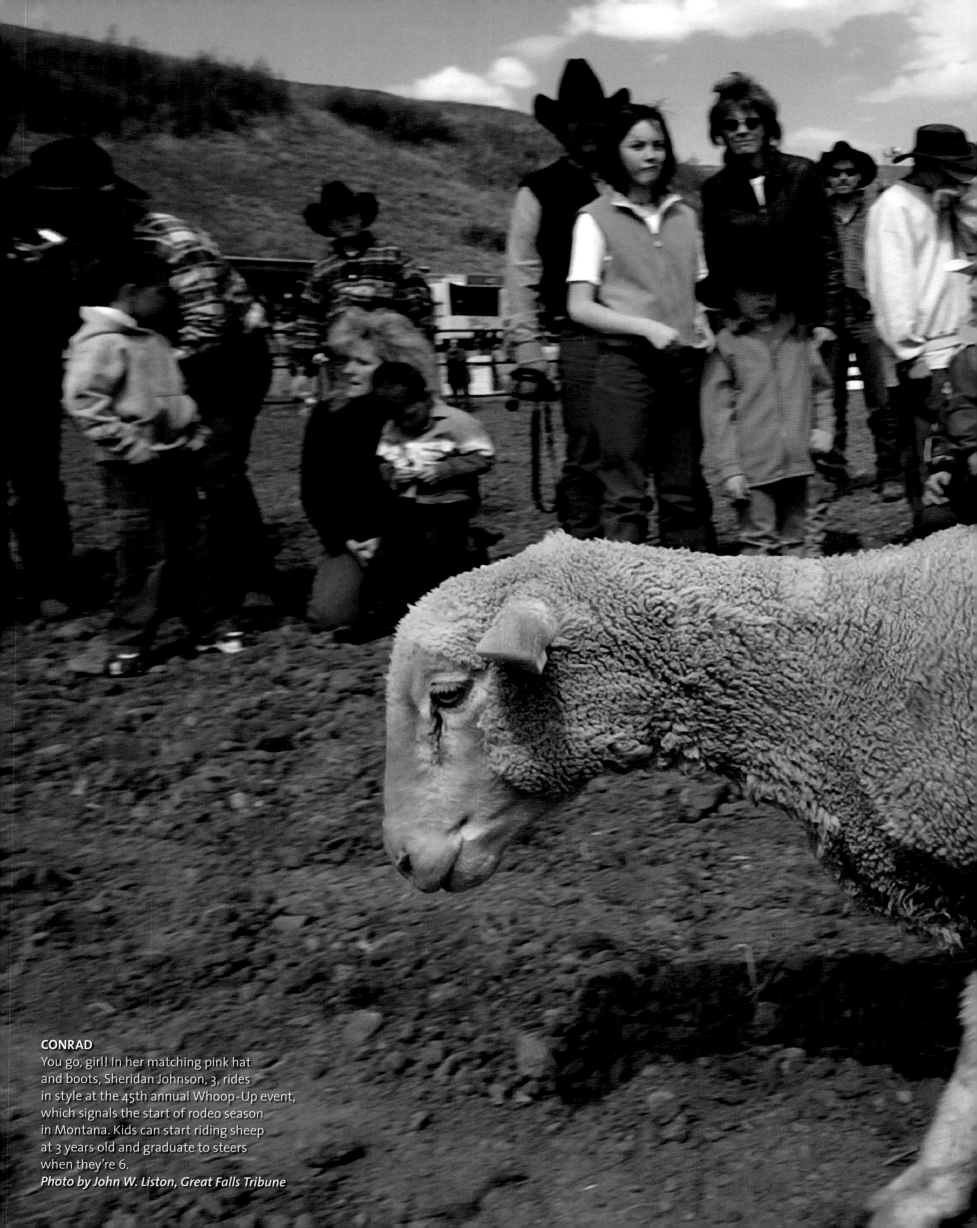

CONRAD
You go, girl! In her matching pink hat
and boots, Sheridan Johnson, 3, rides
in style at the 45th annual Whoop-Up event,
which signals the start of rodeo season
in Montana. Kids can start riding sheep
at 3 years old and graduate to steers
when they're 6.
Photo by John W. Liston, Great Falls Tribune

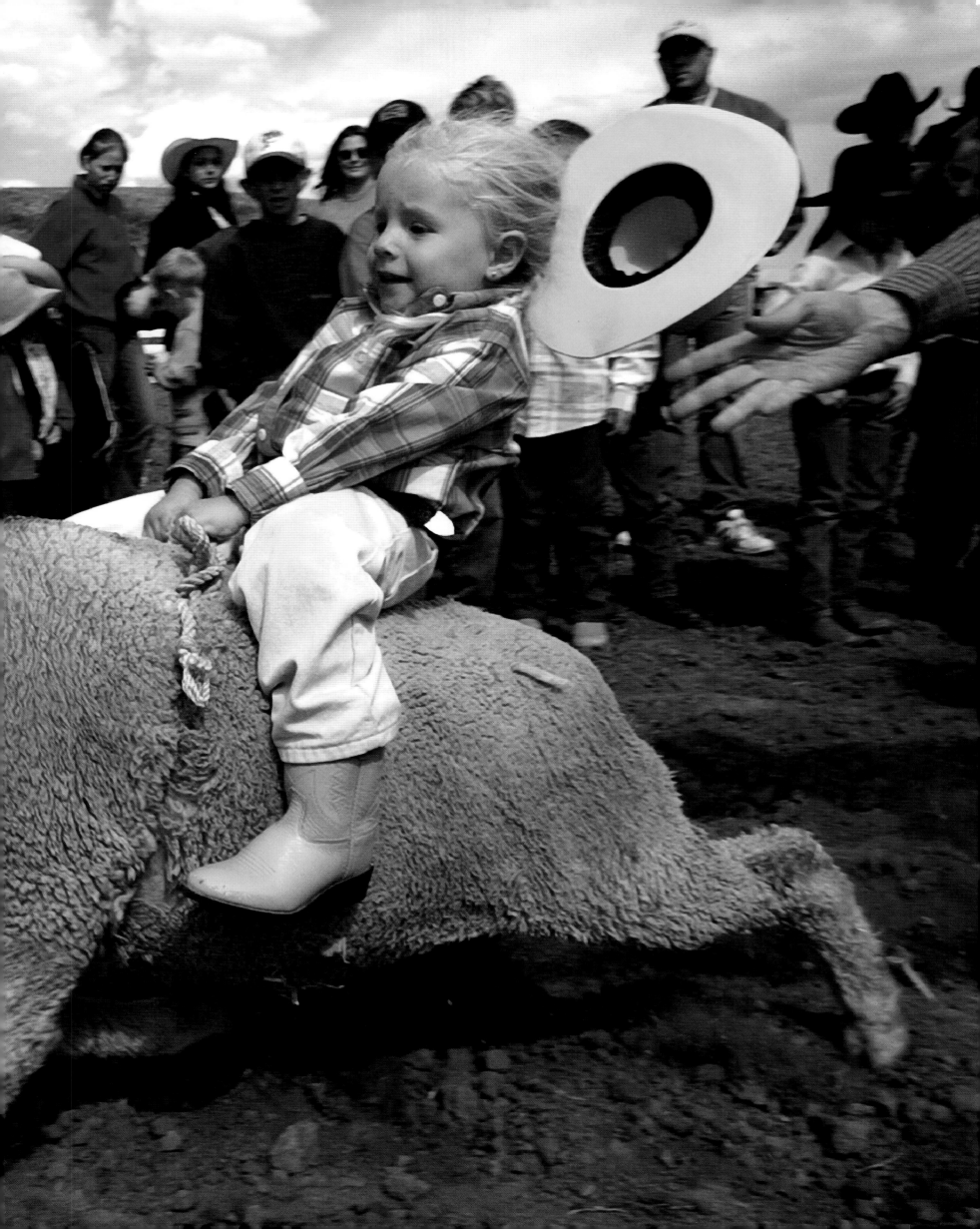

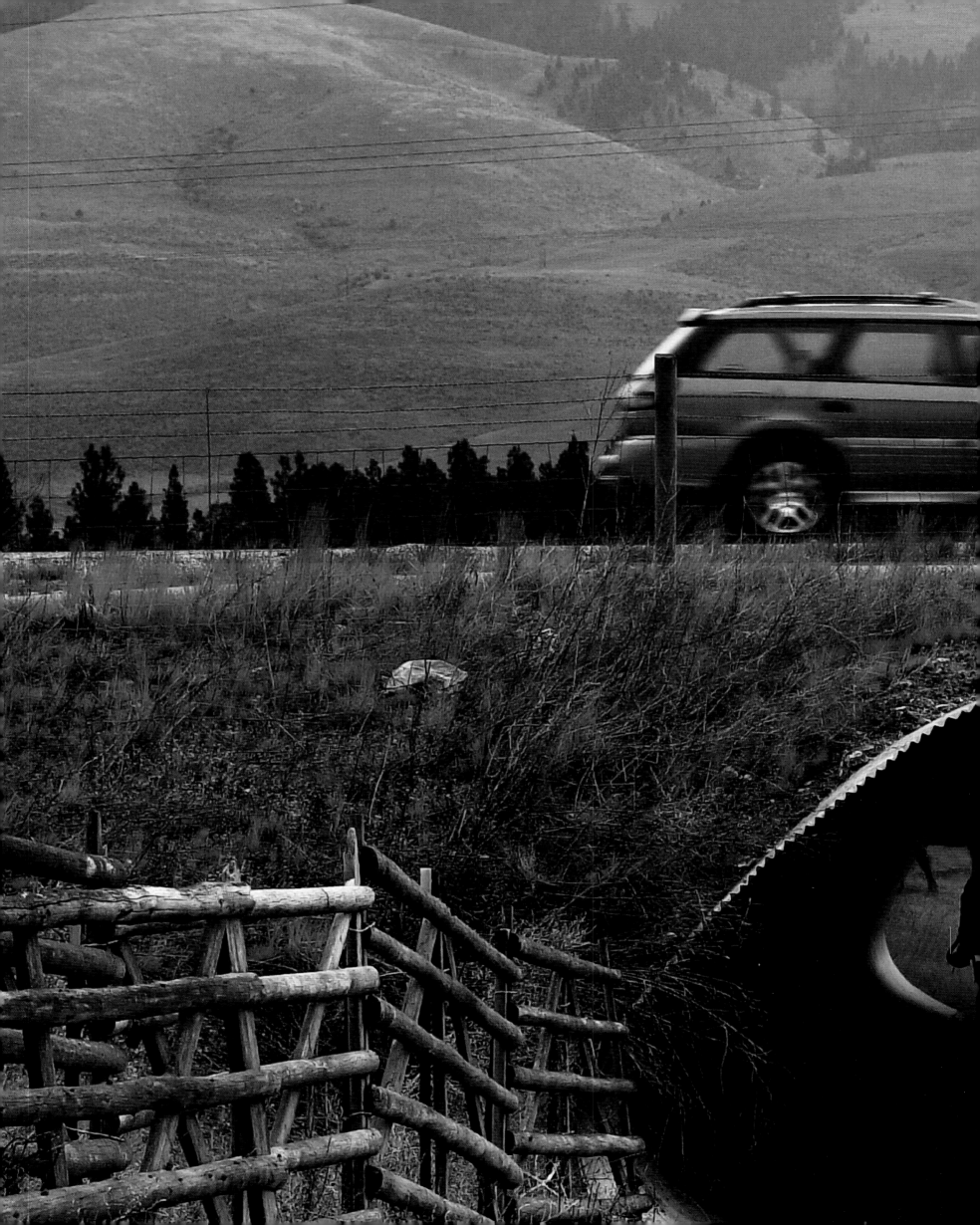

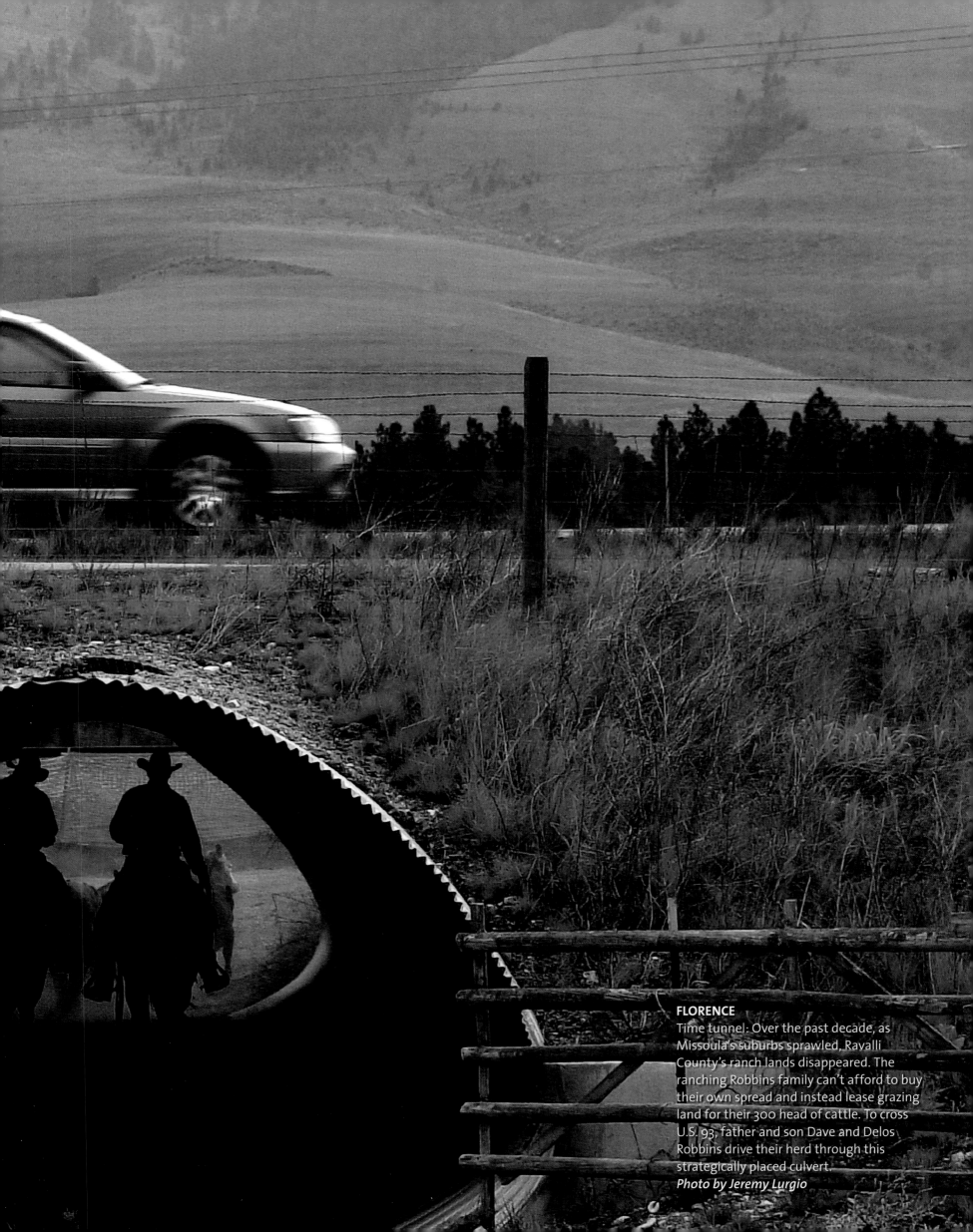

FLORENCE
Time tunnel: Over the past decade, as Missoula's suburbs sprawled, Ravalli County's ranch lands disappeared. The ranching Robbins family can't afford to buy their own spread and instead lease grazing land for their 300 head of cattle. To cross U.S. 93, father and son Dave and Delos Robbins drive their herd through this strategically placed culvert.
Photo by Jeremy Lurgio

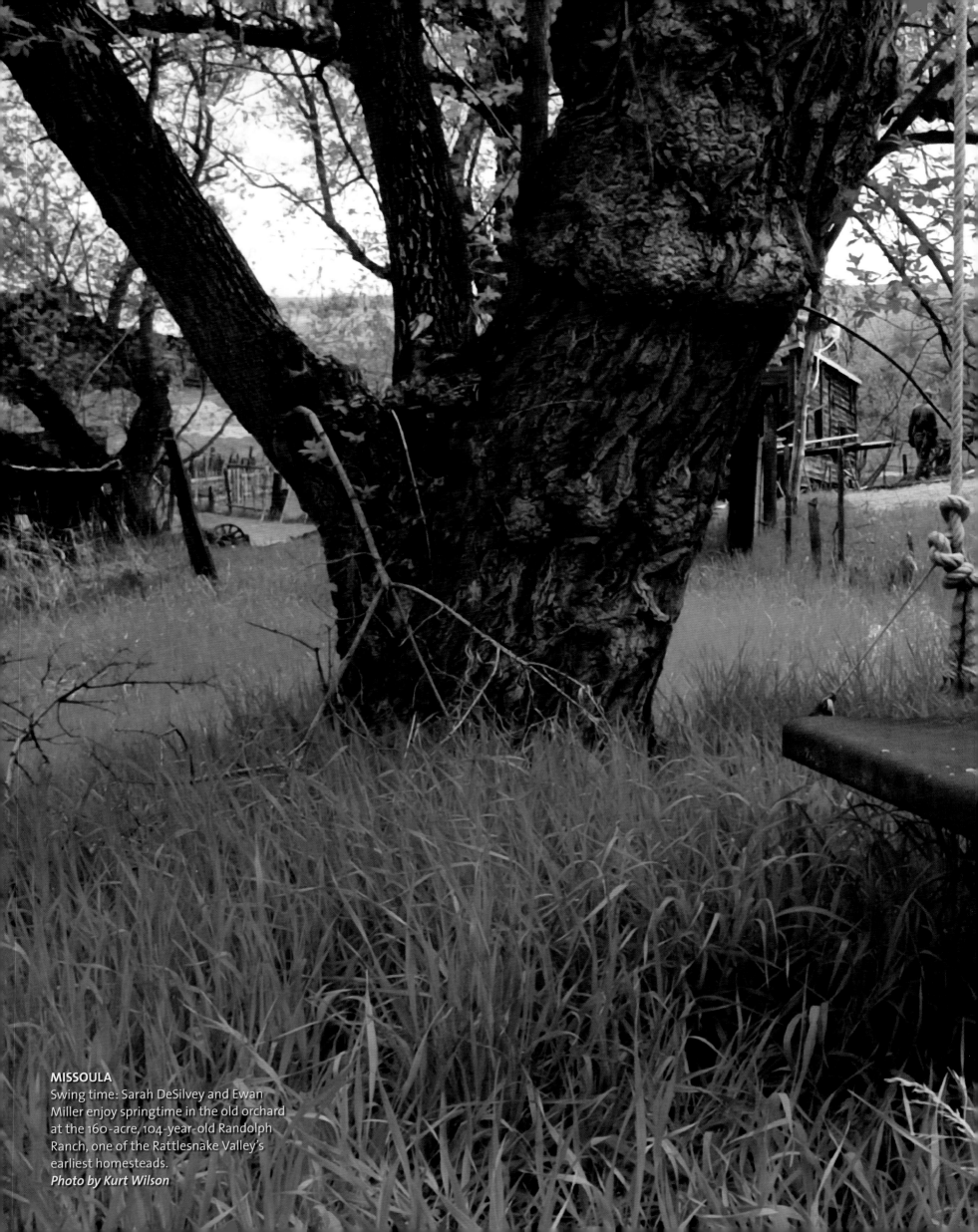

MISSOULA
Swing time: Sarah DeSilvey and Ewan Miller enjoy springtime in the old orchard at the 160-acre, 104-year-old Randolph Ranch, one of the Rattlesnake Valley's earliest homesteads.
Photo by Kurt Wilson

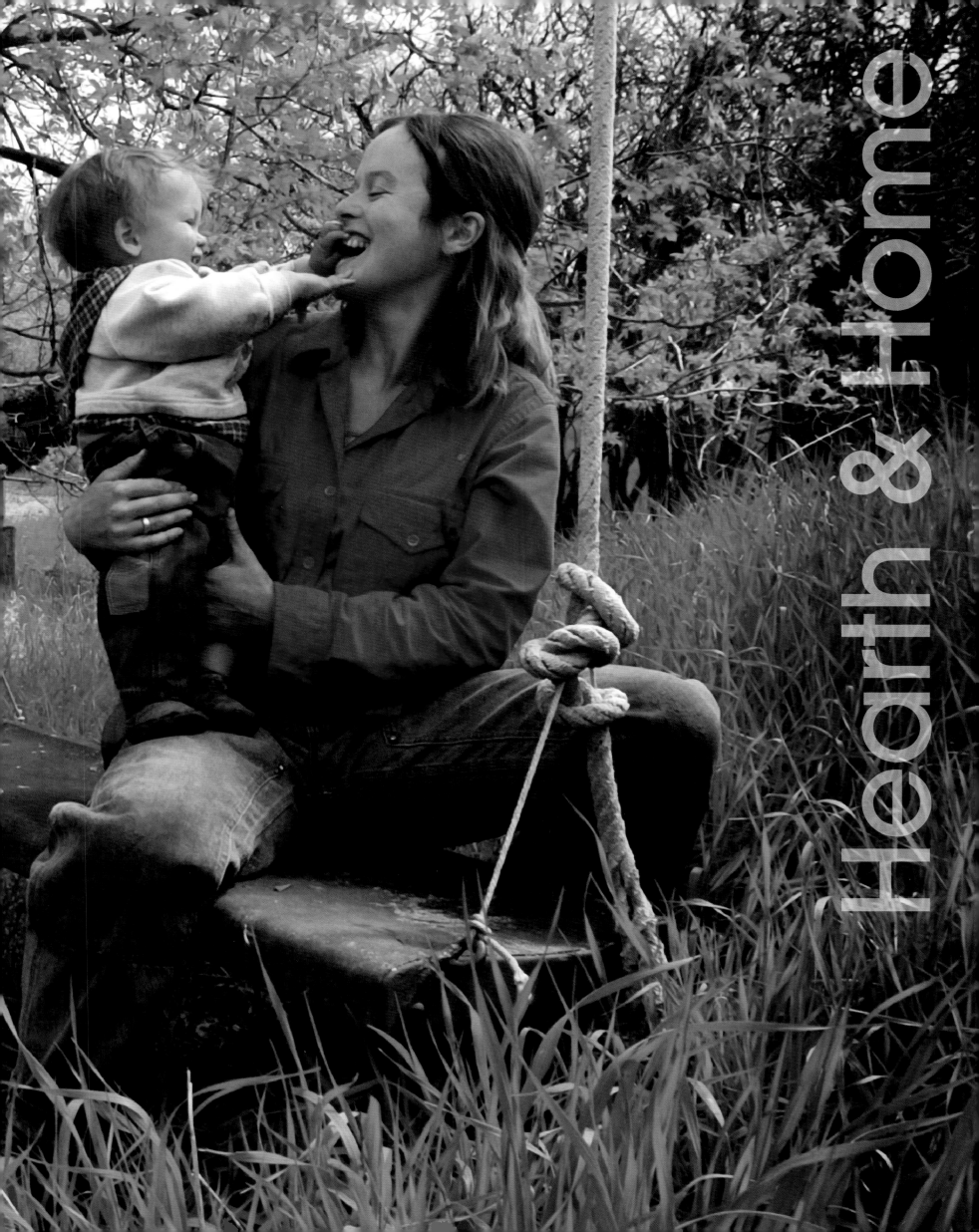

Hearth & Home

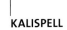

KALISPELL
Lauren Hersey, 10, pulls a wagon with her
little sisters, Aubryn, 2, Kanaan, 4, and
Justine, 7, through their family's field. The girls
live in a trailer with their 9-year-old brother and
parents, who are building a farmhouse on their
20-acre lot.
Photo by Jennifer DeMonte

ROCKER

The Richter family lawn abuts a rail yard, a Superfund site, and an interstate highway, but it's an oasis for dad Jade and 7-year-old daughter Ashley. The pair spent Tuesday afternoon zigzagging across their half-acre property on a lawn tractor. "By the time she's old enough to do this by herself, she'll be too busy doing other things," says dad.

Photo by Derek Pruitt, The Montana Standard

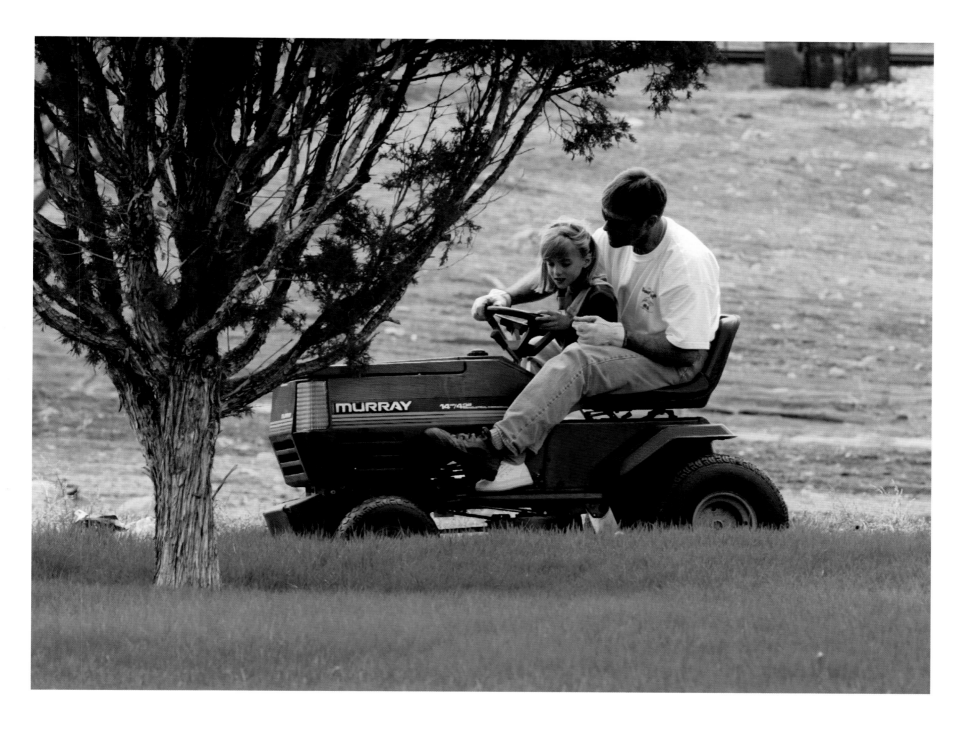

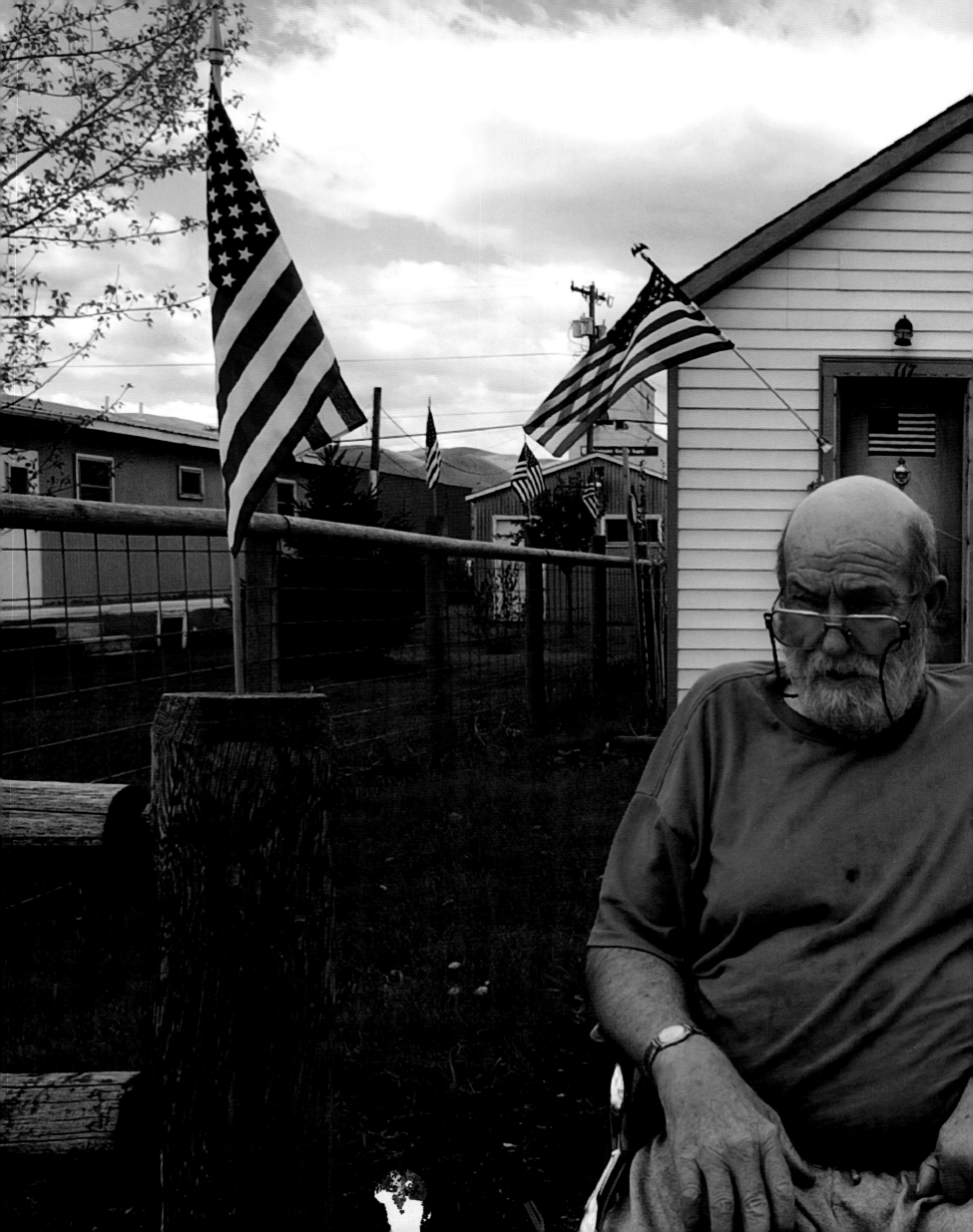

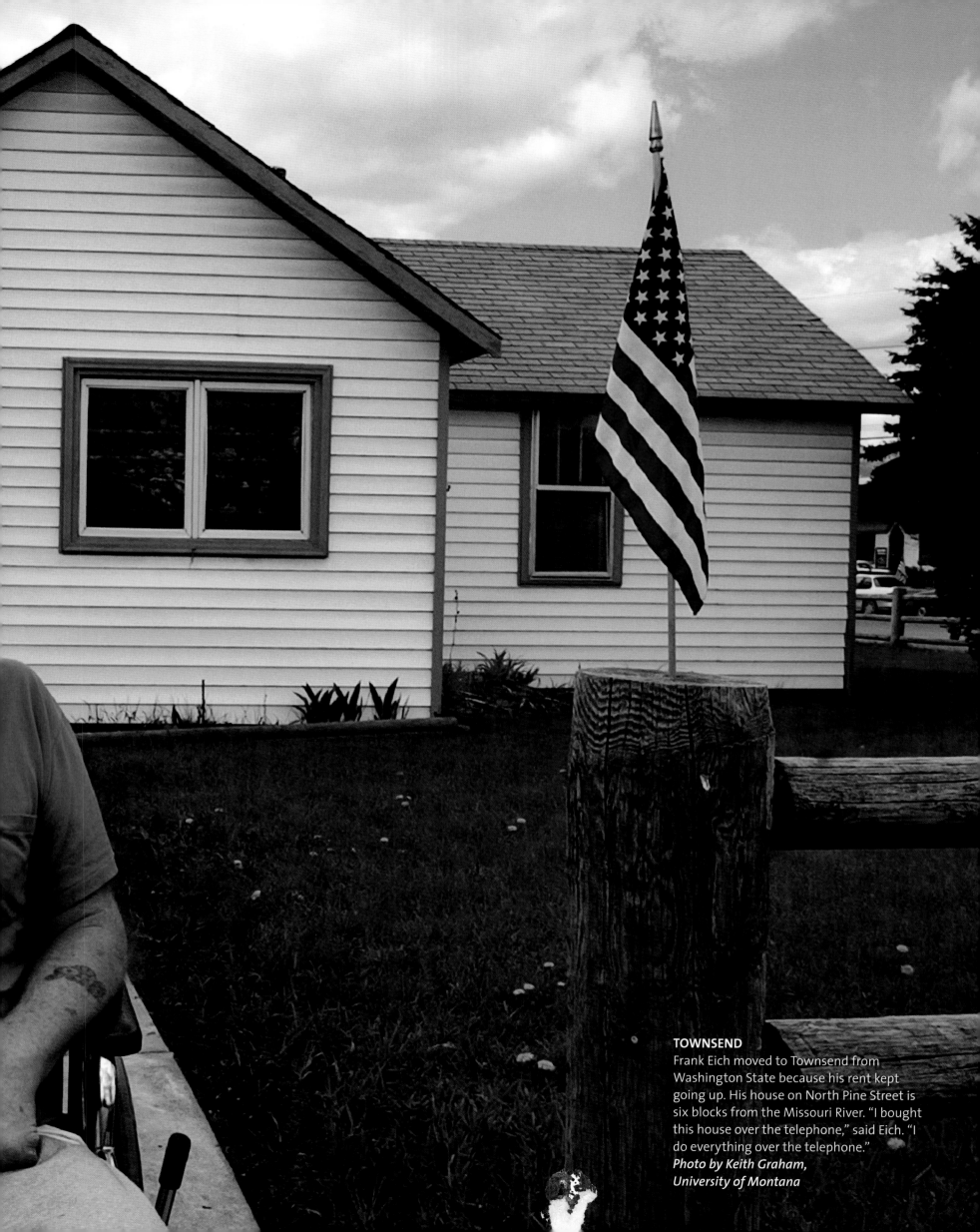

TOWNSEND

Frank Eich moved to Townsend from Washington State because his rent kept going up. His house on North Pine Street is six blocks from the Missouri River. "I bought this house over the telephone," said Eich. "I do everything over the telephone."
Photo by Keith Graham,
University of Montana

WISDOM

This will all be yours someday: Harold Peterson, 68, shows 5-month-old grandson Malcolm their Bitterroot Mountains spread, which was homesteaded by Peterson's grandfather in 1884. They run 500 head of Black Angus cattle at the ranch. The major changes since Peterson was a kid? Electricity and running water.
Photo by Cynthia Baldauf

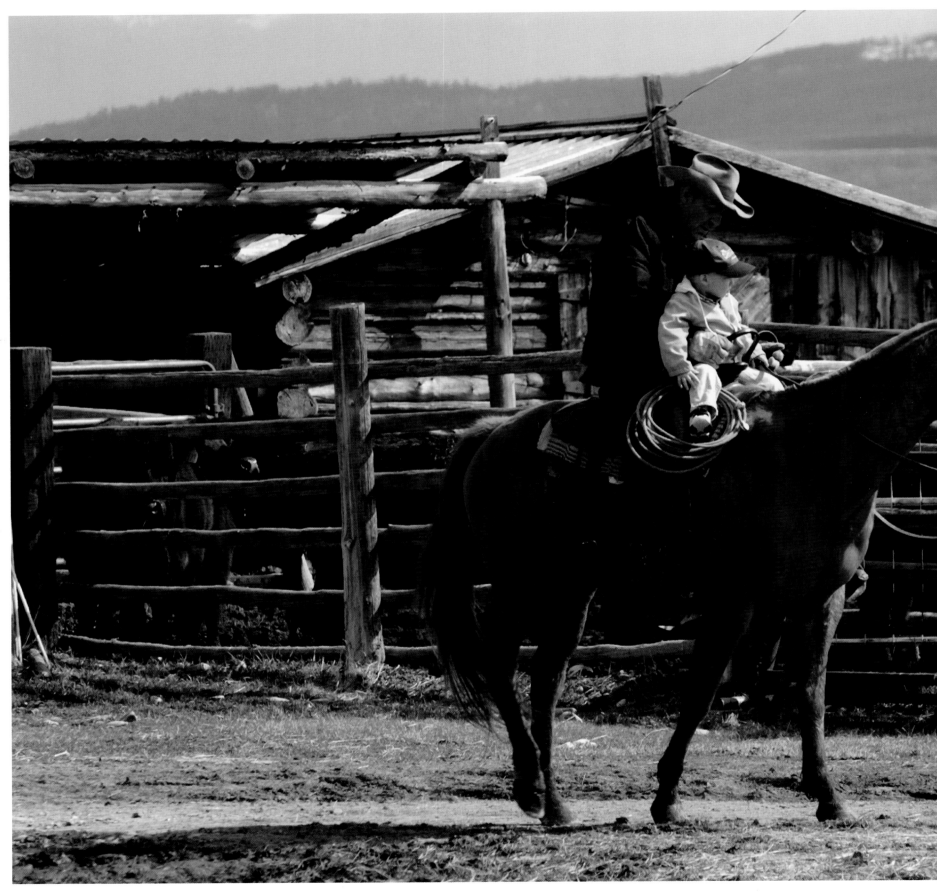

The cowboy and the school marm: The twinkle in Tim Coon's eye has to do with his upcoming wedding to Amy, an elementary school teacher he met in Bible study. When he got up the courage to ask her what she was doing Saturday night, she said, "Cutting your hair."
Photo by Cynthia Baldauf

Kaydee Coon and sisters Jordan and Morgan Peterson settle down on an old Chevy truck stashed for parts at the Peterson Ranch. For fun, the kids ride horses, catch frogs, and raft and fish in Upper Miner Lake. When the weather turns, they ice skate on the ranch pond, ski, snowmobile, and toboggan.
Photo by Cynthia Baldauf

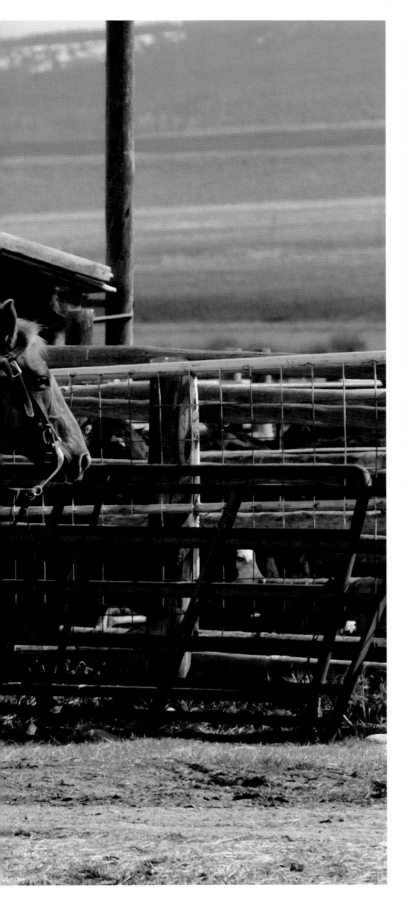

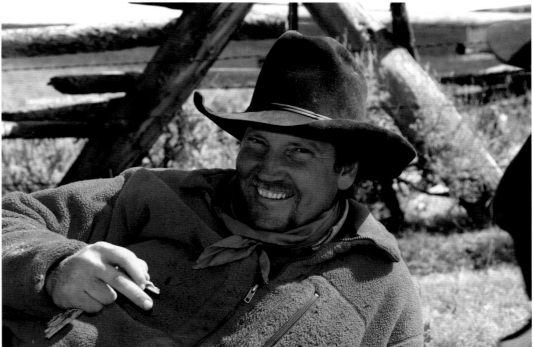

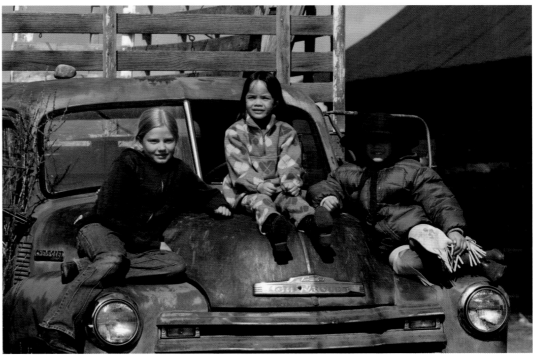

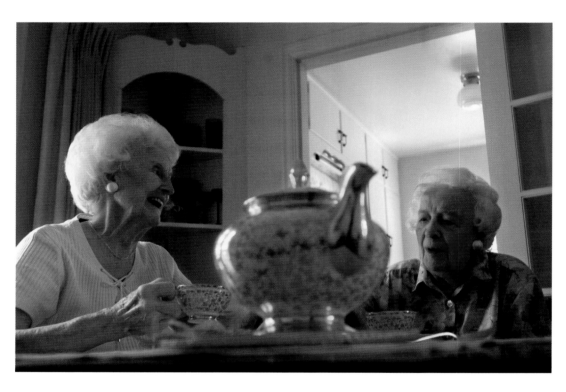

HAMILTON

June Howe, 92, and her sister Zelma Hartley, 98, visit over a cup of tea at June's house in Hamilton (pop. 4,000). The sisters, who live across the street from each other, fondly remember their first tea parties nearly nine decades ago. That's when they formed the Happy Hearts Club with three other girls who lived on what was then a dirt road.

Photo by Jeremy Lurgio

WHITE SULPHUR SPRINGS

A former rancher and chef who spent most of her younger years working sunup to sundown, 99-year-old Carrie Stidham has outlived five of her 12 children. Now two of her sons and a daughter-in-law visit her and her beloved cat Jack regularly at the Mountain View Nursing Home.
Photo by Doug Loneman, Loneman Photography

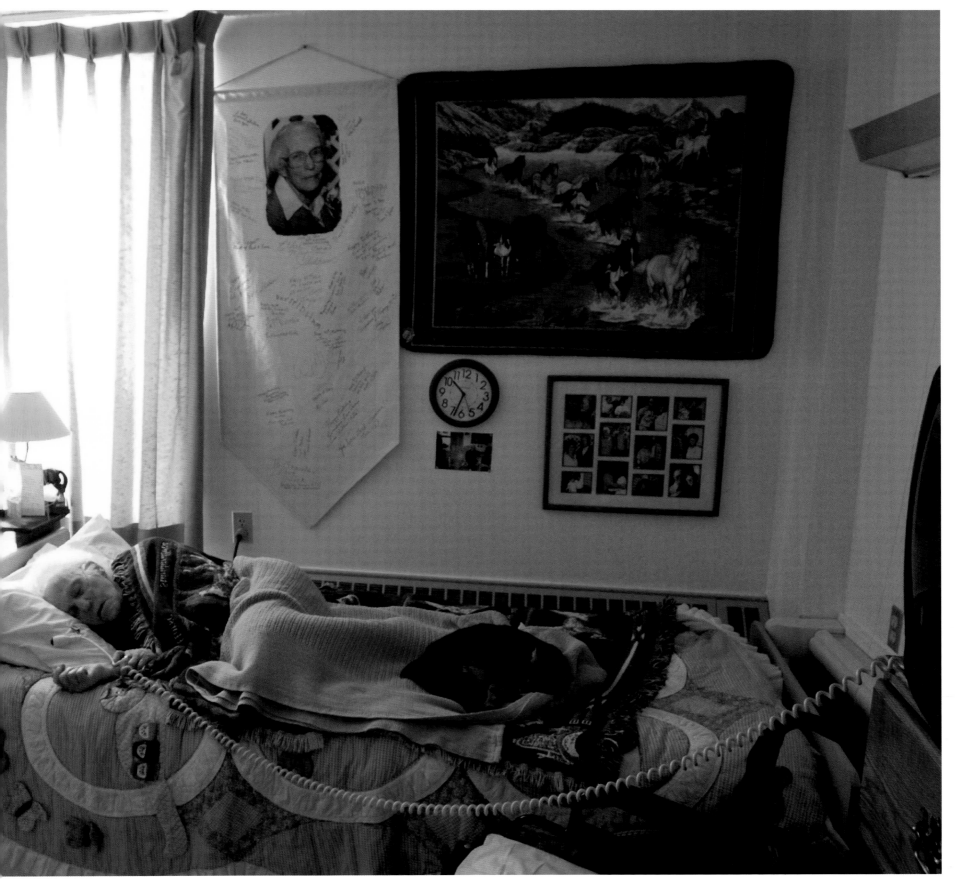

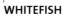

A month past due, Michelle Saurey, 34, gets a
checkup while husband Peter Edland and dog
Spots keep her company. Midwife Kathleen
Gaines (left) and apprentice Marcy Kuntz (right)
are popular in the Whitefish/Kalispell area, tend-
ing to pre- and postnatal women and presiding
at an average of three home births every month.
Photos by Jennifer DeMonte

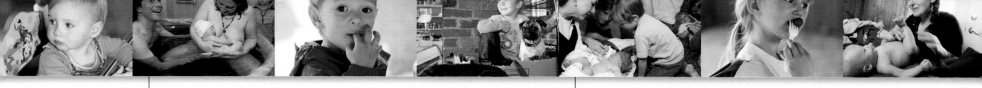

WHITEFISH

Michelle cradles her just born son Niath in the birthing tub she shares with husband Peter. Five-year-old Taven was home birthed, too, but he was too quick for his mom to make it into the bathroom. "Being in the birthing tub is nice because it's warm and I feel buoyant," says Michelle. "But it still hurts when they come out."

WHITEFISH

While brother Curran, 8, hangs back on the couch, Taven, 5, inspects his new baby brother. Both boys agree that their first time watching a baby get born was exciting "but kind of weird."

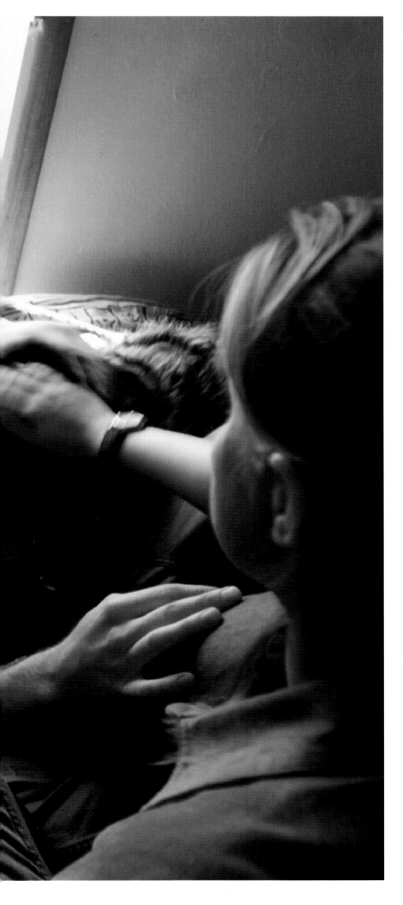

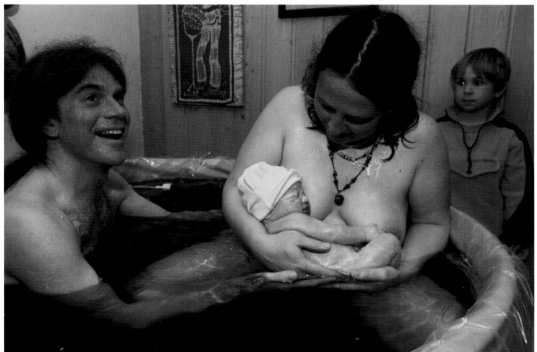

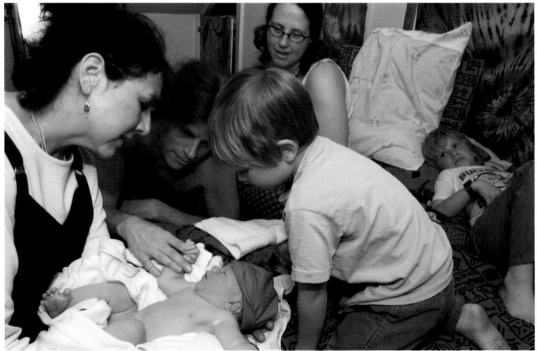

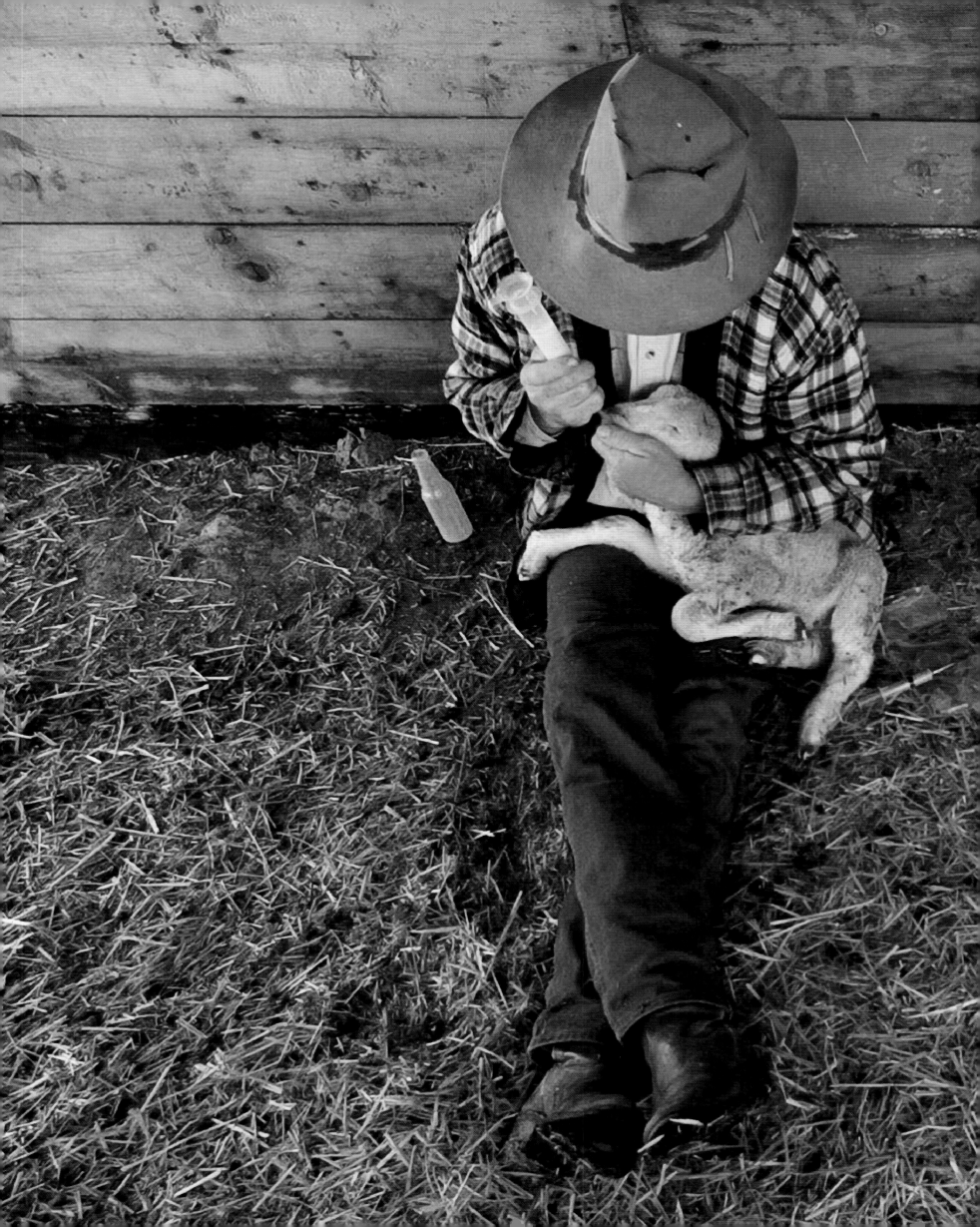

WILSALL
About 120 lambs are born each spring on Chuck Dallas's ranch, and every year a few need hand feeding. This newborn had bad legs and was unable to stand to suckle. Dallas's milk formula and TLC were not enough, however, and the lamb died within a week.
Photo by Erik Petersen

MISSOULA

Homeless and pregnant with her first child at 15, Laura Johnson spent much of her adolescence in and out of jail. When she found a warm bed and caring staff at Mountain Home, a transitional residence for homeless mothers, Johnson turned her life around. In July 2003, she completed her probation, moved out, and regained custody of her 3-year-old daughter Anastasia Monroe.
Photos by Jeremy Lurgio

Dinnertime at Mountain Home can be tough for toddlers like Anastasia. With up to six other kids as playmates, finishing her macaroni and melon isn't a priority.

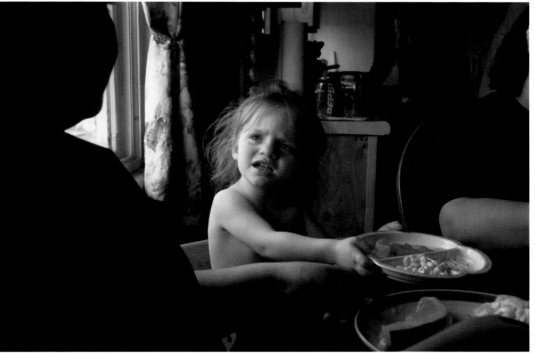

WHITEFISH

Physical therapist Lynnell Finley, who went into labor during a prenatal yoga class, returns with her 7-week-old daughter Ashlyn for a feed and postnatal stretch session at the Whitefish Yoga Center.

Photo by Jennifer DeMonte

WISDOM

Picking lupine is fun, but Kaydee Coon says her real love is her new horse Flash. She hopes he, unlike her two former horses, will help her win some ribbons at local barrel racing and pole bending competitions.

Photo by Cynthia Baldauf

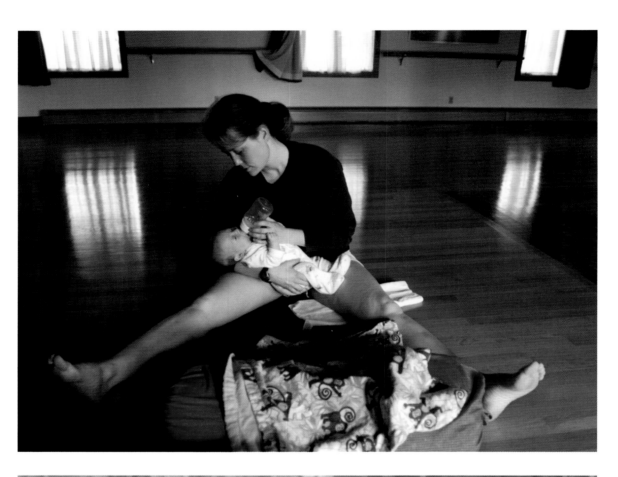

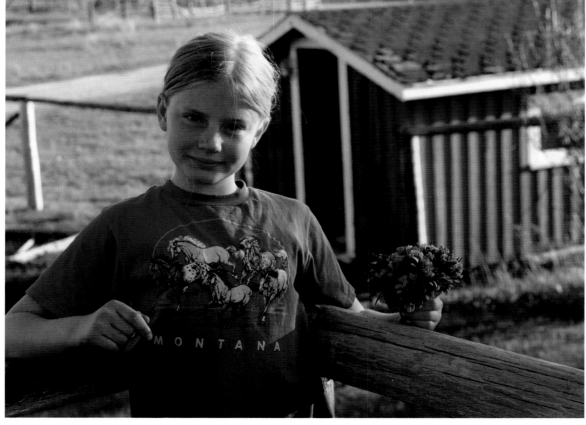

MISSOULA

Lois and James Welch at home in Rattlesnake Valley. The French government knighted James, a Blackfeet Indian, for his well-known 1986 novel *Fools Crow* about a Blackfeet boy coming of age before white men arrived. "The French are wild for Indians," explains Lois, the retired chair of the English Department at the University of Montana.

Photo by Teresa L. Tamura, University of Montana

JOLIET

On the couch, Shadya Jarecke, 9, struggles to stay awake while 6-year-old sister Yasmine makes shadow puppets on the wall.

Photo by Kenneth Jarecke, Contact Press Images

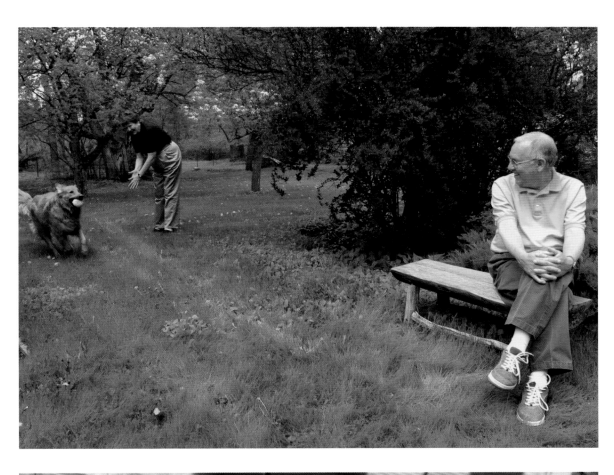

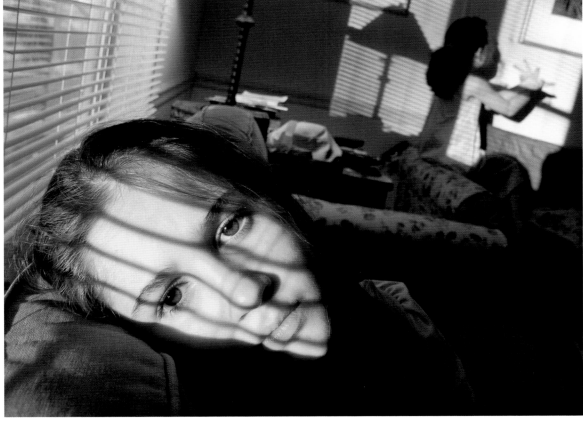

The year 2003 marked a turning point in the history of photography: It was the first year that digital cameras outsold film cameras. To celebrate this unprecedented sea change, the *America 24/7* project invited amateur photographers—along with students and professionals—to shoot and, via the Internet, submit digital images. Think of it as audience participation. Their visions of community are interspersed with the professional frames throughout this book. On the following four pages, however, we present a gallery produced exclusively by amateur photographers.

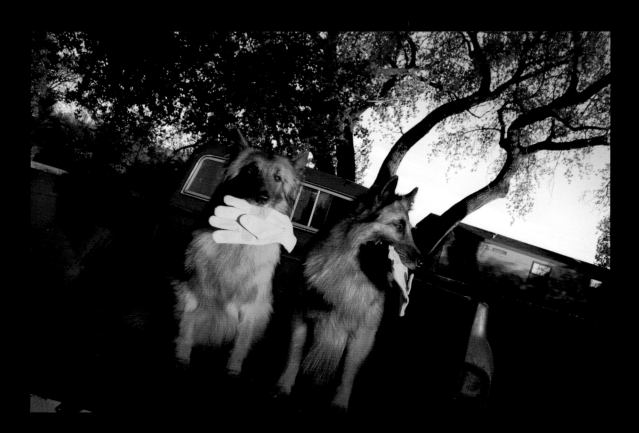

BILLINGS Sit. Now shake. Drifter and Ace, both Belgian Tervurens, are in training to track game. An early lesson is learning to find and retrieve gloves. So far, so good. *Photo by Ronnie James*

LITTLE BELT MOUNTAINS Anna Simonsen wants to be a veterinarian and has plenty of practice. In addition to Mickey Blue Eyes, her family's menagerie includes three other dogs, six cats, four horses, and a parakeet. *Photo by Karen Simonsen*

he annual What the Hay contest showcases sculptural creat
Hobson, and Windham. *Photo by Karen Simonsen*

n shakes off the season's last snowfall. *Photo by Alyssa H*

ers, 10, dirt bikes in the dry bed of the Cottonwood River botto
s family's house. *Photo by Elizabeth Powers*

had a foal of her own, Sundance, 25, adopted Keanu Armstro
o feed the horse his bottle. *Photo by Kathy Muskopf*

SEELEY LAKE So this is what grandpas taste like. Christopher Mayes from Dallas, Texas, lends a finger while visiting his first grandchild, 2-week-old Keagan Mayes. *Photo by JoAn Mayes*

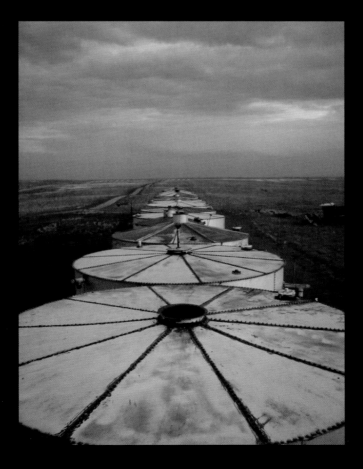

HILGER Grain bins storing winter or spring wheat line up in central Montana. *Photo by Rob Tweedy*

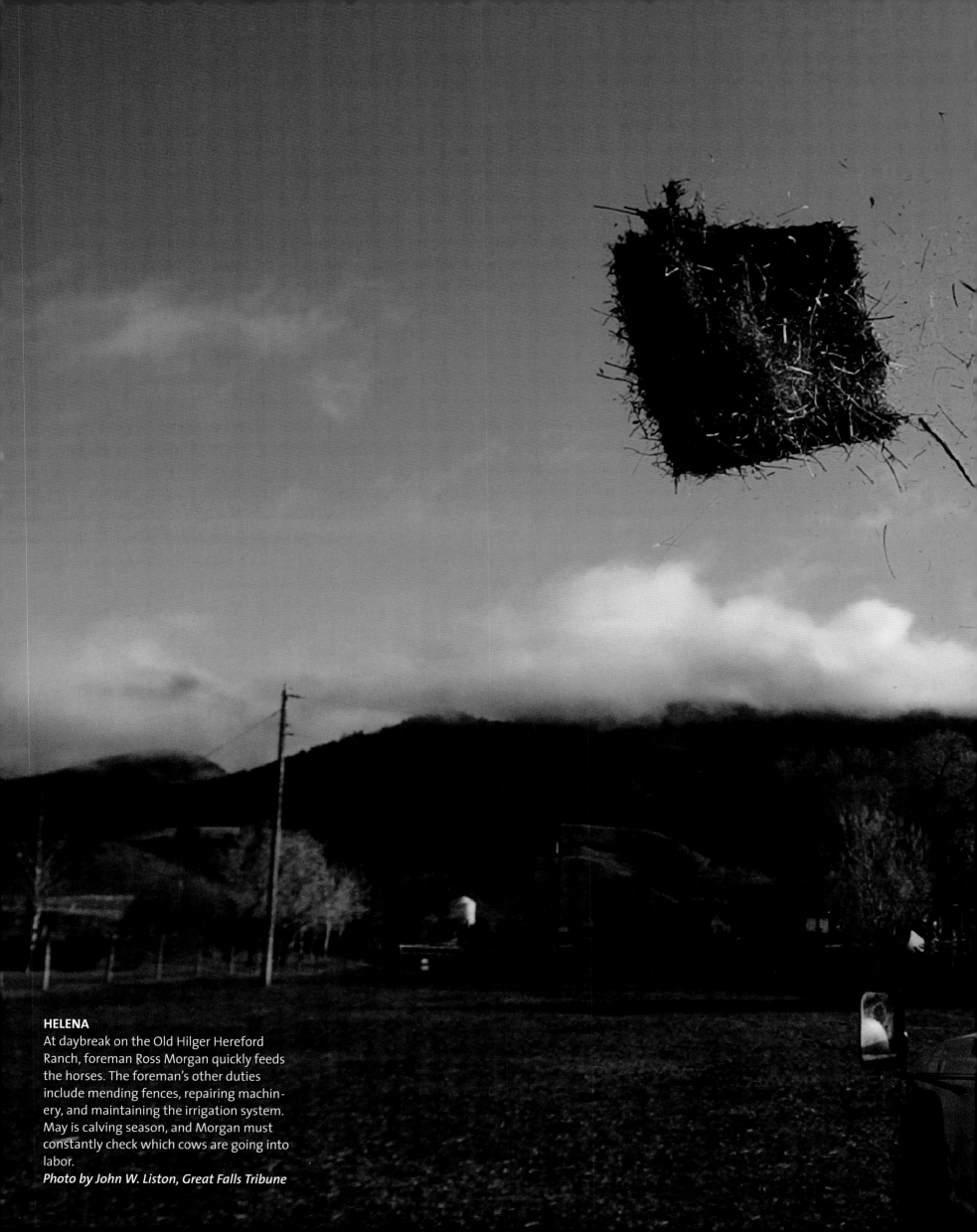

HELENA
At daybreak on the Old Hilger Hereford Ranch, foreman Ross Morgan quickly feeds the horses. The foreman's other duties include mending fences, repairing machinery, and maintaining the irrigation system. May is calving season, and Morgan must constantly check which cows are going into labor.
Photo by John W. Liston, Great Falls Tribune

Hard At Work

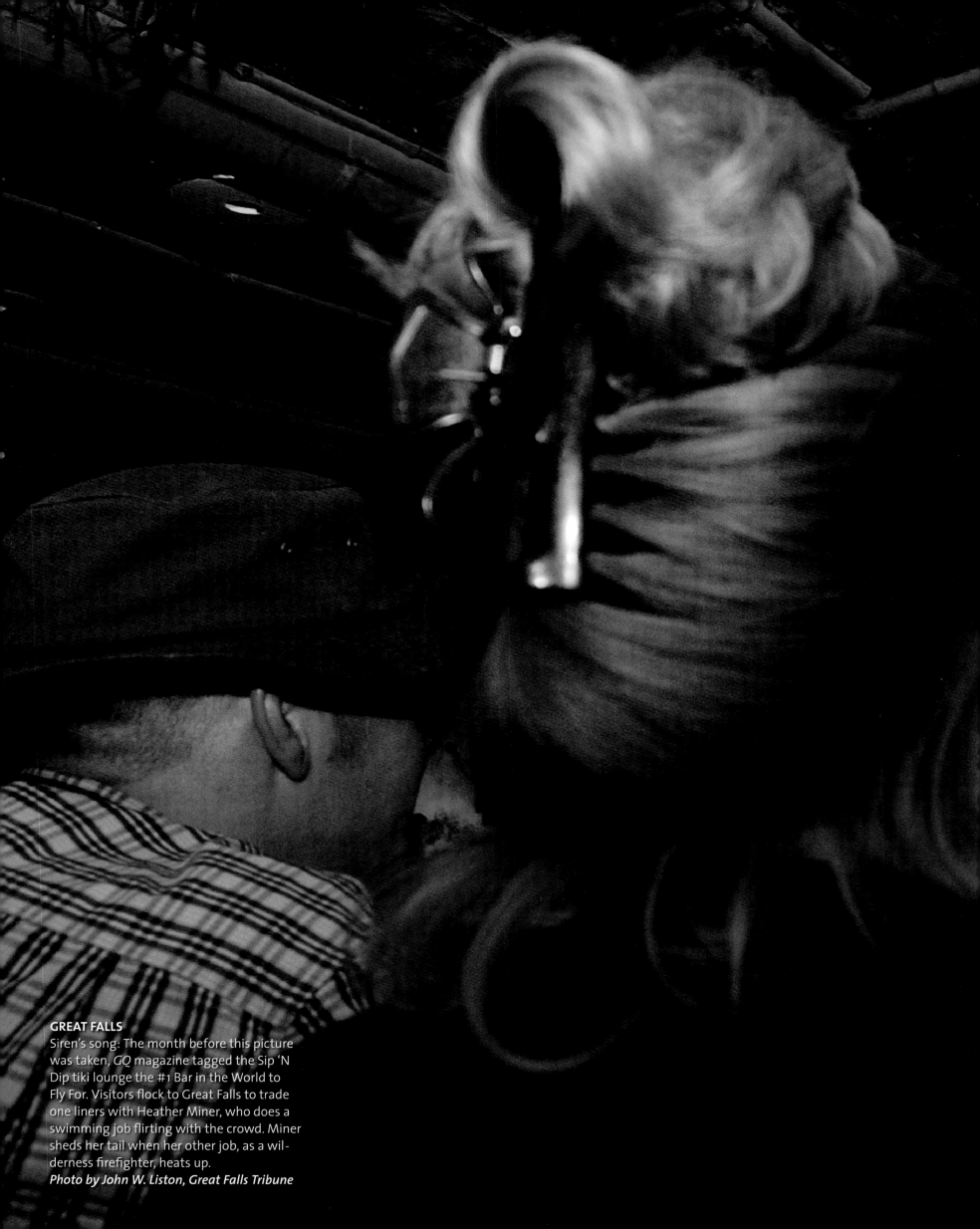

GREAT FALLS

Siren's song: The month before this picture was taken, *GQ* magazine tagged the Sip 'N Dip tiki lounge the #1 Bar in the World to Fly For. Visitors flock to Great Falls to trade one liners with Heather Miner, who does a swimming job flirting with the crowd. Miner sheds her tail when her other job, as a wilderness firefighter, heats up.

Photo by John W. Liston, Great Falls Tribune

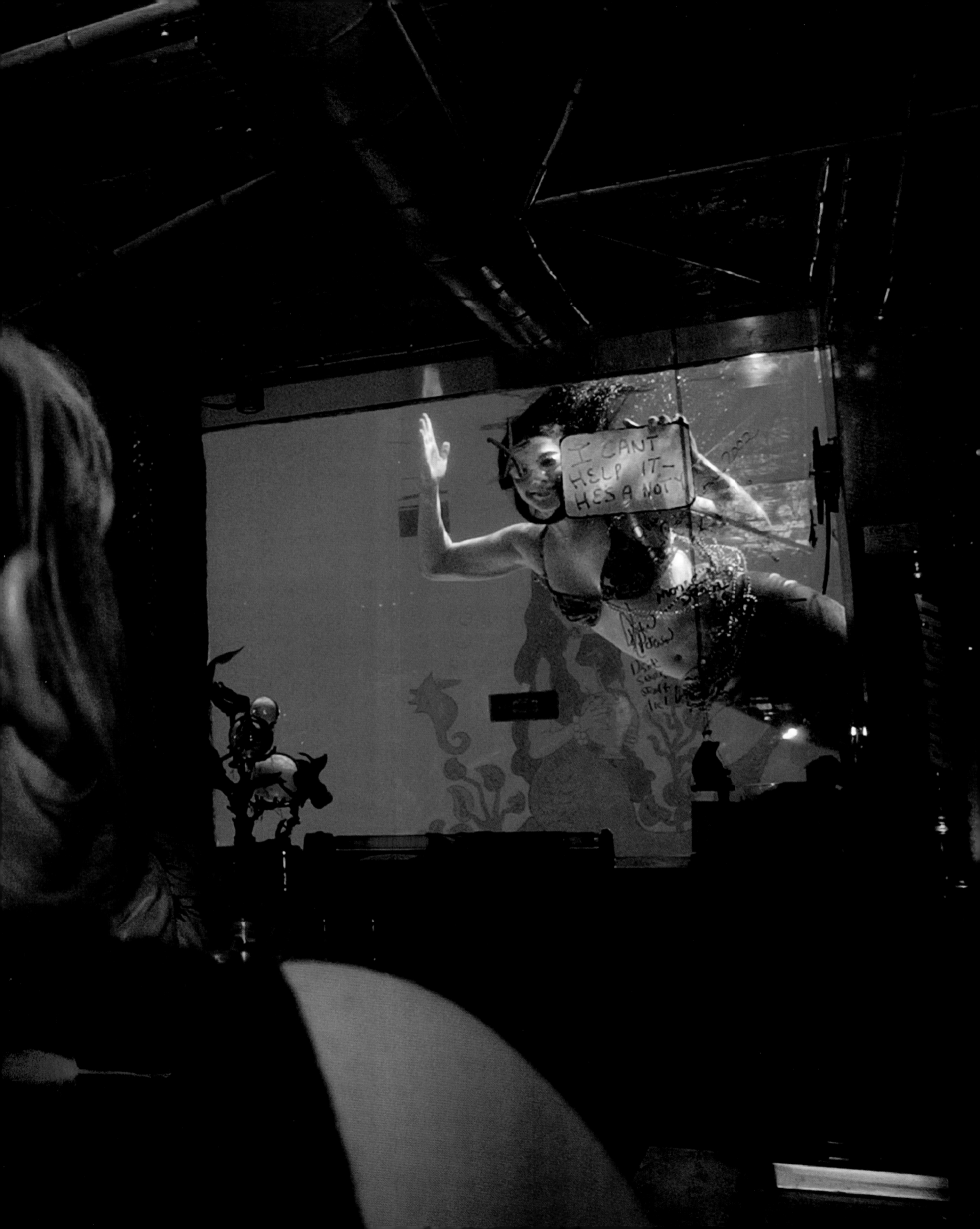

DILLON

On the Helle sheep ranch, traditional sheepherder methods like "tubing out" survive. Peruvian native Raul Tacuma takes less than an hour to skin a lamb that has died, tie the skin sack onto an orphan lamb, and introduce it to the dead lamb's mother. Her sensitive nose recognizes the smell of her own offspring. Within days, the bond is complete, and the sack discarded.

Photo by Michael Coles

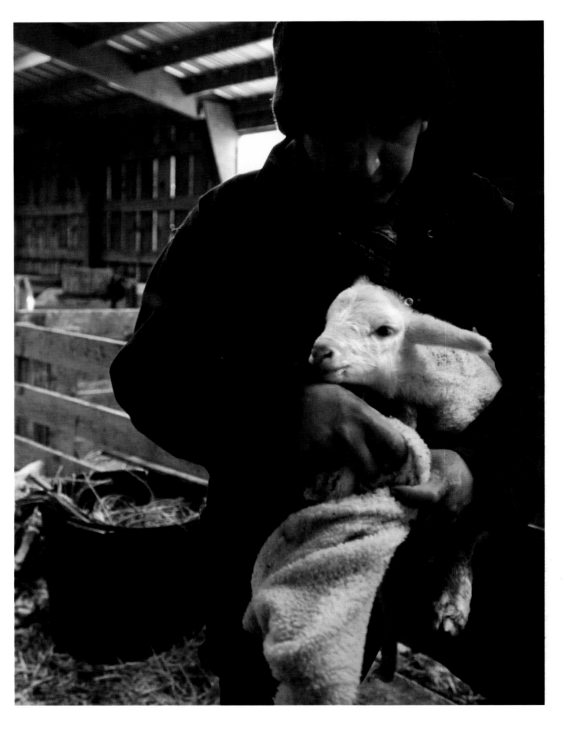

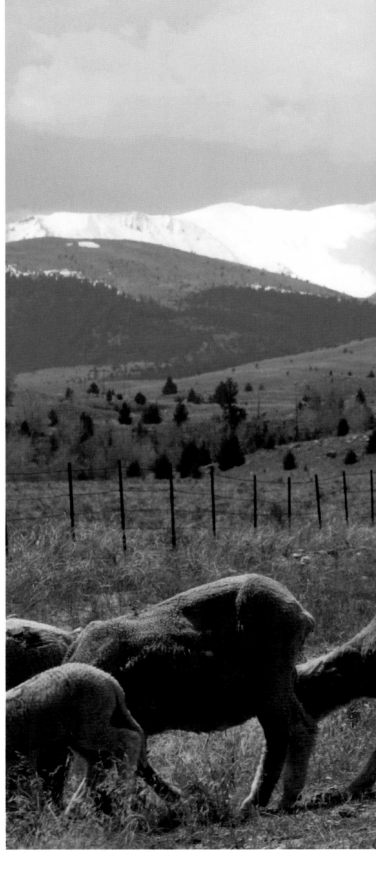

DEER LODGE

Weed wackers: John Lehfeldt unleashes his 350
voracious Rabouillet sheep on a weed called
"leafy spurge" at the 5 Rockin' MS ranch. Unlike
chemical herbicides, the sheep selectively clear
weeds without harming the environment or
destroying grasses favored by cattle.
Photo by Derek Pruitt, The Montana Standard

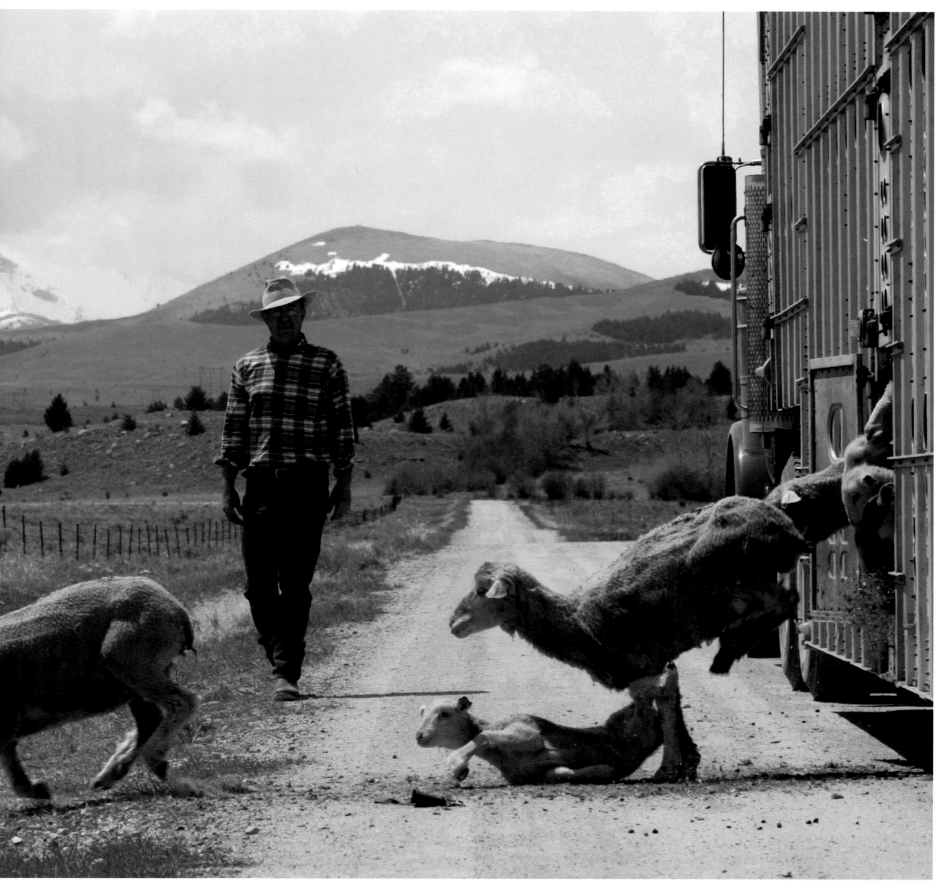

FLORENCE
Taxidermist Steve Brett applies an elk's "cape"—
the actual tanned hide—to a prefabricated
polyurethane form. The tannery takes three to six
months to finish the hide, while Brett does the
mounting in a day. Total cost for a shoulder
mount is around $700.
Photo by Teresa L. Tamura, University of Montana

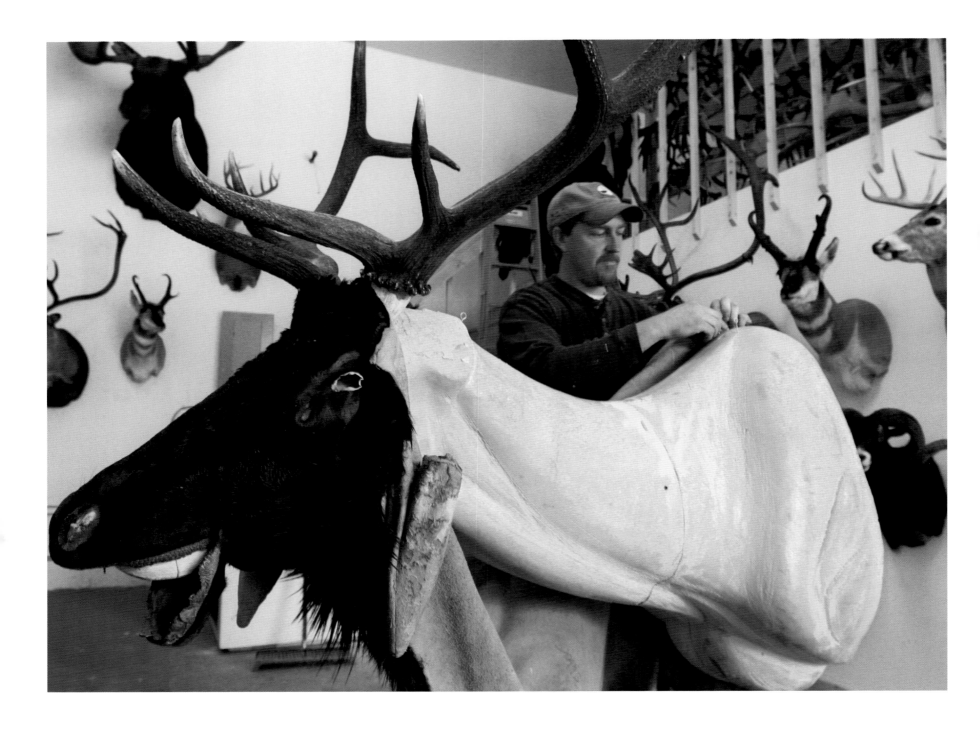

BOZEMAN

Paleontologist Jack Horner stands among the Maiasaurus skeletons he found at Egg Mountain, a graveyard for thousands of dinosaur bones. The curator of the Egg Mountain exhibit at the Museum of the Rockies garnered international fame for his 1978 discovery of baby dinosaur skeletons and his subsequent study of dinosaur parenting.

Photo by Doug Loneman, Loneman Photography

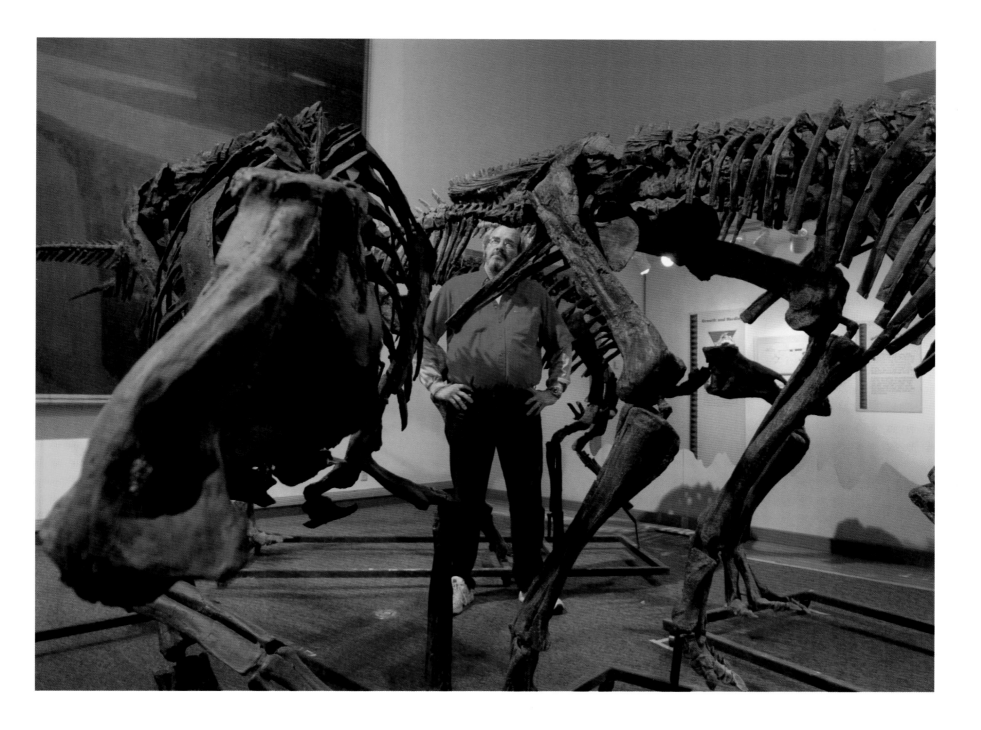

SHELBY

Joseph Ewald fills out his logbook after a dinner break at a Shelby truck stop. The trucker, who was hauling bales of corrugated cardboard, will spend the next seven hours sleeping in his rig before heading home to Calgary, Alberta, 180 miles away.
Photo by Todd Korol

BUTTE

Mining haul trucks take a sabbatical in a machinery storage yard near the Montana Resources Copper Pit. Due to declining copper prices, the mine temporarily closed its doors in 2000. It reopened in August 2003 when prices recovered.
Photo by Derek Pruitt, The Montana Standard

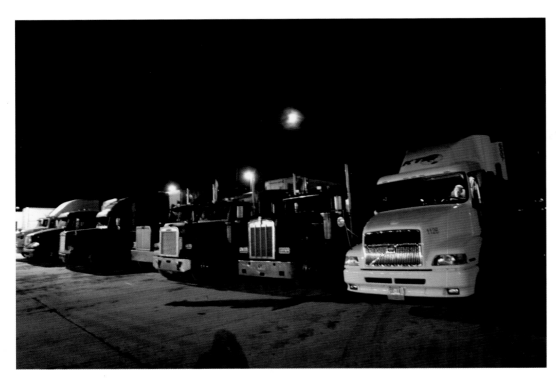

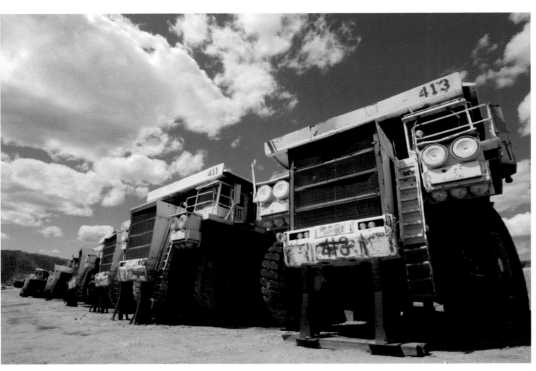

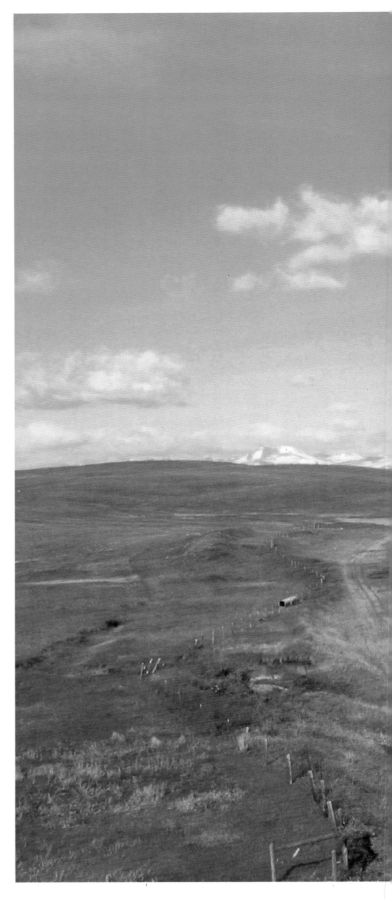

GLACIER COUNTY
The Rocky Mountain Front: A westbound Burlington Northern freight train leaves the Great Plains to climb through foothills toward Maria's Pass (elev. 5,213 feet) in Glacier National Park.
Photo by Dudley Dana, Dana Gallery

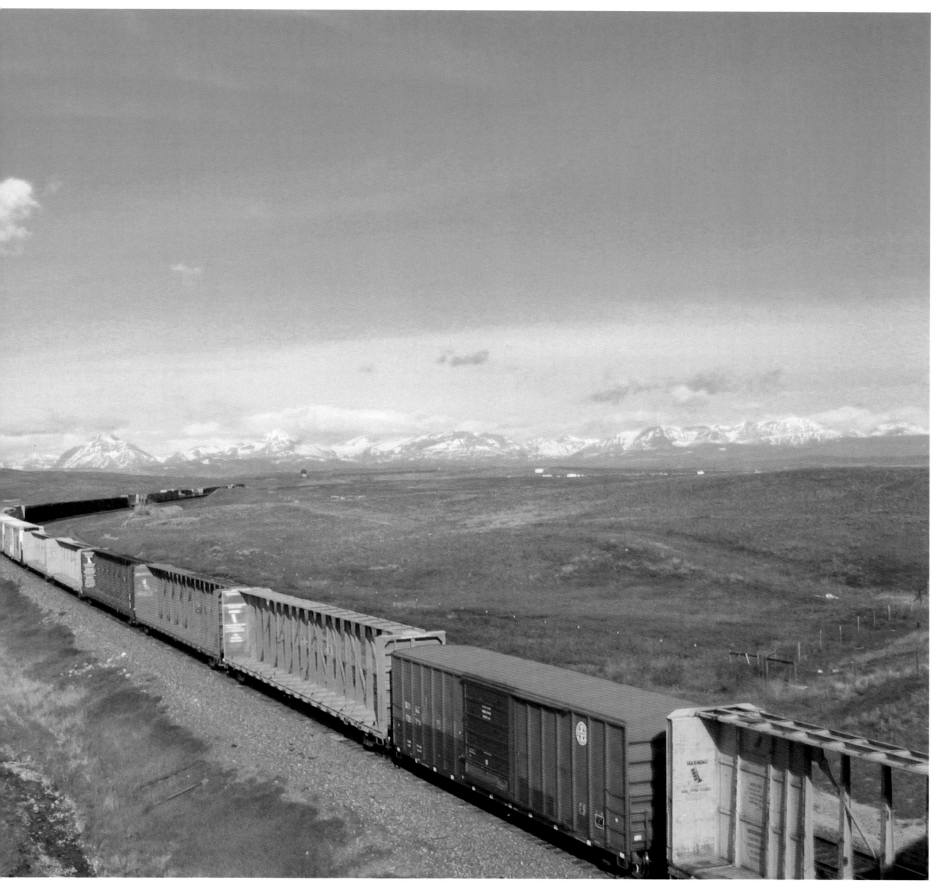

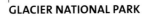

COOKE CITY

Ralph Glidden clears the winter's build-up in front of his store. Opened in 1886, the Cooke City General Store still has its original wood floors and rolling ladders, and the 1911 cash register. Located at the northeast entrance to Yellowstone National Park, the store caters to tourists from May to September.

Photo by Erik Petersen

GLACIER NATIONAL PARK

Herb Ferguson's rotary plow chews up a 30-foot drift to open Logan Pass (elevation 6,646 feet)— the highest point on Glacier's Going-to-the-Sun Road, a narrow, winding, 50-mile-long miracle carved out of the rock 65 years ago. In addition to treacherous snow drifts up to 90 feet deep, plow operators face avalanches, sheer 3,000-foot dropoffs, and blinding sunlight.

Photo by Robin Loznak

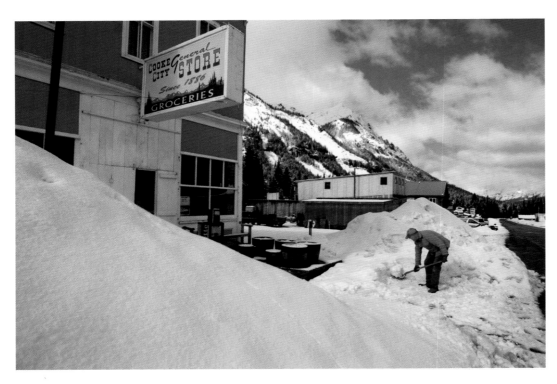

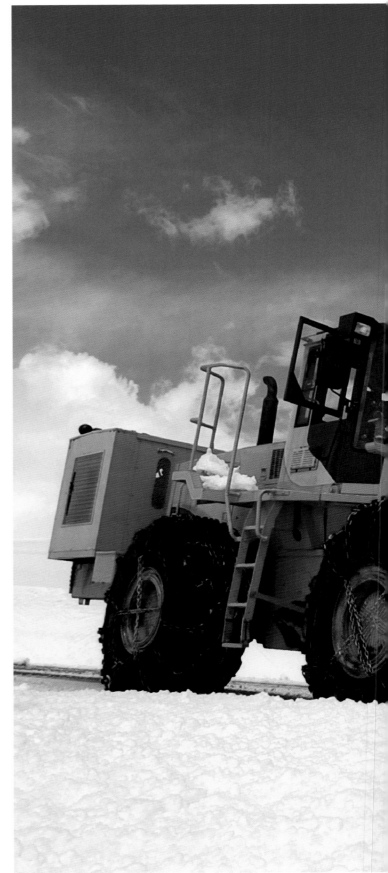

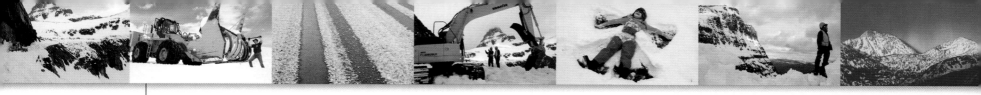

MISSOULA

Sticky, wet snow is the bane of Jim Avent's existence. On warm afternoons, the crud builds up on the teeth of his industrial-strength snowblower and has to be unclogged with a hand shovel. But his job has its rewards. "The Beartooth Highway [U.S. 212] is one of the country's most spectacular roads, and I'm on it every day," Avent says.

Photo by David Grubbs

MOIESE

Rancher Skip Palmer works full-time on the maintenance crew at the National Bison Range. The crew takes care of roads and fences and puts on their wrangler hats whenever it's time to move the 370-buffalo herd to new pastures.

Photos by Kurt Wilson

MOIESE

Once a year, the National Bison Range maintenance crew saddles up the horses and corrals the entire buffalo herd for genetic and disease testing and culling.

MOIESE

Bucked off a horse two years ago, Brent Woodger broke his leg and now needs help taking his boots off.

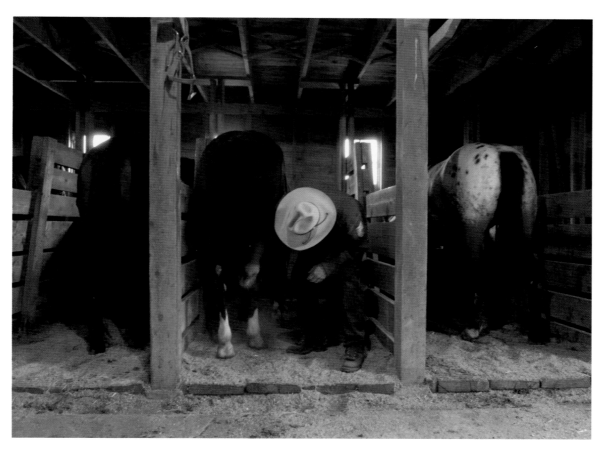

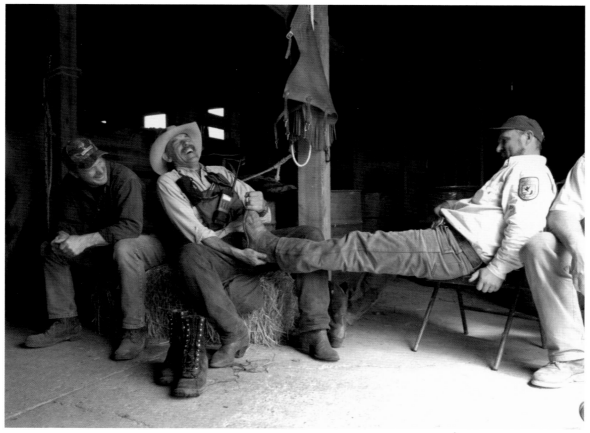

HARLOWTON

A cowboy brands and vaccinates one of 185 calves during the May roundup at the Cooney Brothers Ranch. Each calf's right ear is notched so it can be recognized from a distance. With more than 1.4 million head of beef cattle, Montana is the fourth largest beef-producing state.

Photos by Keith Graham,
University of Montana

MELVILLE

Branding calves is an annual spring rite. Neighboring ranchers move from ranch to ranch until the work is done. Wyatt Donald, whose family ranch, Cayuse Livestock, lies 15 miles down the road, ropes calves at the Rein Anchor Ranch in the Crazy Mountains.

MELVILLE

The practice of branding livestock arrived in the Western Hemisphere with the Spanish in 1493. Originally applied with pine tar or paint, brands were later made permanent by burning them into the animals' hide. Today, Montana state law requires that owners brand their livestock.

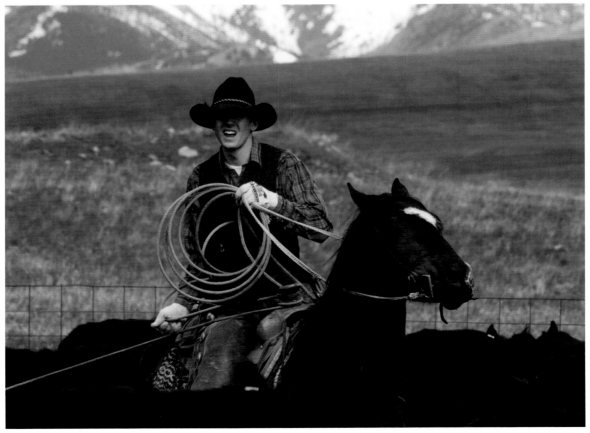

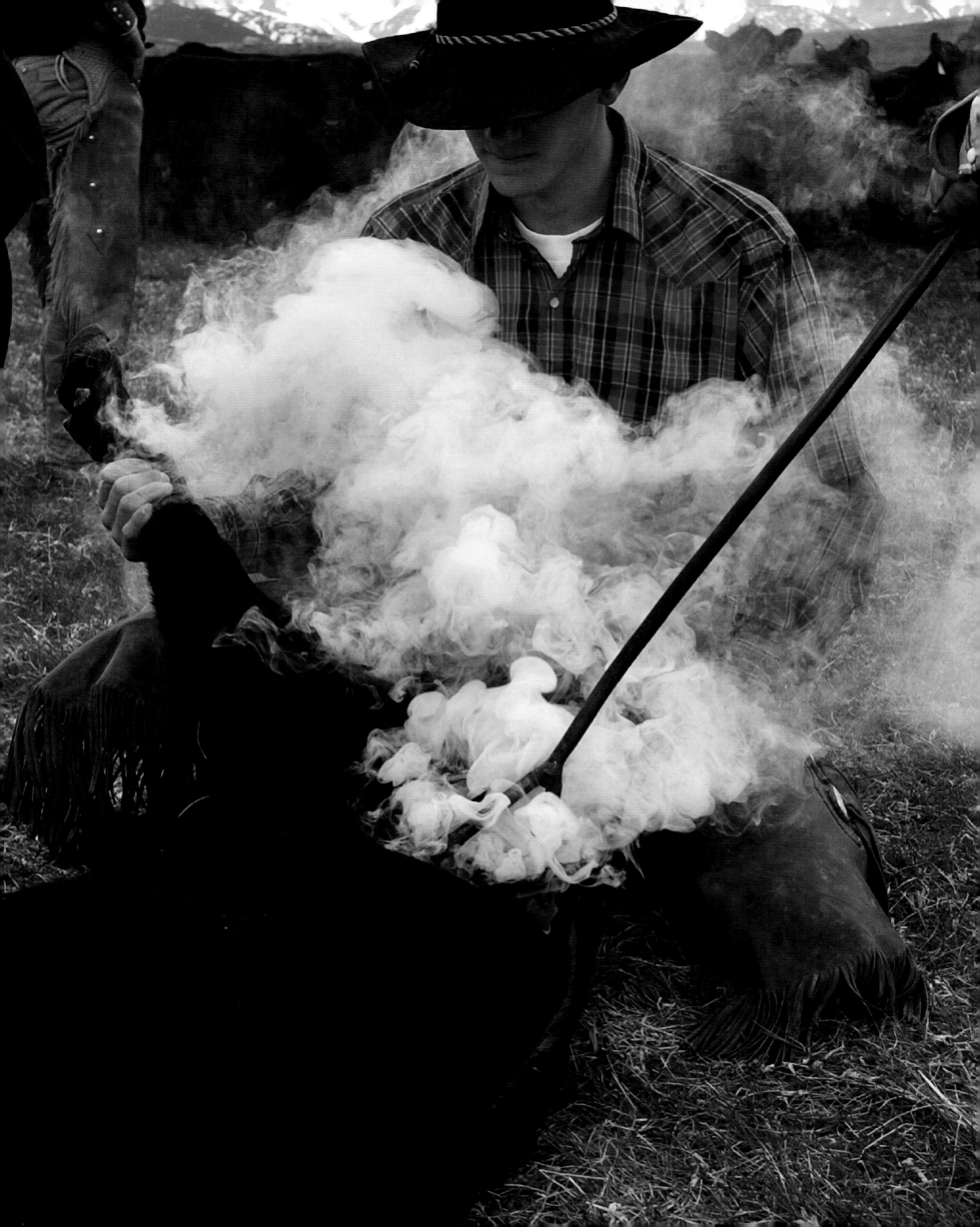

CORVALLIS

Eighteen years ago, Gail Shulund (with dog Cheyenne) and partner Paula Plettenberg bought two cows and their first ranch in the Bitterroot Valley. Since then, the women have learned to move sprinkler pipes, haul bales of hay, dig post holes, build machine sheds—in short, how to operate a profitable cattle business.
Photos by Jeremy Lurgio

CORVALLIS

For Shulund and Plettenberg, heaving hay bales is easy compared to selling their calves to feedlots in the spring. The women get attached to their 100-plus head of cattle—each has a name and a personality. "We treat them like our kids," Plettenberg says. "We do without a lot so they can have everything."

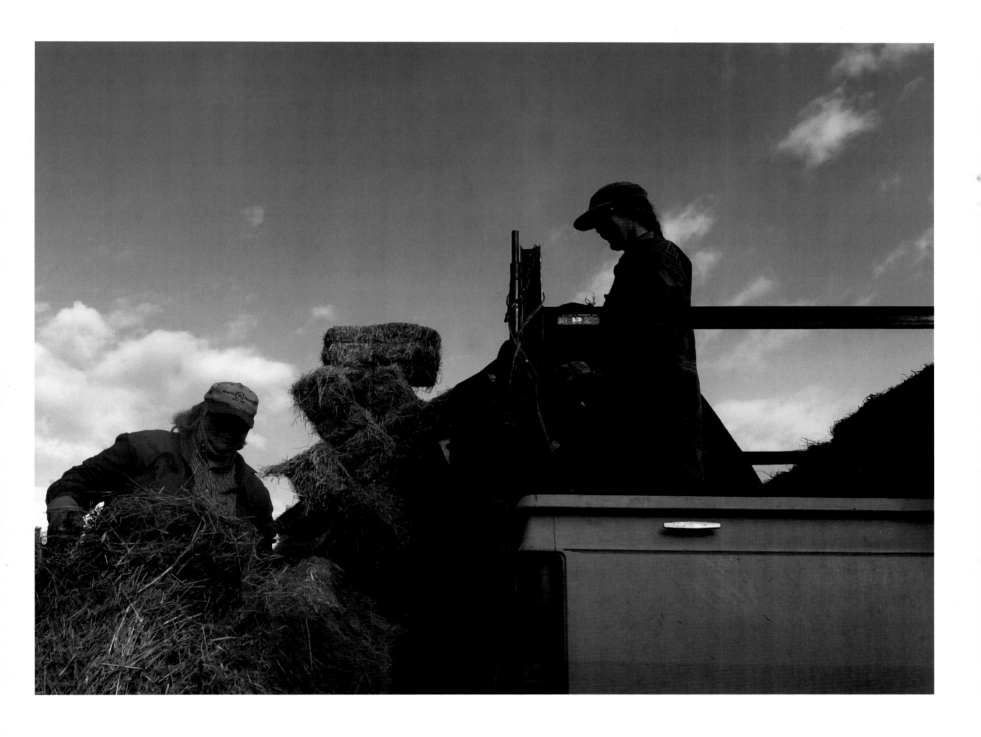

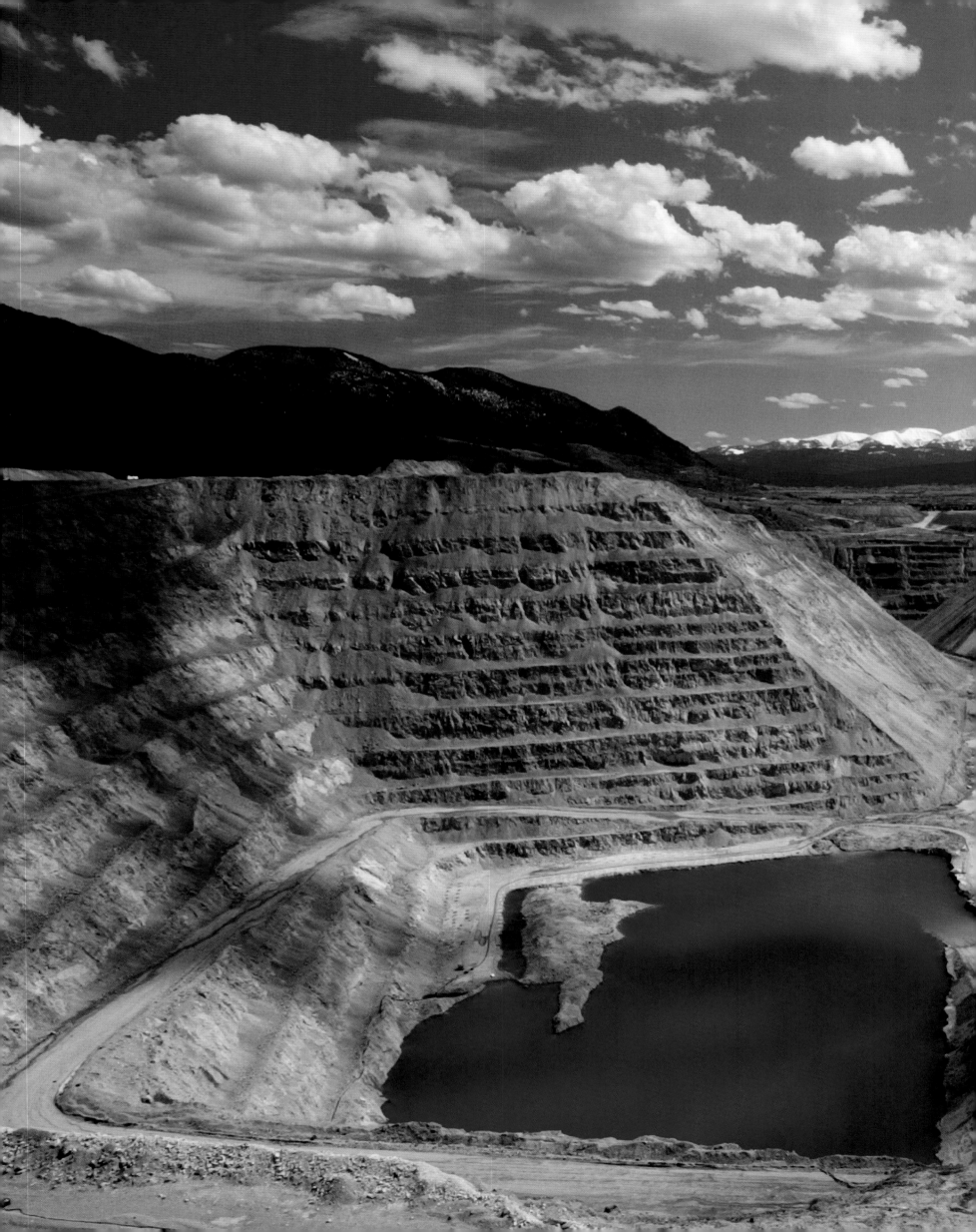

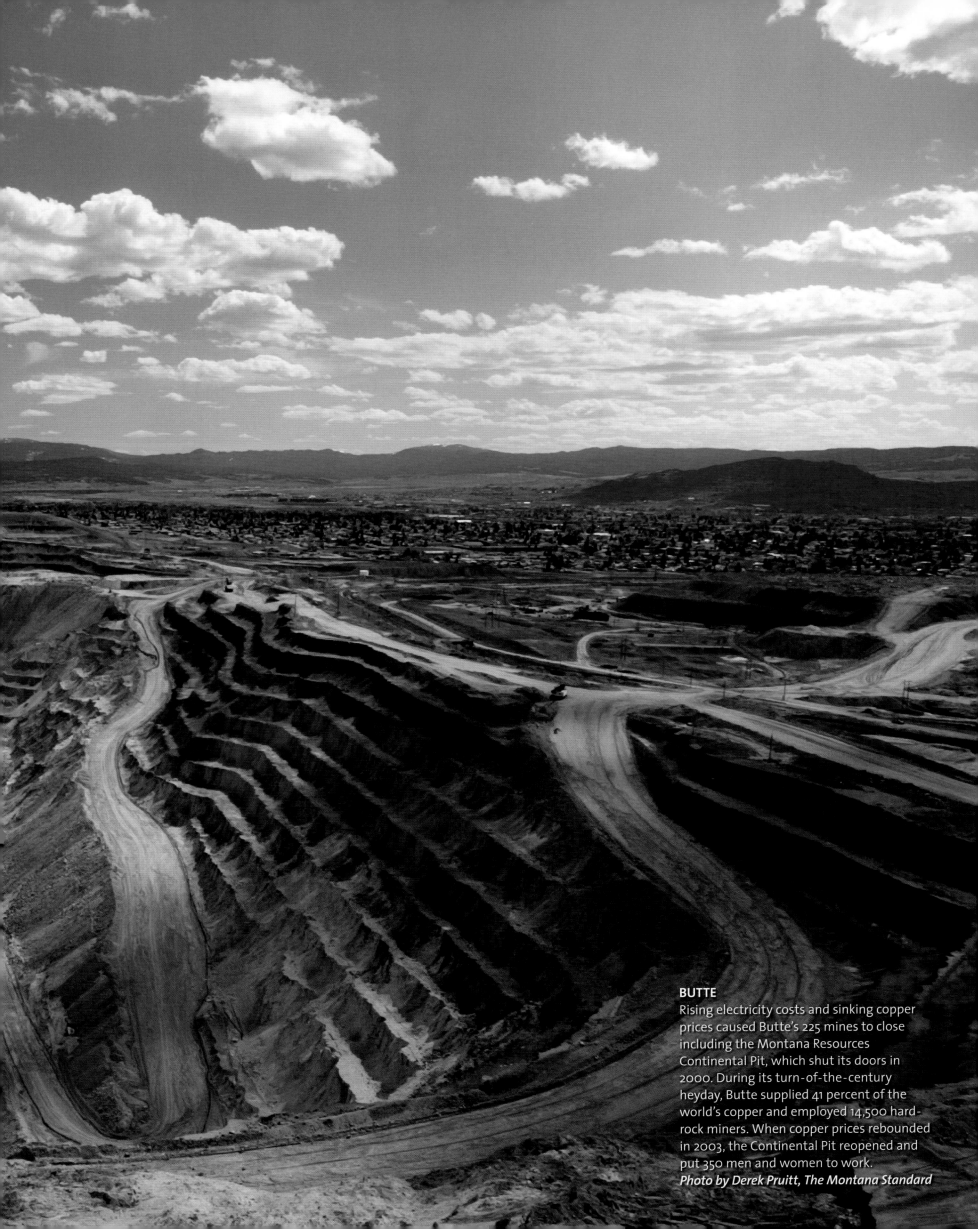

BUTTE
Rising electricity costs and sinking copper prices caused Butte's 225 mines to close including the Montana Resources Continental Pit, which shut its doors in 2000. During its turn-of-the-century heyday, Butte supplied 41 percent of the world's copper and employed 14,500 hard-rock miners. When copper prices rebounded in 2003, the Continental Pit reopened and put 350 men and women to work.
Photo by Derek Pruitt, The Montana Standard

MISSOULA
Trained by the U.S. Forest Service, smokejumpers parachute into remote areas of national forests to battle wildfires. Aerial Fire Depot, the nation's largest training base, offers refresher courses that take place above Six Mile Creek, west of Missoula.
Photos by Tom Bauer

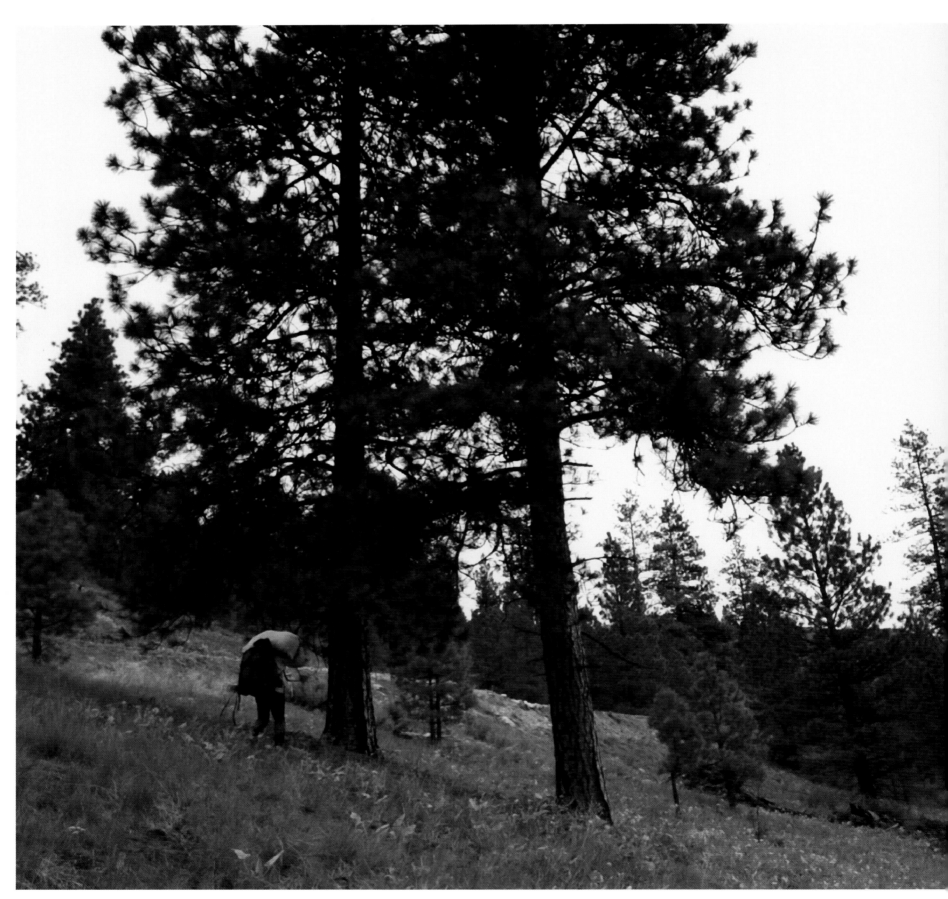

MISSOULA

Jumping into a forest requires pinpoint precision. Smokejumpers like 15-year veteran John Davis parachute from no higher than 1,500 feet.

MISSOULA

After a practice jump, Mike Pennacchio makes his way up a hill with 90 pounds of gear including water, food, a change of clothes, parachute, and jumpsuit (which most smokejumpers sew themselves). Firefighting equipment is parachuted separately.

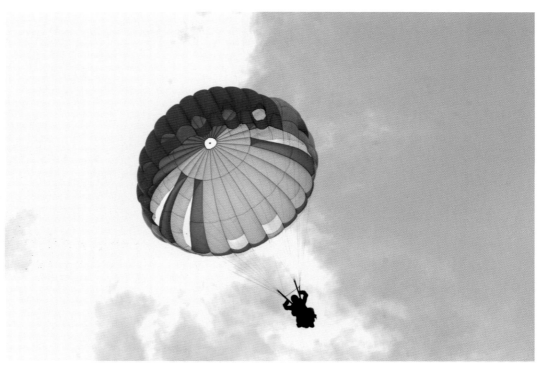

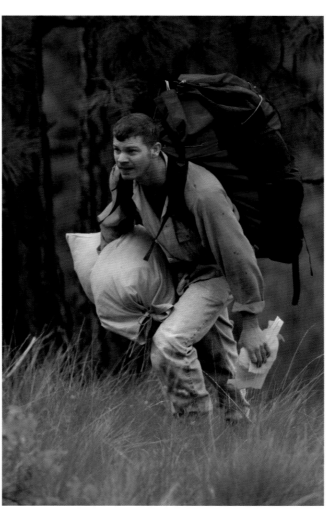

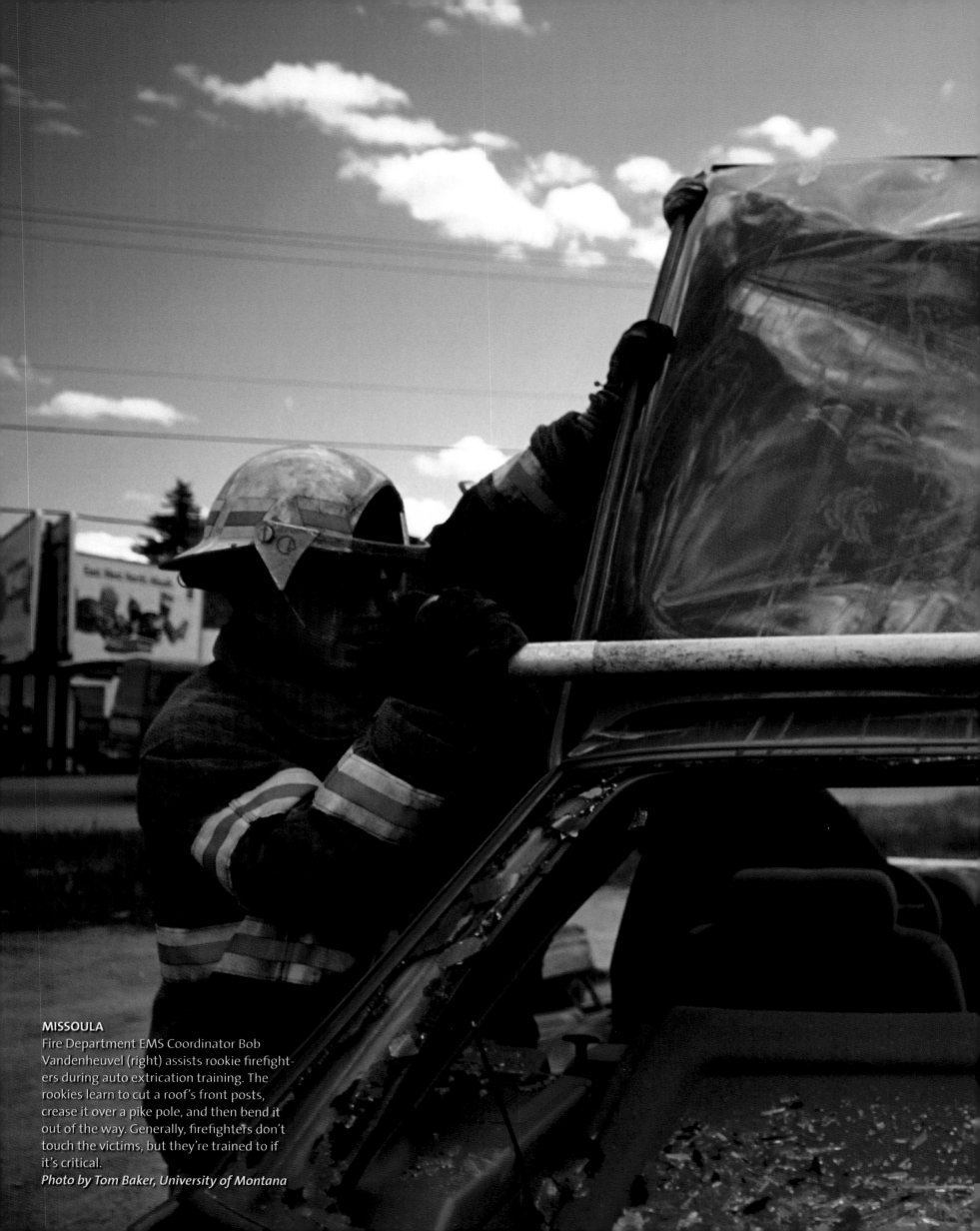

MISSOULA

Fire Department EMS Coordinator Bob Vandenheuvel (right) assists rookie firefighters during auto extrication training. The rookies learn to cut a roof's front posts, crease it over a pike pole, and then bend it out of the way. Generally, firefighters don't touch the victims, but they're trained to if it's critical.

Photo by Tom Baker, University of Montana

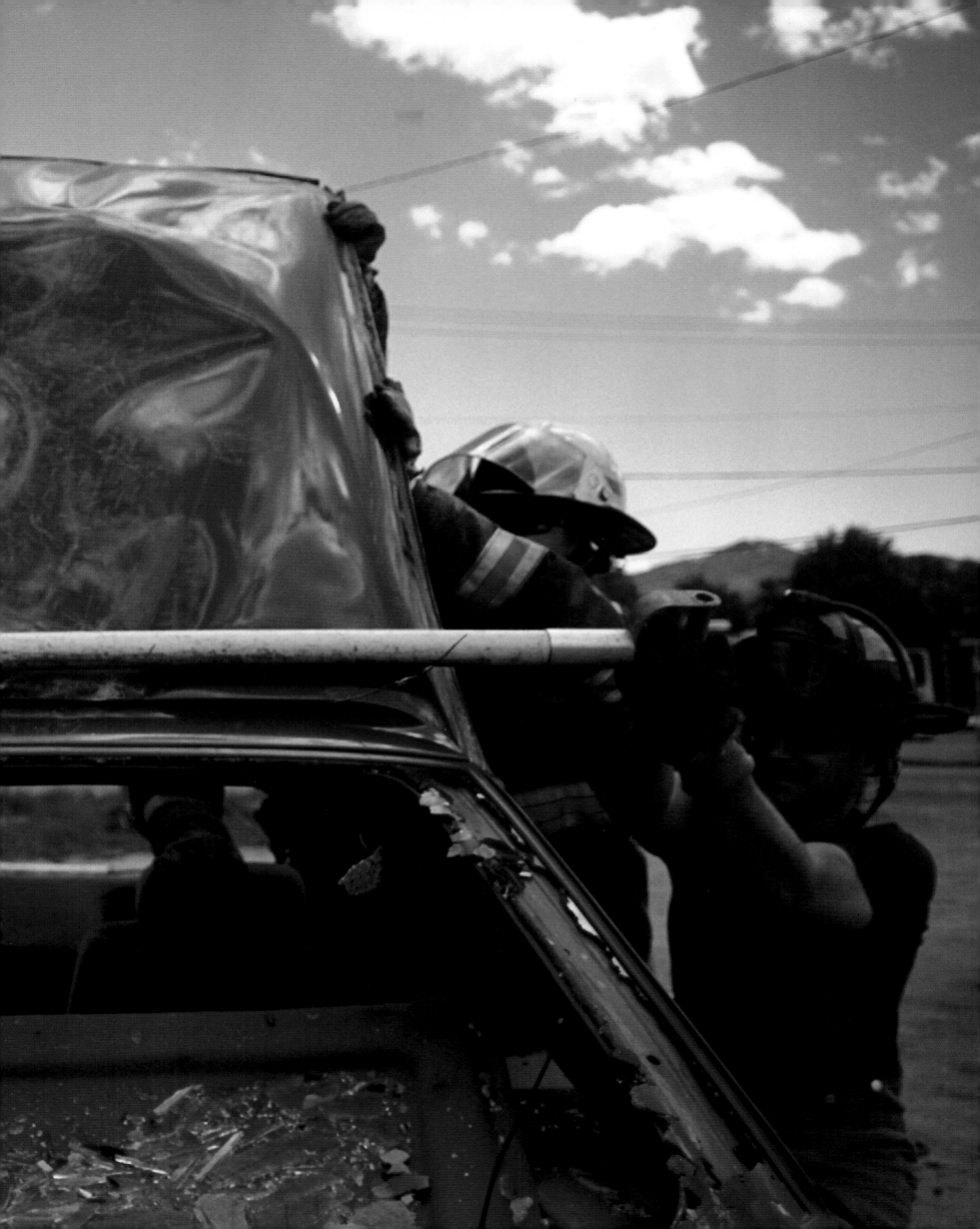

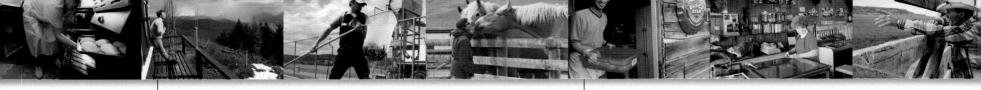

GLACIER NATIONAL PARK

Leif Haugen has spent 10 summers living and working in a remote lookout in Glacier National Park. He monitors local weather and fire conditions and maintains trails. Haugen enjoys his three months of solitude, which affords plenty of time for reading, writing, and getting to know the many moods of the Livingston mountain range.

Photos by Jennifer DeMonte

POLEBRIDGE

Wisconsin native Timothy Good comes to Polebridge every summer to cook for the Northern Lights Saloon. Co-owner Sean Ziegert describes the restaurant as "a gourmet experience in the middle of nowhere." Although Polebridge has only seven permanent residents, during the peak summer season, the saloon serves up to 170 dinners per day to tourists passing through nearby Glacier National Park.

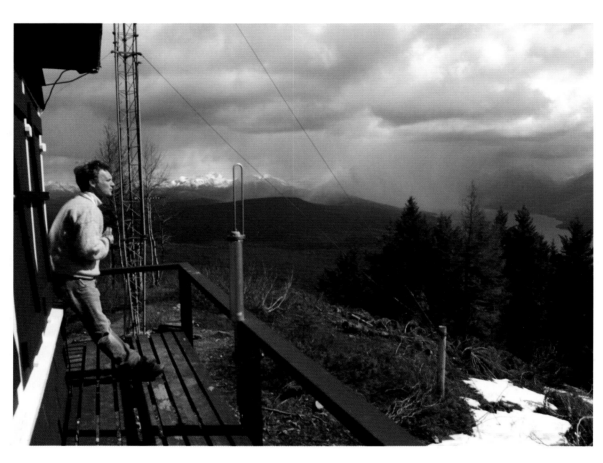

WEST OF DEER LODGE

Road-trippers and big rigs traverse four-lane Interstate 90 during busy summer months. Before then, repair crews, including traffic controller Jo Garner, patch up the 551-mile, east-west freeway.

Photo by Daniel Armstrong, New Rider Print

WHITE SULPHUR SPRINGS

Berg Garage, Montana's oldest Chevy dealership, has been in the family since Harry's father Elmer bought it in 1924. Harry, 80, runs it with the help of his two sons. He says the '41 Chevy Bel Air he's leaning against, like the '57 Special Deluxe Sport Coupe behind him, still run fine, but he uses them mostly for decoration.

Photo by Doug Loneman, Loneman Photography

RED LODGE

With songs like "Sheep Shearers' Lament" and "Hoop-de Poop-de Polka," the Ringling 5 (aka the Norwegian Studs of Rhythm) started performing in 1977 at each other's weddings. Now the ranchers by day have three CDs and are getting gigs throughout the Midwest and Canada.

Photo by Erik Petersen

MISSOULA

John Reed, 72, supplements his railroad pension and Social Security checks by collecting discarded cardboard and hauling it to a recycling center. He earns about $10 per pickup load.

Photo by Tom Bauer

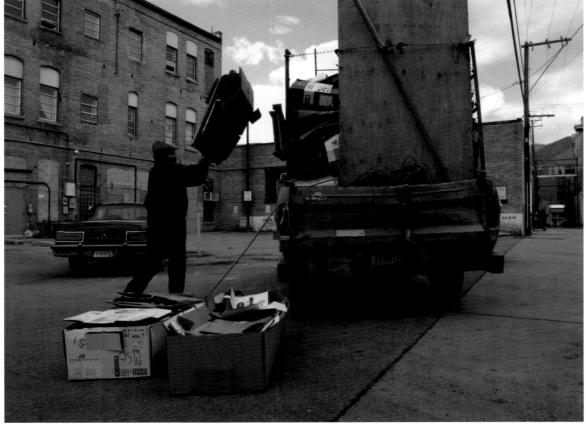

MISSOULA

In the Tissue Engineering Laboratory at The International Heart Institute of Montana, French research fellow Dr. Jerome Jouan, Dr. Carlos M. G. Duran, and medical student Matthew Hiro discuss their sonomicrometry (3D imaging) tricuspid valve study. Duran is one of only a few cardiac surgeons worldwide studying the tricuspid valve.
Photo by Tom Bauer

WISDOM

Branding week in the Big Hole River Valley finds 56-year-old Gail Dooling, a lifelong cattlewoman, joining other ranchers to rope, wrestle, brand, castrate, and vaccinate new calves. They tackle about 400 head in a day.
Photo by Cynthia Baldauf

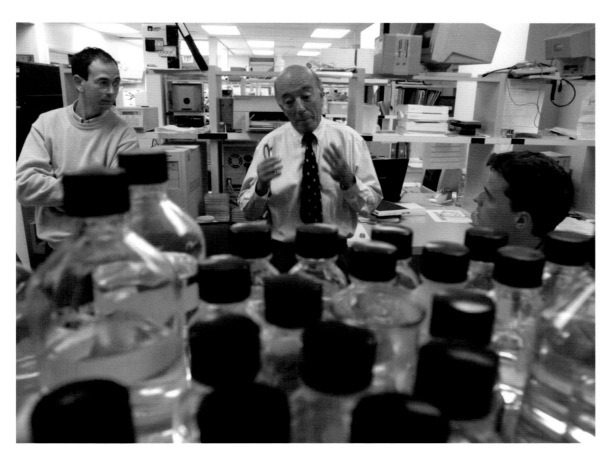

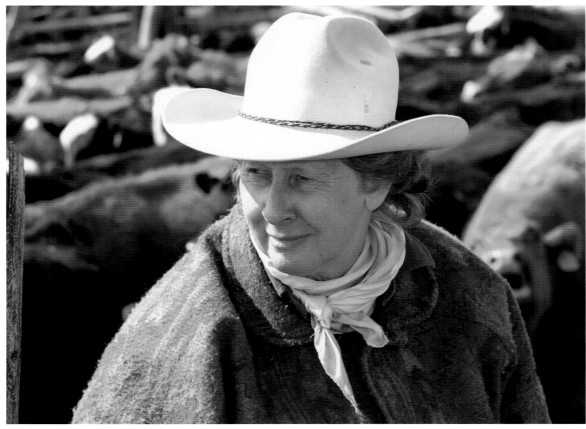

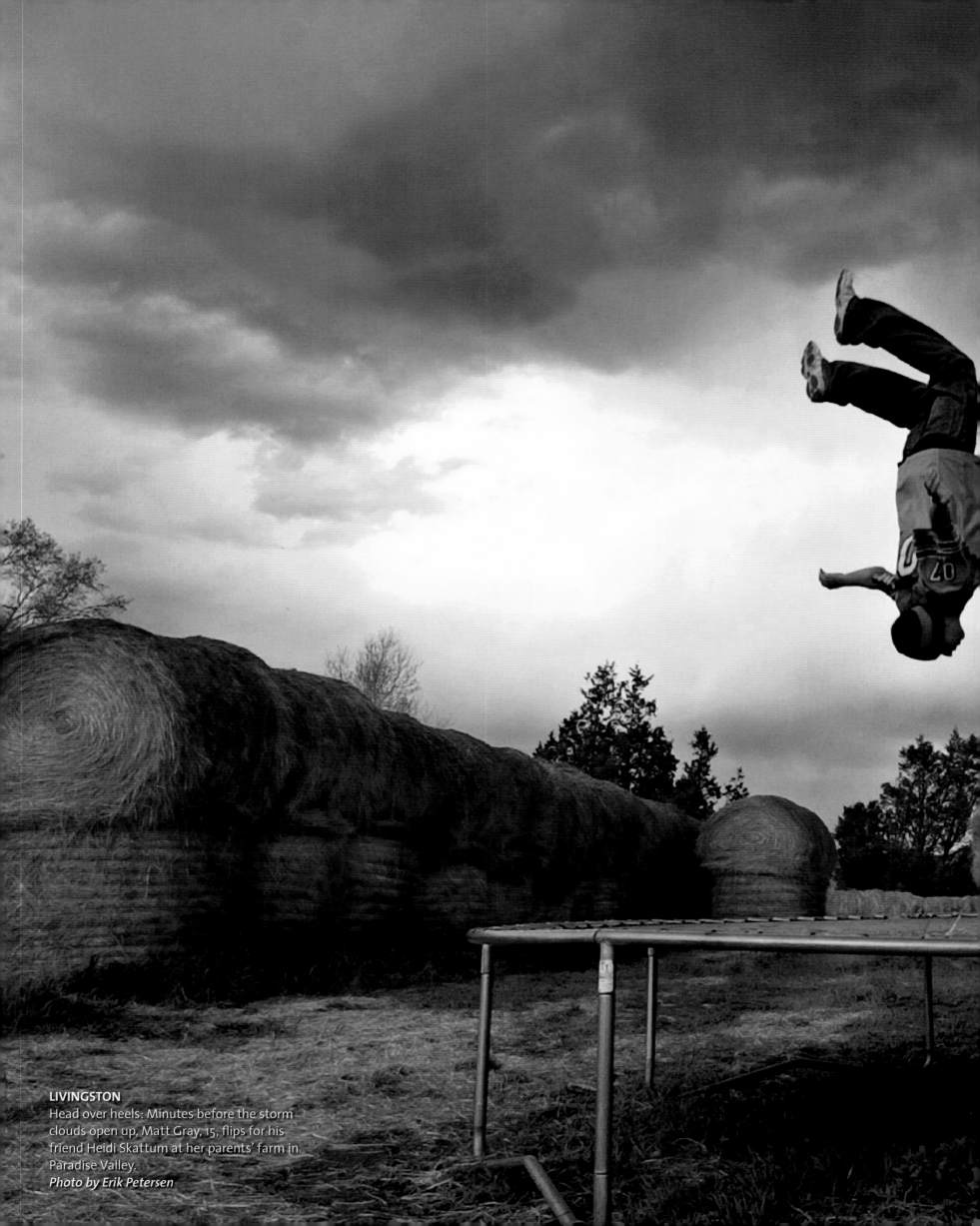

LIVINGSTON
Head over heels: Minutes before the storm
clouds open up, Matt Gray, 15, flips for his
friend Heidi Skattum at her parents' farm in
Paradise Valley.
Photo by Erik Petersen

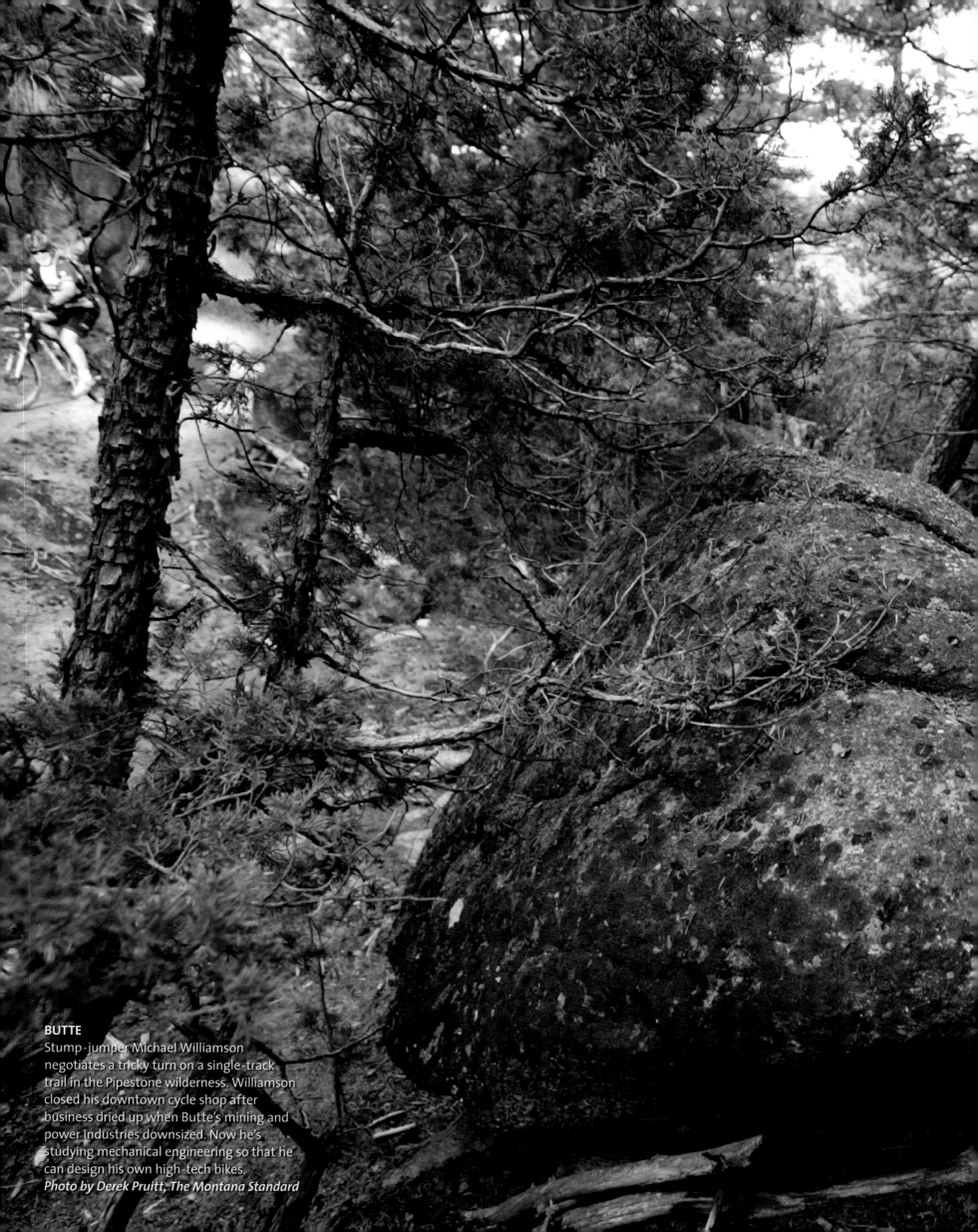

BUTTE
Stump-jumper Michael Williamson
negotiates a tricky turn on a single-track
trail in the Pipestone wilderness. Williamson
closed his downtown cycle shop after
business dried up when Butte's mining and
power industries downsized. Now he's
studying mechanical engineering so that he
can design his own high-tech bikes.
Photo by Derek Pruitt, The Montana Standard

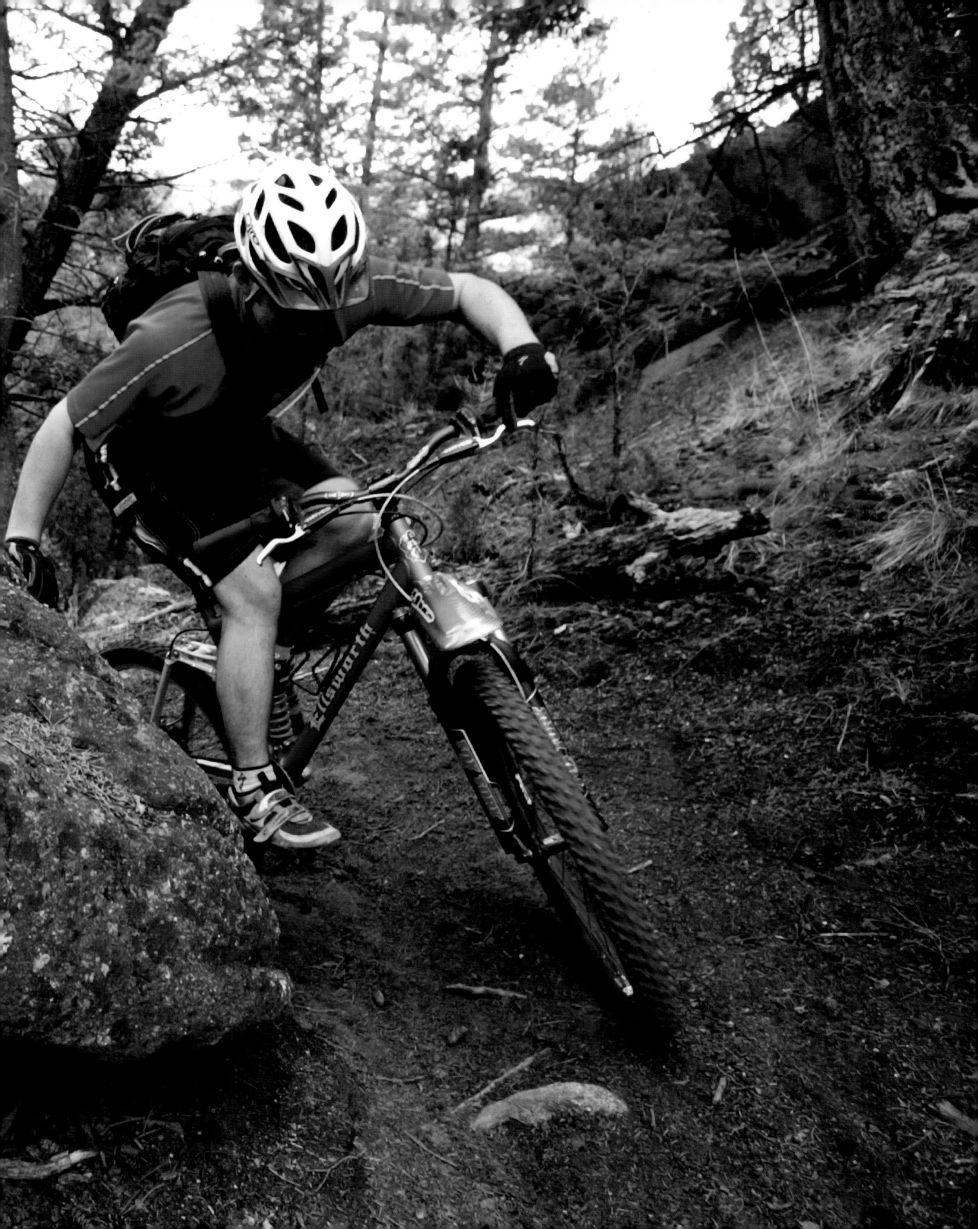

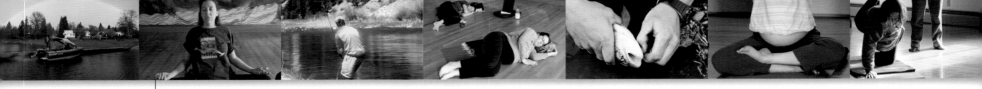

WHITEFISH
At the Whitefish Yoga Center, Paula Halama practices a bound angle pose during her 17th week of pregnancy. A nurse who recently relocated from Washington state, Halama says she is in Montana to stay.
Photo by Jennifer DeMonte

SMITH RIVER

Travis Smith and Andy Cline soak up some after-dinner starlight. The two friends spent four days fly fishing on Smith River and exploring the remote canyons of the 60-mile riparian corridor near Great Falls.

Photo by Daniel Armstrong, New Rider Print

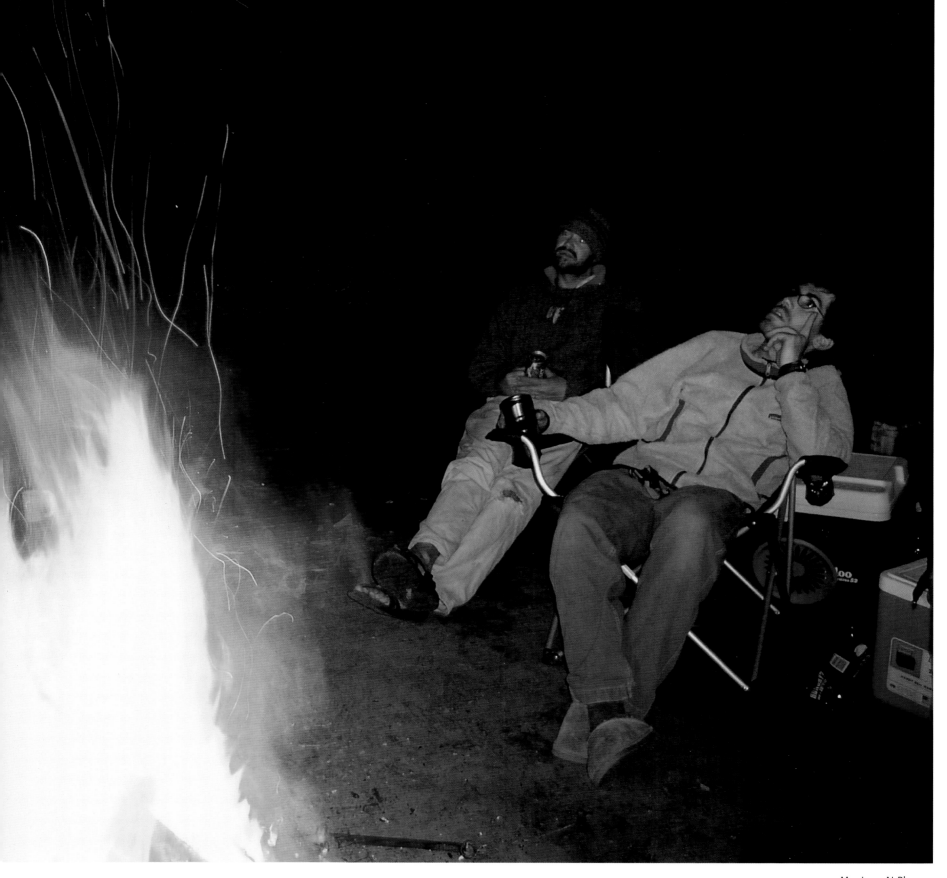

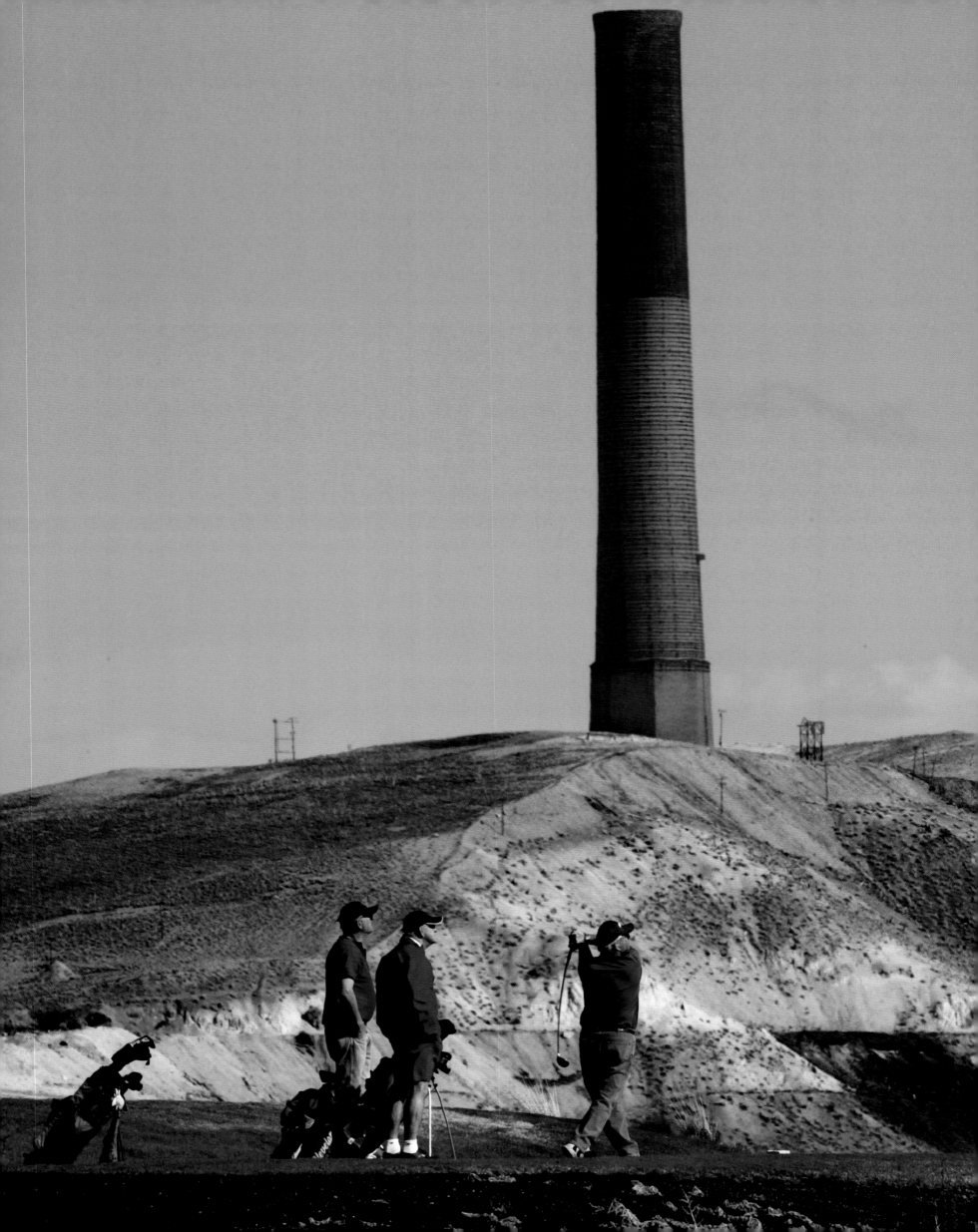

ANACONDA

A century of copper smelting just about ruined this town's scenery, but one benighted spot got a face-lift of sorts in 1997. It became the 18-hole, Jack Nicklaus–designed Old Works Golf Course. The world's largest brick smokestack now towers over the seventh hole.

Photo by Derek Pruitt, *The Montana Standard*

ALBERTON GORGE

Freestyle kayaking champion Rush Sturges side-surfs on a playhole—a river depression that generates stationary waves—during the White-water Rodeo on the Clark Fork River.

Photo by Daniel Armstrong, *New Rider Print*

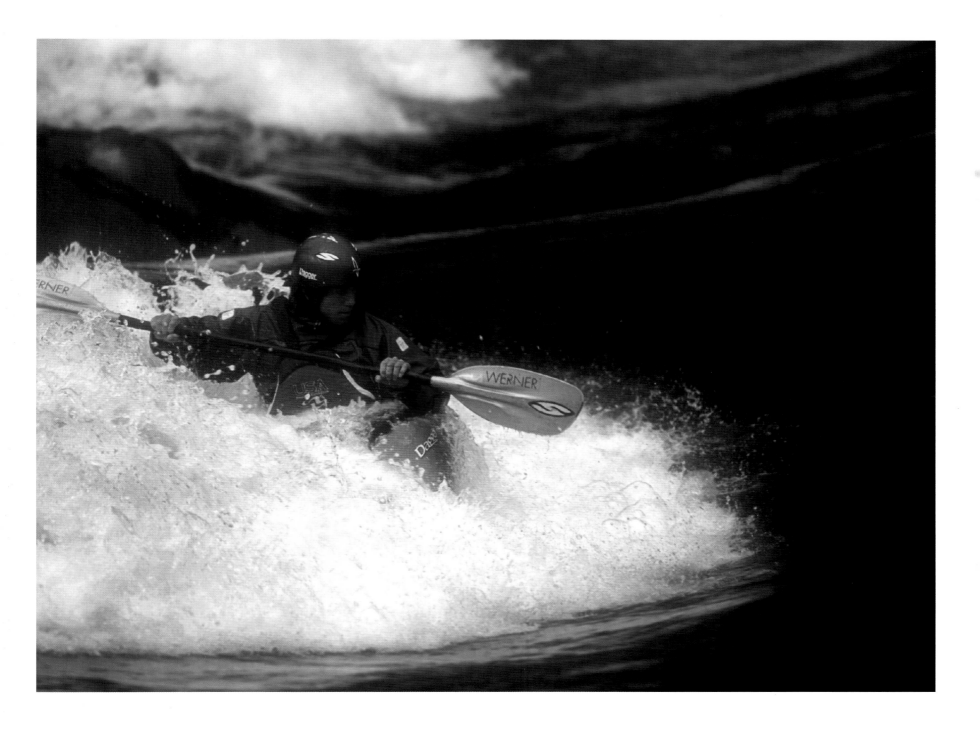

BOULDER
As a blizzard arrives, Ryder Bricker, 15, waits for his scores by the announcer's stand at the Montana High School Rodeo Association competition. The sophomore's perseverance paid off. He placed in the top 10 and qualified for the state finals.
Photo by Dudley Dana, Dana Gallery

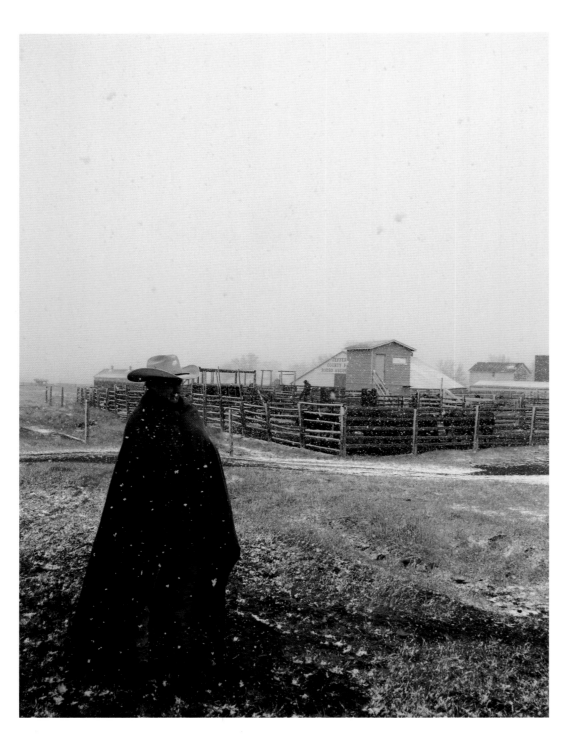

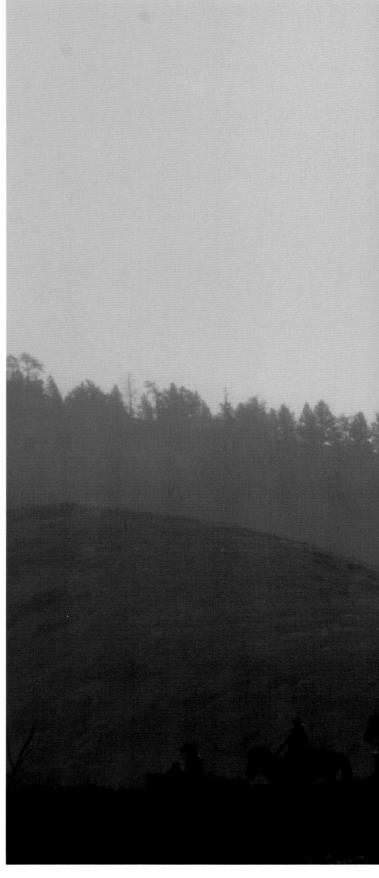

MOIESE

Horses are allowed onto western Montana's National Bison Range one day a year. The Mission Rangers Saddle Club steers clear of the buffalo herd, though, because the bulls are known to charge. Glimpsed around every bend elk, mountain goats, and antelope.
Photo by Kurt Wilson

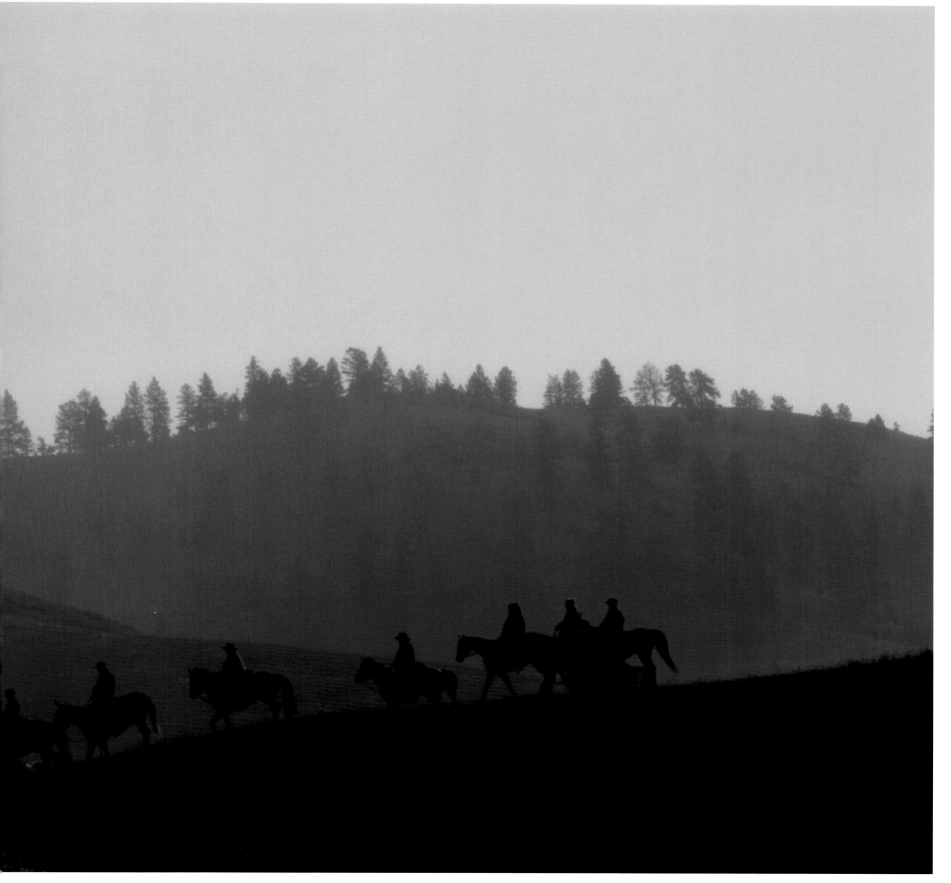

Hikers peer out at the forested banks of the Smith River from the mouth of Indian Cave. The 1,800-square-foot cavern gets its name from the prehistoric pictographs that line its limestone walls and record the presence of Montana's earliest people.

Photo by Daniel Armstrong, New Rider Print

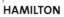

HAMILTON

"I've got a lot to do while I'm still young," says Mario Locatelli, 70. The local mountain climbing legend has scaled 47 of America's highest peaks since his 61st birthday. On this morning, Locatelli climbed and skied Downing Mountain in the Bitterroot Range. Tanzania's Mt. Kilimanjaro and Mt. McKinley in Alaska are next on the retiree's hit list.

Photo by Jeremy Lurgio

HAMILTON

Champagne powder is the reward for backcountry skiers who make the four-hour climb up Downing Mountain. In the spring, when the snow in Downing's wide-open bowl and avalanche chute has settled into a stable layer, skiers begin to appear on the mountain's lonely slopes.
Photo by Jeremy Lurgio

LOLO

To air is human: Matt Baldwin tucks into a backside grab after catching air off the lip of a cornice on Lolo Peak.
Photo by Nick Wolcott

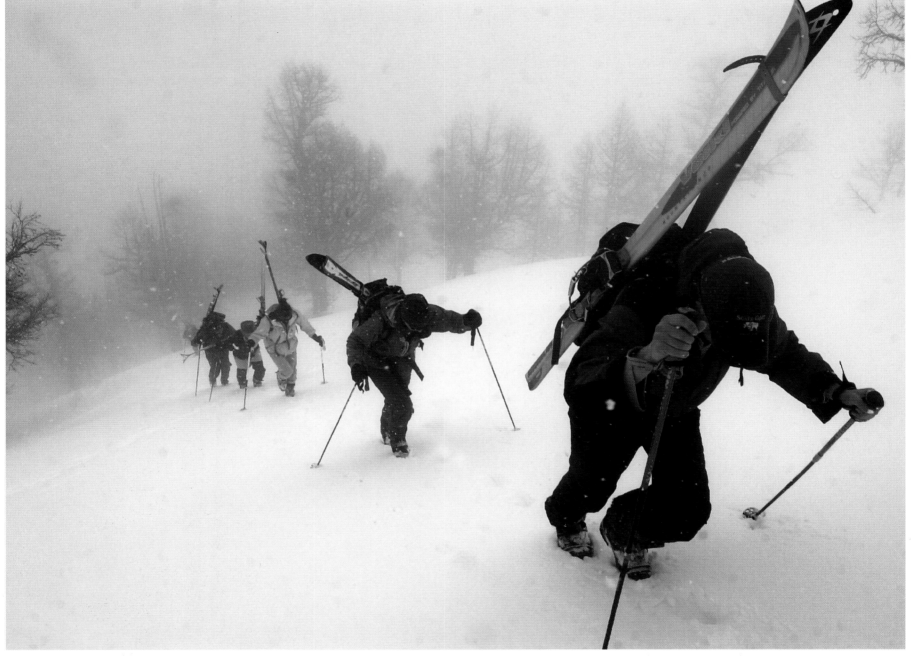

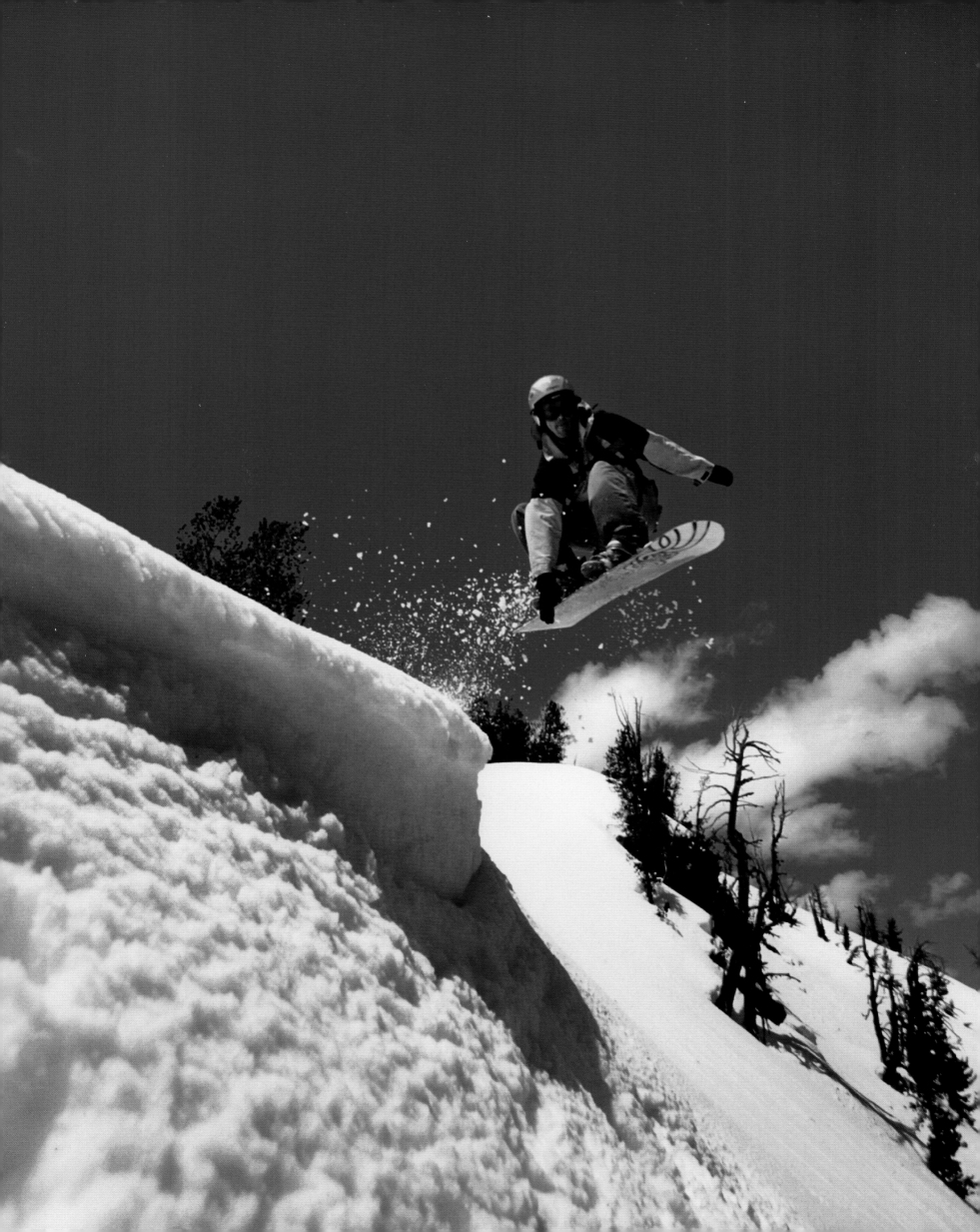

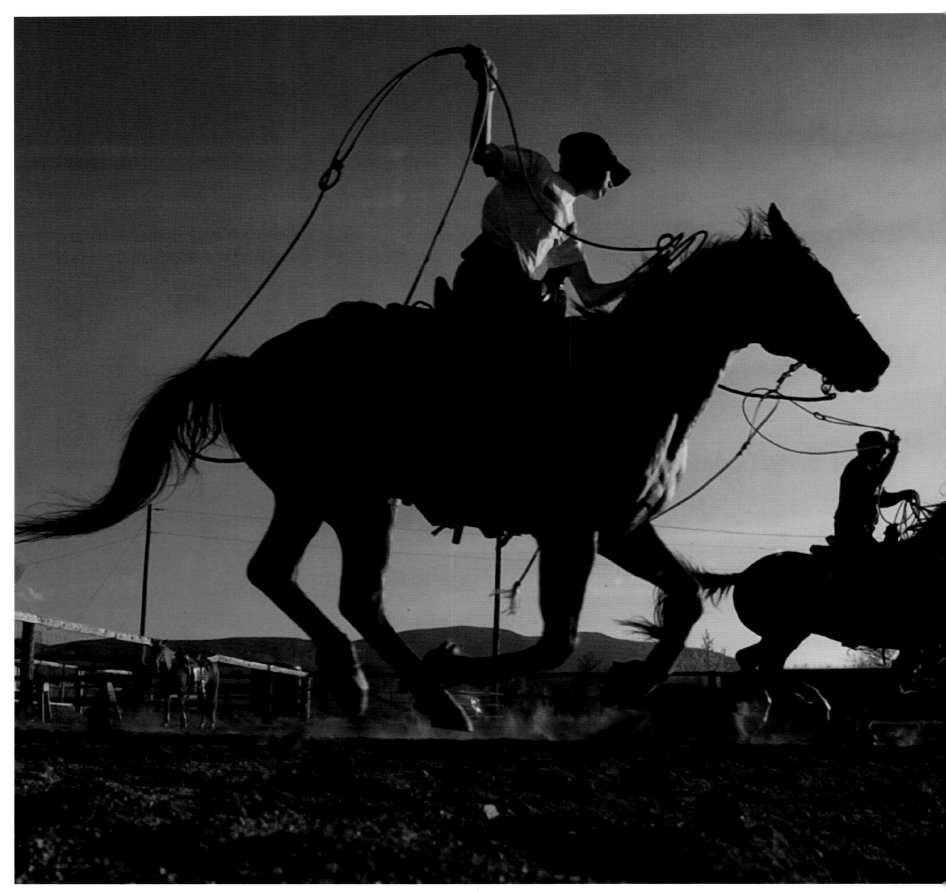

LIVINGSTON

After lots of practice with the Livingston Roping Club, Joseph Magalsky, 13, successfully heeled a steer (looped his lariat around both back legs) during the team roping competition at the 4-H Rodeo.

Photo by Erik Petersen

MILES CITY

The stick pony rodeo doesn't have much of a following yet, but Haven, 5, and Hayes Meged, 3, are unfazed. Spectators were busy watching the bull chute at the 53rd Annual Bucking Horse Sale while Haven played cowboy to Hayes's bronco.
Photo by David Grubbs

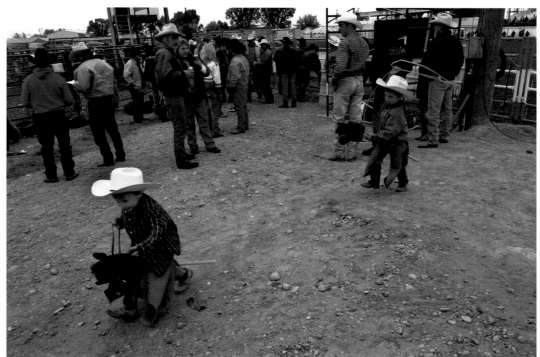

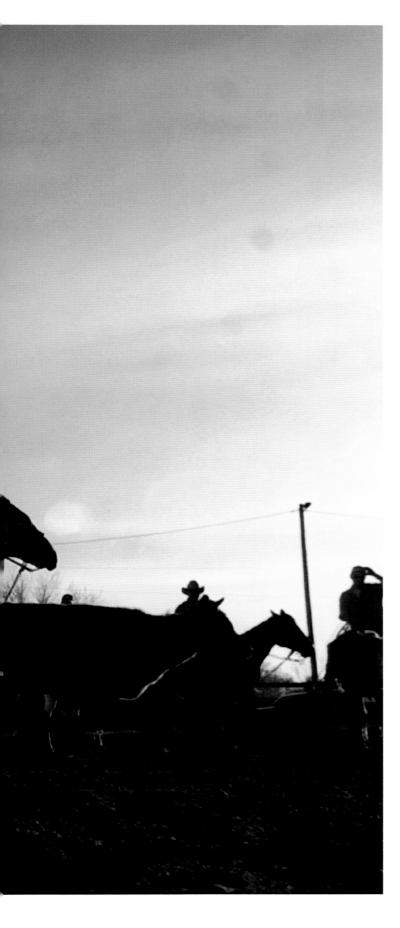

WHITE SULPHUR SPRINGS

Keith Forkin, 10, has been playing baseball since he was 4. Now he's a pitcher for the White Sulphur Springs Miners, named for the town's first settlers who arrived during the gold and silver fever of the 1880s.

Photo by Doug Loneman, Loneman Photography

SUNBURST

Grain-stand seats: The Sunburst grain elevator looms large over the Athletics Little League team, readying themselves to do battle with the Orioles. The town of Sunburst, pop. 437, is on the fabled Hi-Line, the 470-mile strip of civilization across northern Montana that sprouted alongside the Great Northern Railroad tracks laid down in 1887.
Photo by Todd Korol

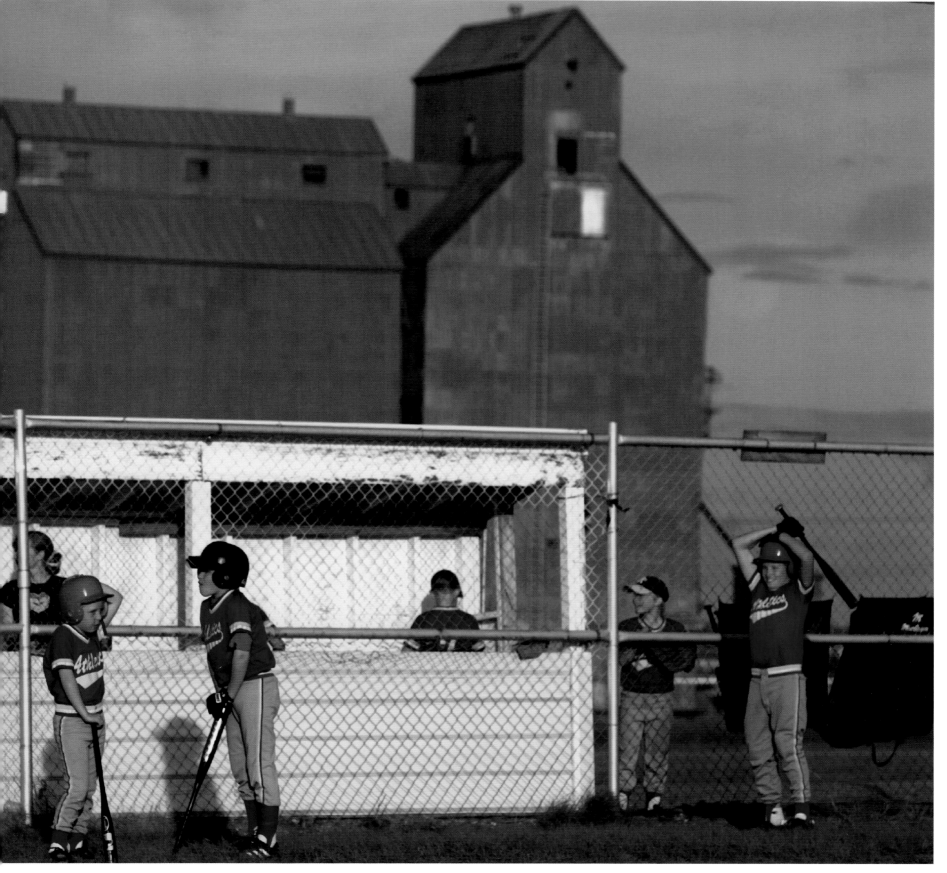

BELGRADE

While maypoles originated as pagan symbols of fertility, children at the one-room Springhill Community School honor their playground equipment as a deity of flight.

Photo by Doug Loneman, Loneman Photography

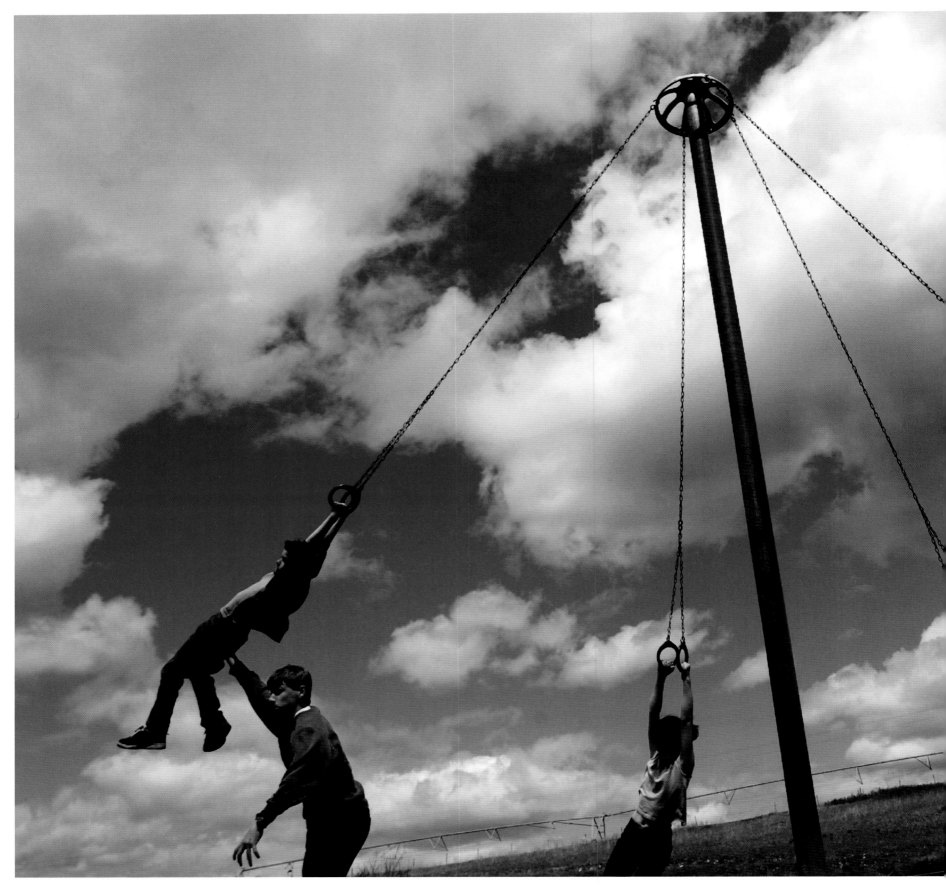

A 20,000-pound fire truck was no match for the Performance Dodge tugging team, which easily rolled it 20 feet to raise money for the Special Olympics. Butte residents rally around local fundraisers. During Tip-A-Cop day, for example, police officers and firemen don aprons and wait tables at downtown eateries. Tips go to charity.
Photo by Derek Pruitt, The Montana Standard

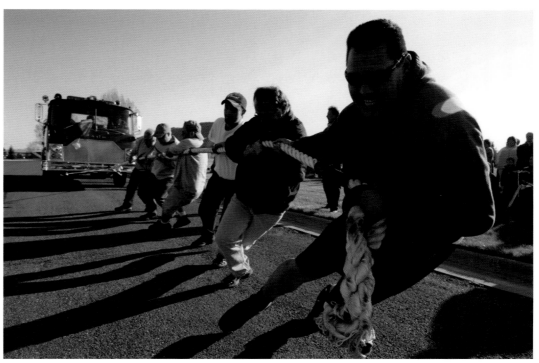

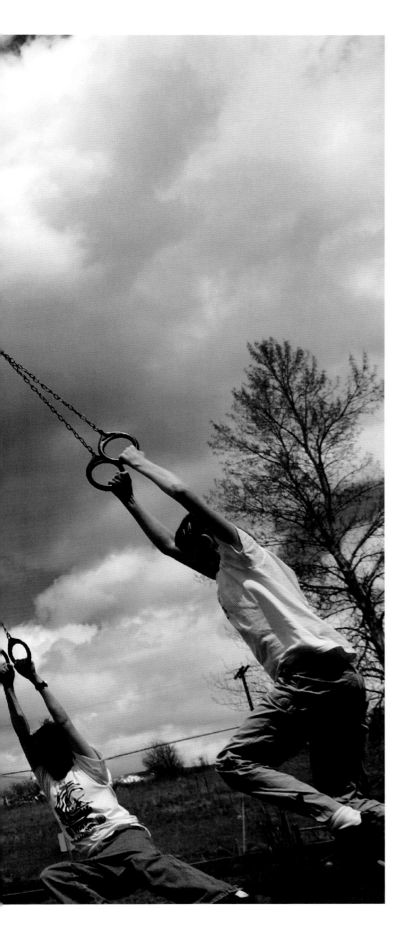

MISSOULA

Nine-year-old Elizabeth Evans takes "Midnight Rose" for a Sunday ride. Built by community volunteers who spent hundreds of hours hand-carving horses and building the machine works, "A Carousel for Missoula" opened in 1995. With a perimeter speed of 7.82 mph, it's one of the fastest carousels in America.

Photo by Tom Bauer

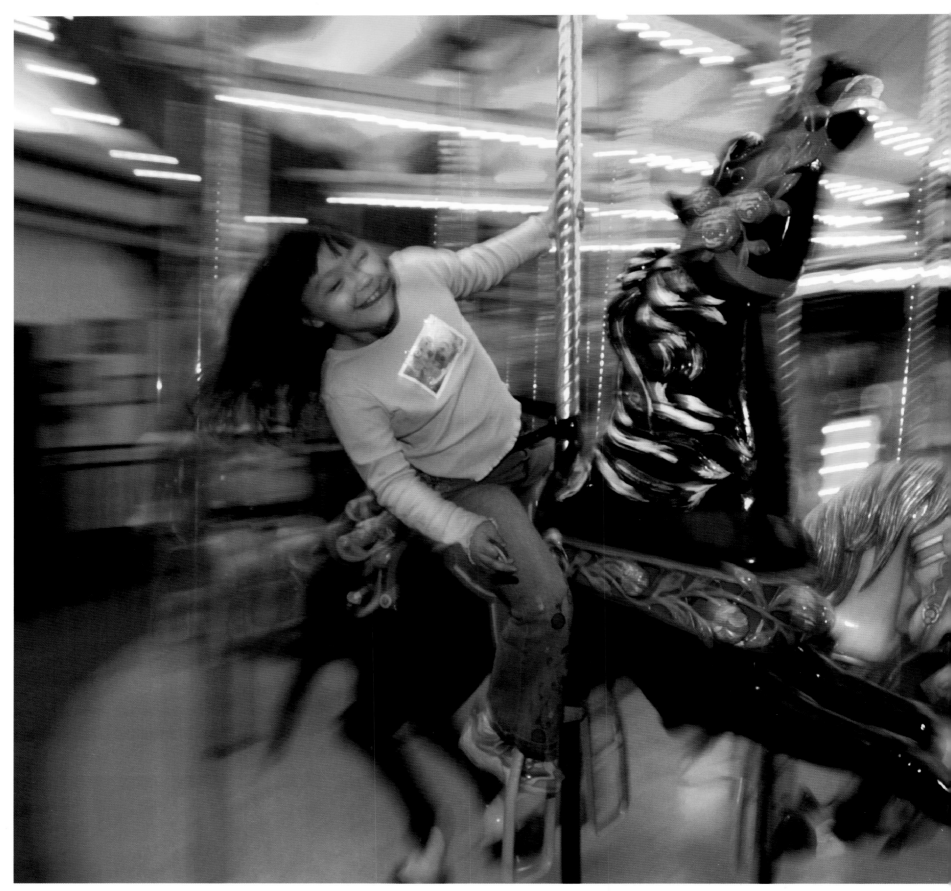

KALISPELL

At the end of the rainbow: The Swan Range serves as backdrop for software engineer Tony Brown and his flying 3-year-old daughter Brina.
Photo by Robin Loznak

BOZEMAN

Do You Believe in Magic? Brad Smith, 8, does, and he can't wait to ride her. Dad Joe secures a bareback saddle, which he feels is safer than a regular saddle: "Kids'll get hung up in the stirrups, then drug along the ground," he says. "I'd rather have Brad fall than have that happen."
Photo by Mary Campbell

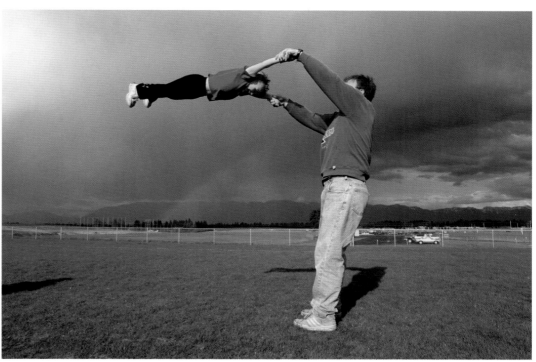

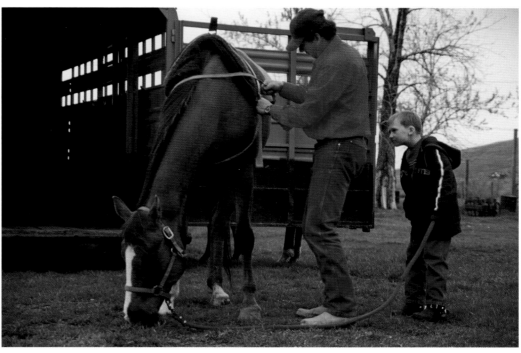

SMITH RIVER

Alex Allen divides the year into three seasons: fishing season, hunting season, and working-so-you-can-hunt-and-fish season. When insects hatch in the spring, brown trout congregate near the surface of his favorite fishing hole and Allen casts his rod well into the evening.
Photo by Daniel Armstrong, New Rider Print

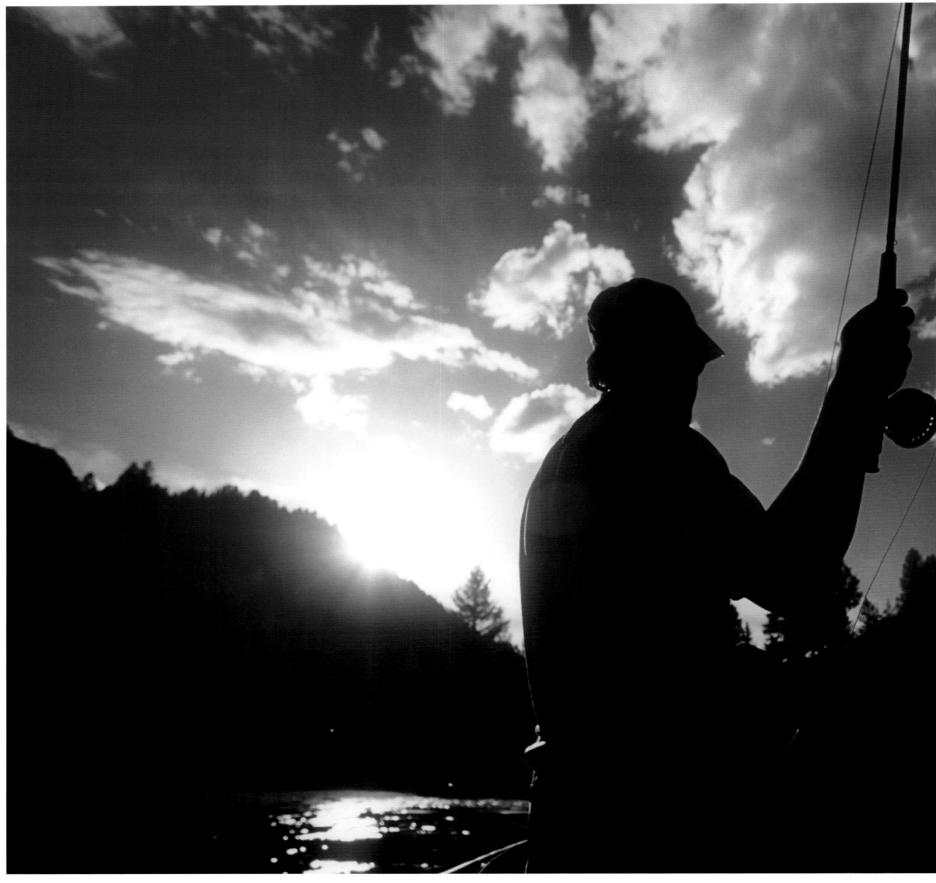

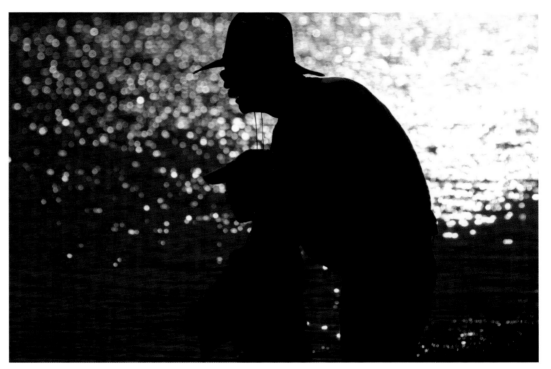

DARBY

"To be a good fly fisher you need to think like a fish and act like a bug," says Bear McKinney, an instructor with Trout Unlimited's Bitterroot Buggers fly fishing program. Student Cameron Harder, 10, learned to tie flies with McKinney over the winter and casts his rod for the first time at Lake Louise.

Photo by Jeremy Lurgio

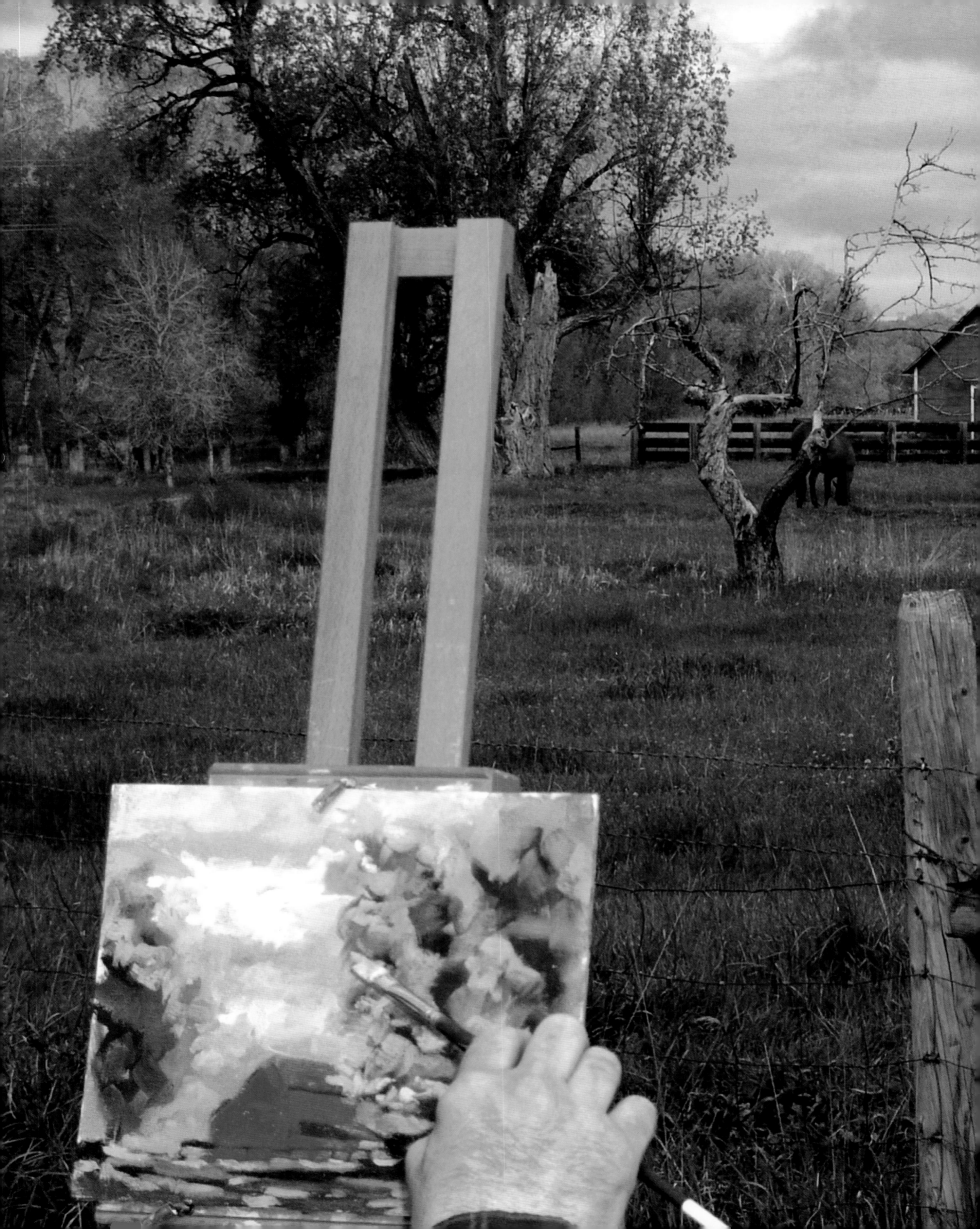

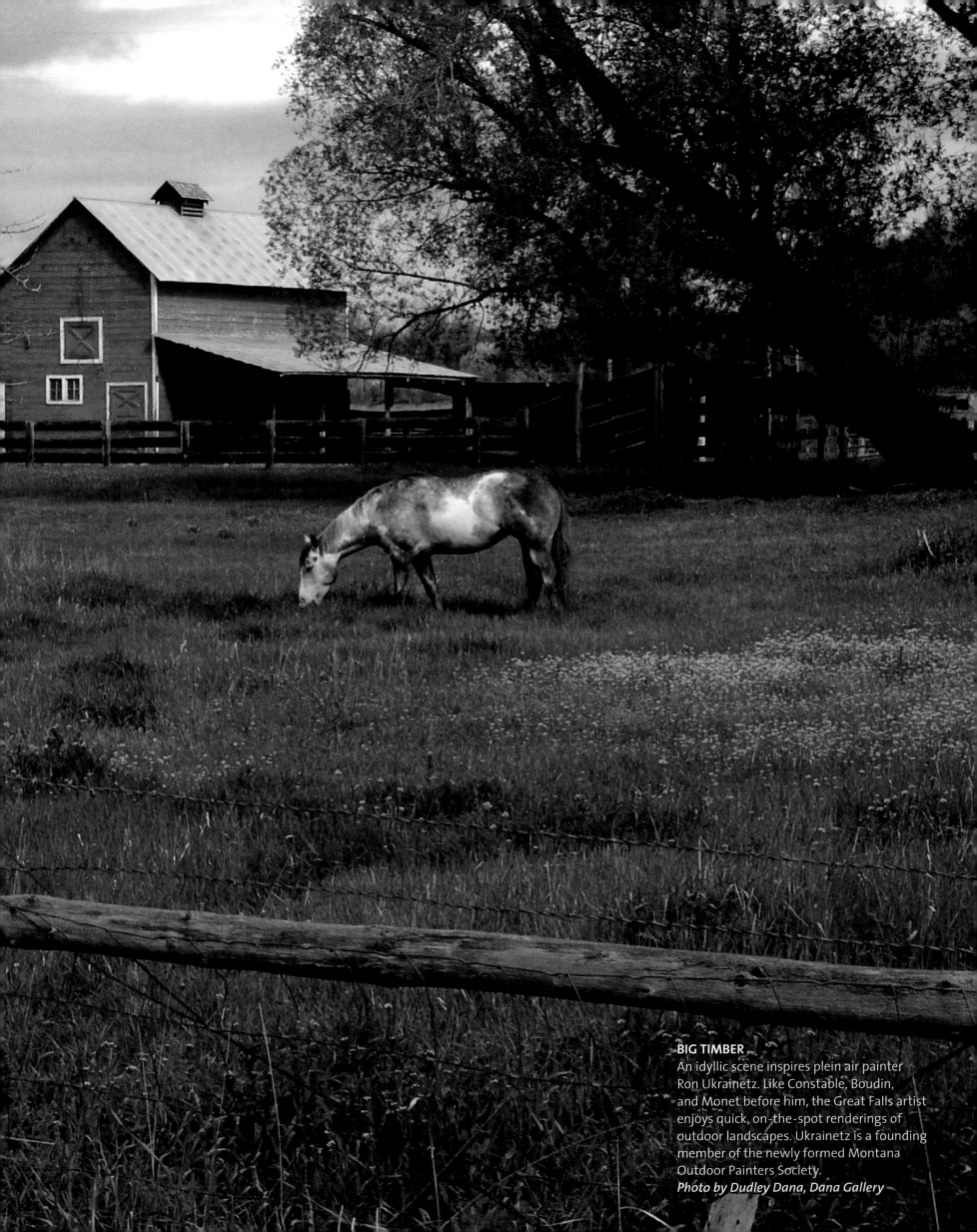

BIG TIMBER
An idyllic scene inspires plein air painter Ron Ukrainetz. Like Constable, Boudin, and Monet before him, the Great Falls artist enjoys quick, on-the-spot renderings of outdoor landscapes. Ukrainetz is a founding member of the newly formed Montana Outdoor Painters Society.
Photo by Dudley Dana, Dana Gallery

HAMILTON

The Saddle Tramps is a women's trail-riding group that meets every Wednesday for meanders through the Bitterroot-Selway Wilderness. Male riders, including photographer Jeremy Lurgio, are invited to come along—only if they wear a wig and bra. "I was hoping we wouldn't run into anyone I knew," says Lurgio.

Photo by Jeremy Lurgio

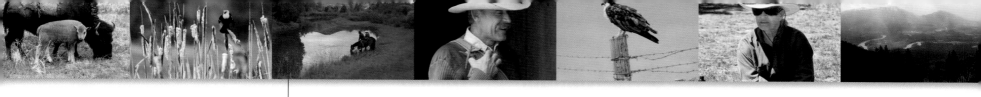

MOISE

The lower Flathead River flows out of Flathead Lake, its water level regulated by Kerr Dam. Near its confluence with the Clark River in the Mission Valley, the once-mighty river meanders into quiet backwaters.

Photo by Kurt Wilson

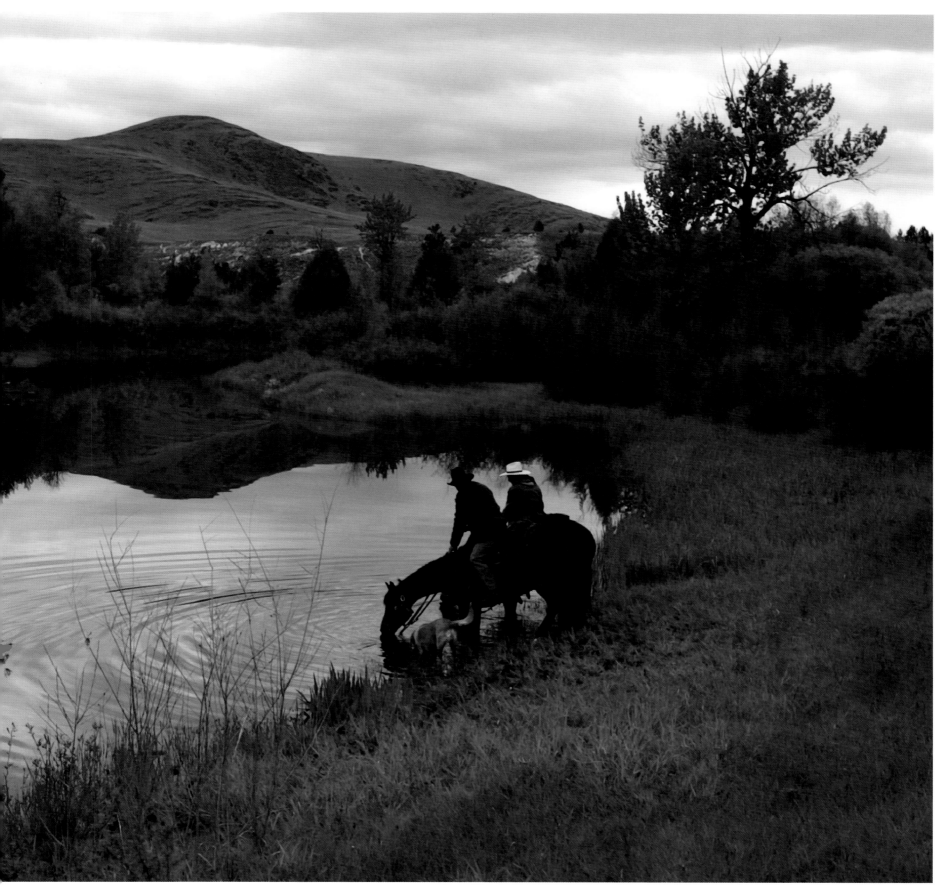

WHITEFISH

At the North Valley Music School, Abe West Willows, 5, follows the Suzuki Method to learn to play the violin. The method teaches children to play an instrument the same way they learn language—by listening and imitating. Abe also picks out tunes on the guitar under the tutelage of his father, James West Willows, a singer and songwriter.

Photos by Jennifer DeMonte

WHITEFISH

Like her brother Abe, 9-year-old Esther Johanna Okme Willows began her formal music study at the North Valley Music School when she was 5. She has competed in a music festival at the University of Montana and regularly serenades shoppers at her parents' roadside huckleberry stand.

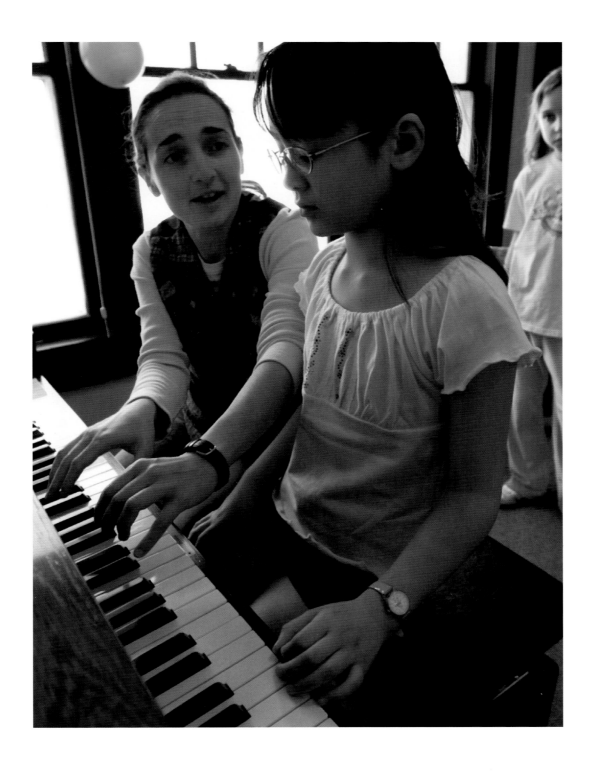

LODGE GRASS
Joe Medicine Crow, 90-year-old historian for the Crow tribe, has a direct connection to the battle of Little Bighorn. His great uncle was a scout for Lieutenant Colonel George Armstrong Custer. Many Native Americans have criticized the Crows for helping Custer, but Medicine Crow says friendly ties with whites were based on a tribal prophecy.
Photo by Steven G. Smith

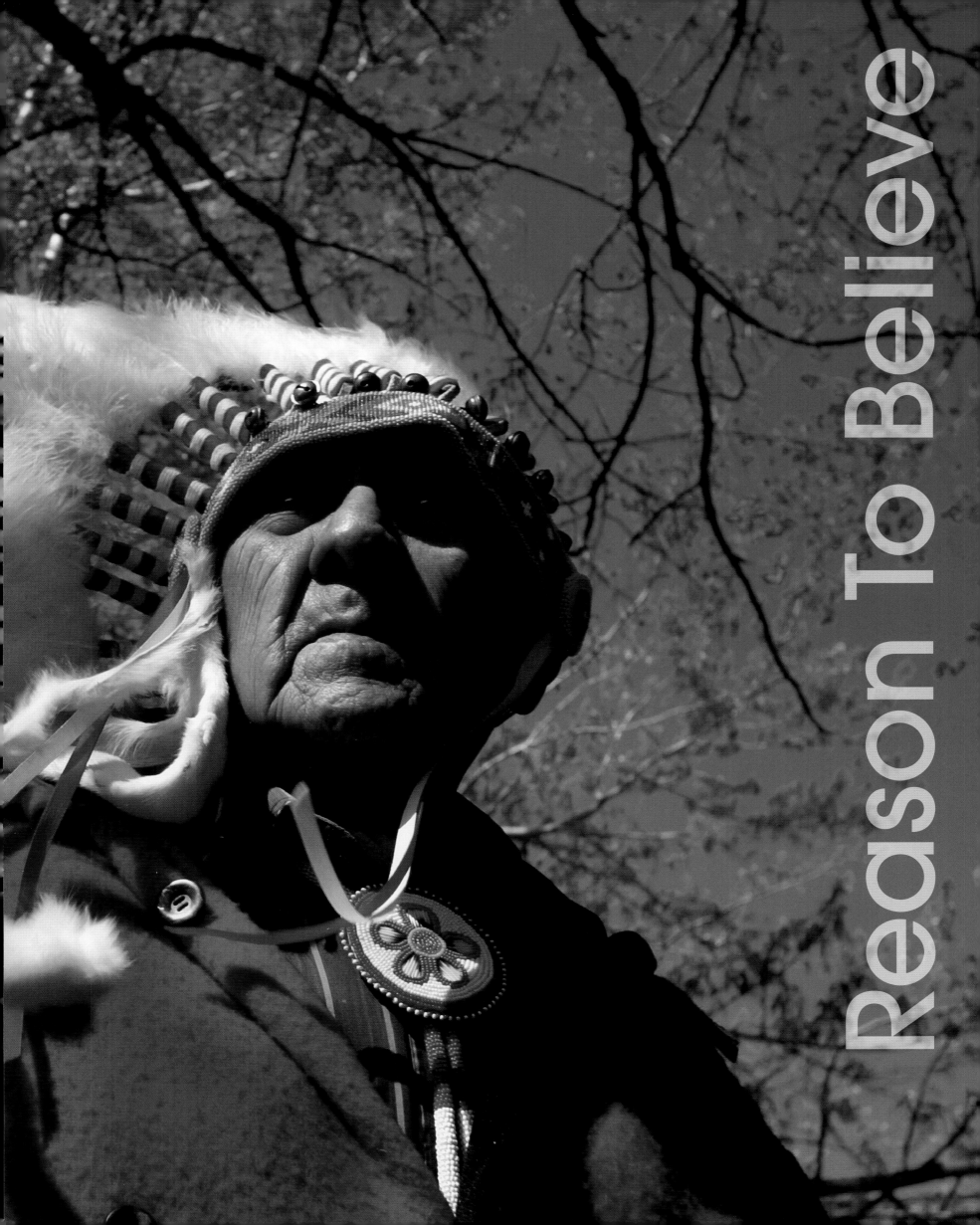

Reason To Believe

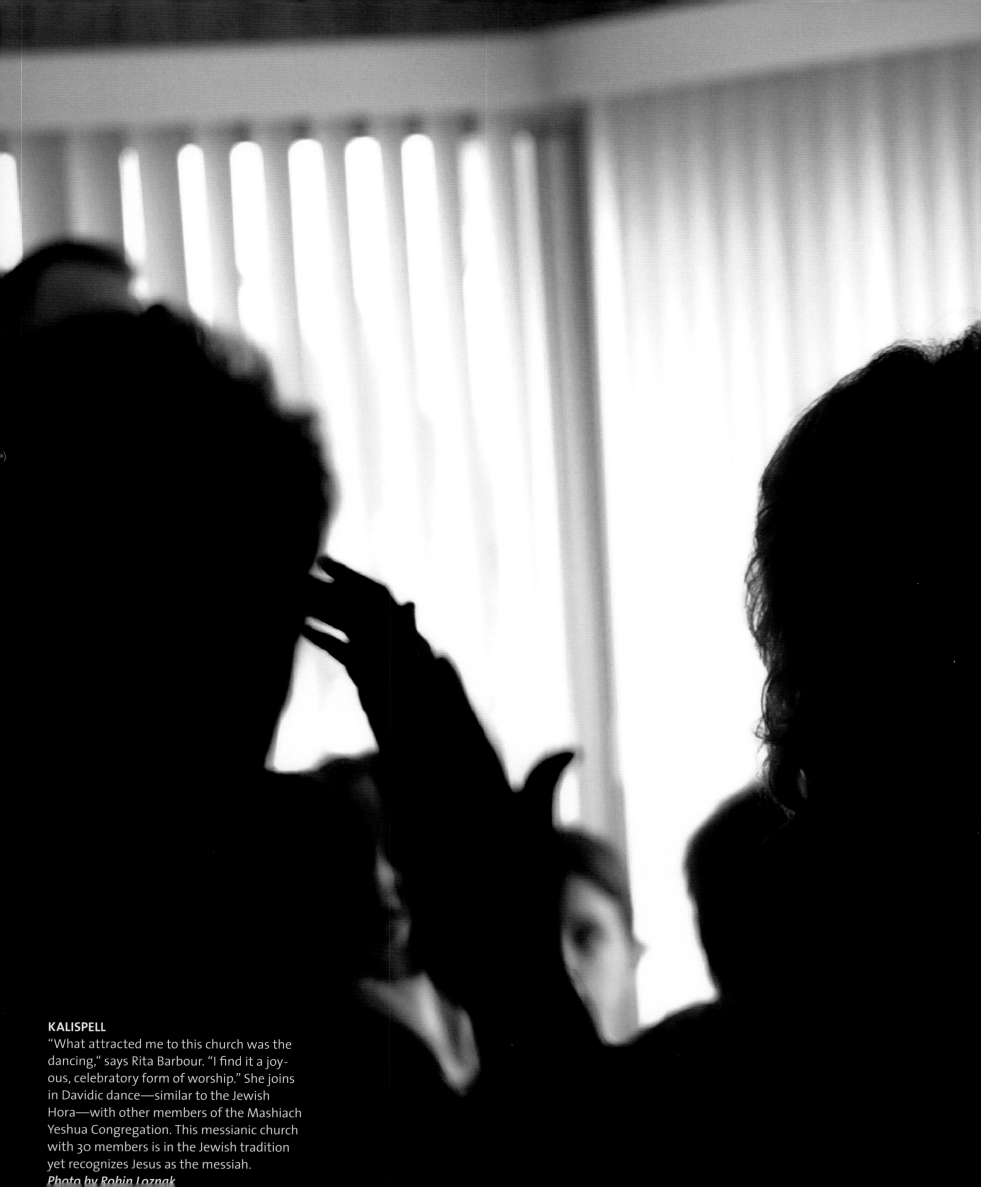

KALISPELL

"What attracted me to this church was the dancing," says Rita Barbour. "I find it a joyous, celebratory form of worship." She joins in Davidic dance—similar to the Jewish Hora—with other members of the Mashiach Yeshua Congregation. This messianic church with 30 members is in the Jewish tradition yet recognizes Jesus as the messiah.
Photo by Robin Loznak

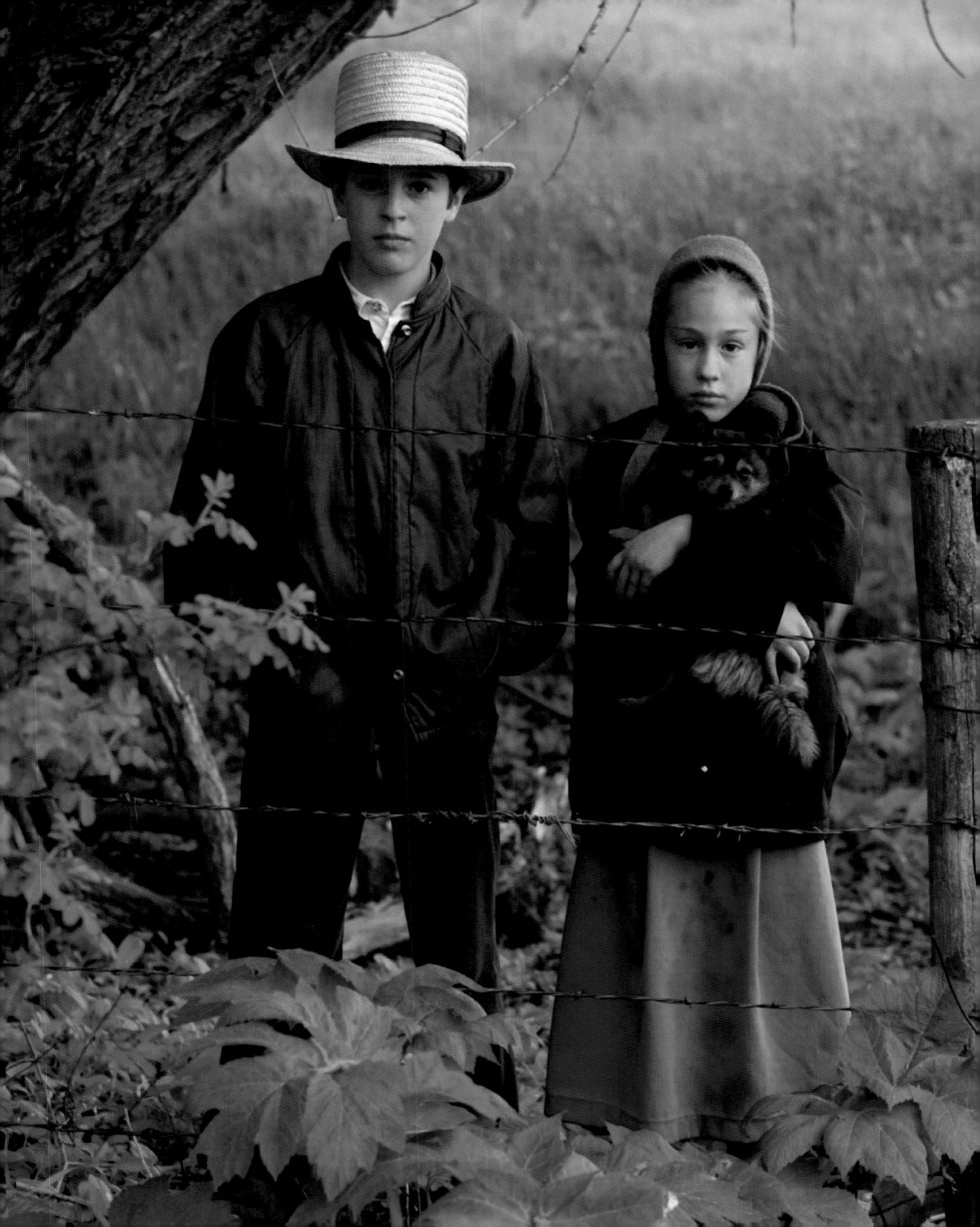

ST. IGNATIUS

Conrad Beachy, 10, and his sister Melanie, 7, belong to a 20-family Amish community in western Montana's Mission Valley. The children, whose religious beliefs prohibit the use of computers, TV, or video games, attend a church school through the eighth grade, after which it is assumed they will work and marry within the community.
Photos by Kurt Wilson

ST. IGNATIUS

Simon Miller takes care of the 18 horses his family uses for transportation and farming: three draft horses to plow the fields and harvest the hay, four Standard breds to pull the buggies, and the rest to ride. The Millers are part of the Mission Valley Amish community.

ST. IGNATIUS

When they're not attending the Amish community school—or on the swing, Rosemary and Naomah Miller help their mother with baking, canning, gardening, cleaning, and sewing the family's clothes.

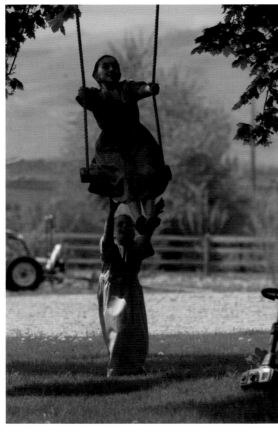

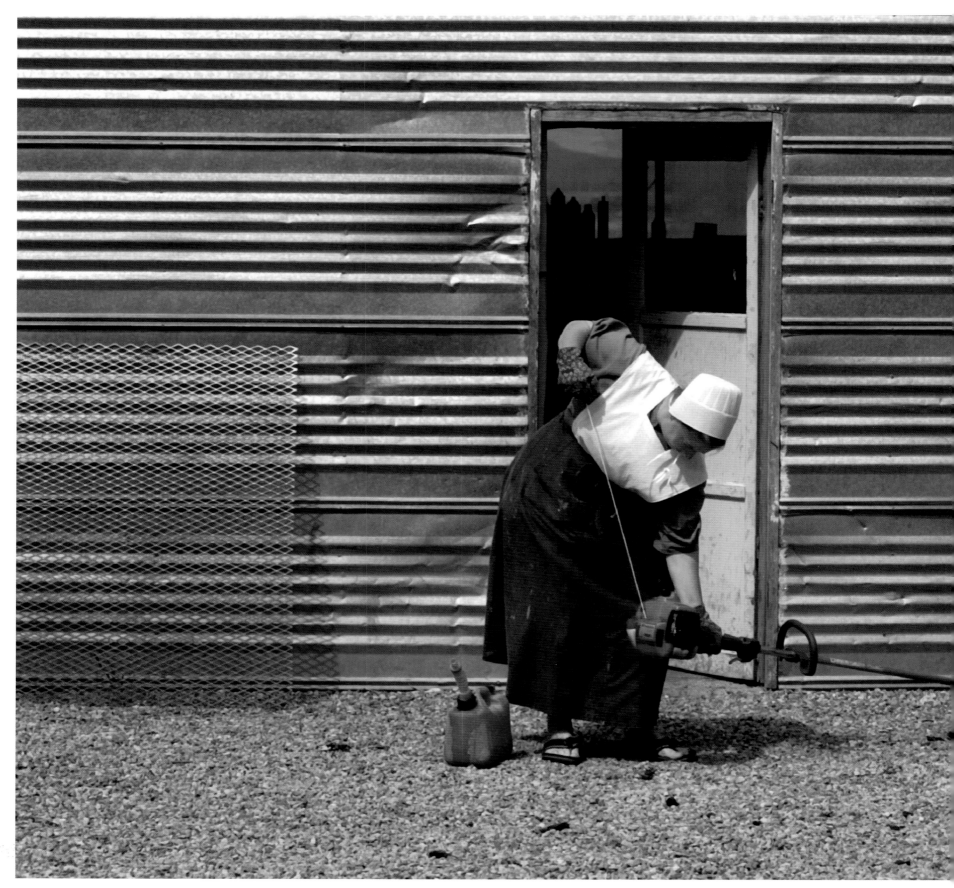

Esta Miller has lots to do on her family's 40-acre farm, and, contrary to popular belief, some Amish don't do it all by hand. Mechanical tools like her weed whacker are allowed in Mission Valley. This new building houses buggies, provides extra sleeping space for visitors, and has enough room to hold Sunday church services, which move by turns to each family's farm.
Photos by Kurt Wilson

ST. IGNATIUS

Luke Miller, 15, packs wood cut from old fence rails on the family ranch, recycling it into new fences, buildings, and firewood. He's finished his formal schooling, so he works with his father on construction jobs for the "English" (non-Amish) in the valley. The money Luke earns goes into the family kitty until he's 21.

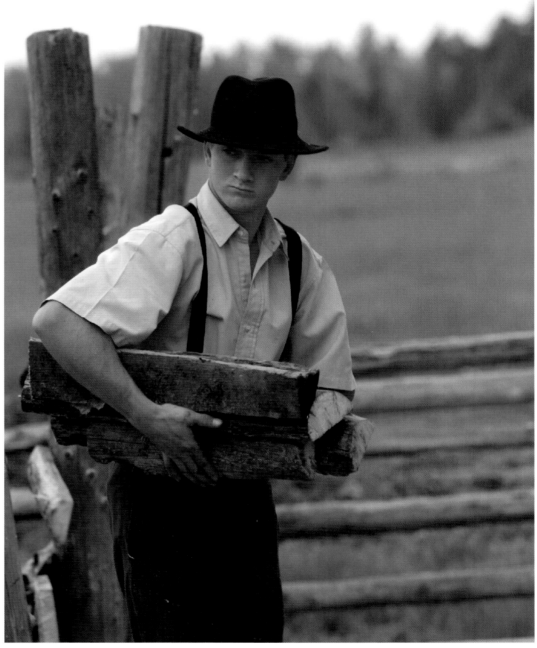

KALISPELL

The Robertson and Nerne children join hands in Davidic dance, an integral part of Saturday services at the Mashiach Yeshua Congregation. There are approximately 600 messianic congregations in America.

Photos by Robin Loznak

KALISPELL

Before wrapping the tallith around her shoulders, Stephanie Robertson covers her head and says a blessing at Mashiach Yeshua services. With her is her 4-year-old daughter Chevah, whose name means "source of life" in Hebrew.

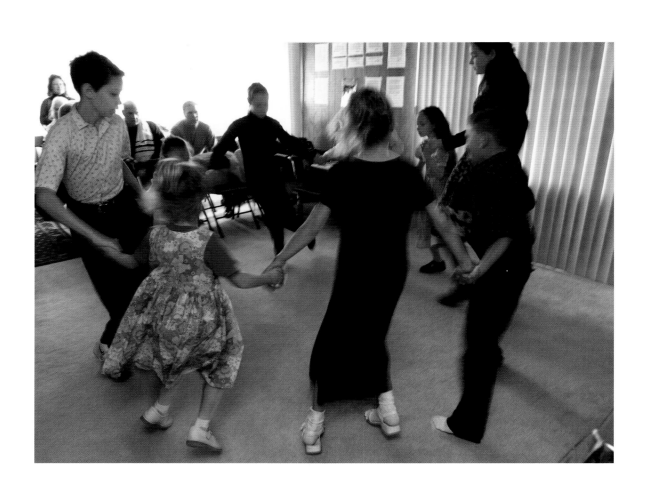

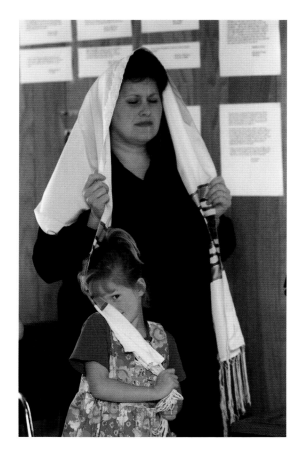

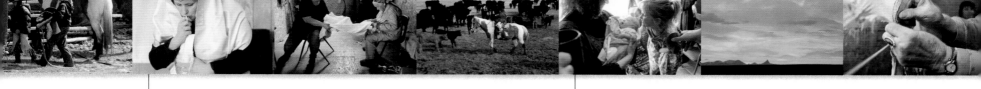

KALISPELL

Stephanie Robertson kisses the tzitzit prior to reading from the Torah. The core belief of her sect of messianic Judaism is that Jesus fulfilled all of the Old Testament prophecies about the coming of the messiah.

KALISPELL

After Mashiach Yeshua services, Dr. Ann Bukacek cradles sleeping 15-day-old Yeshera Robertson while the baby's sister Chevah takes a close look.

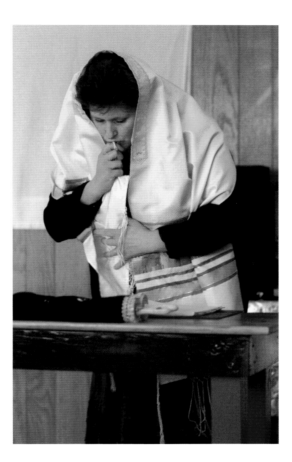

BUTTE

First communicants are all frills and nerves before mass at St. Ann's. Butte's Irish Catholic community traces its roots to the early 20th century, when immigrants came to work in the town's prolific copper mines. The Gaelic spirit asserts itself in Butte's Irish pub (with Guinness on tap), four Catholic churches, and Irish Cultural Center.

Photos by Derek Pruitt, The Montana Standard

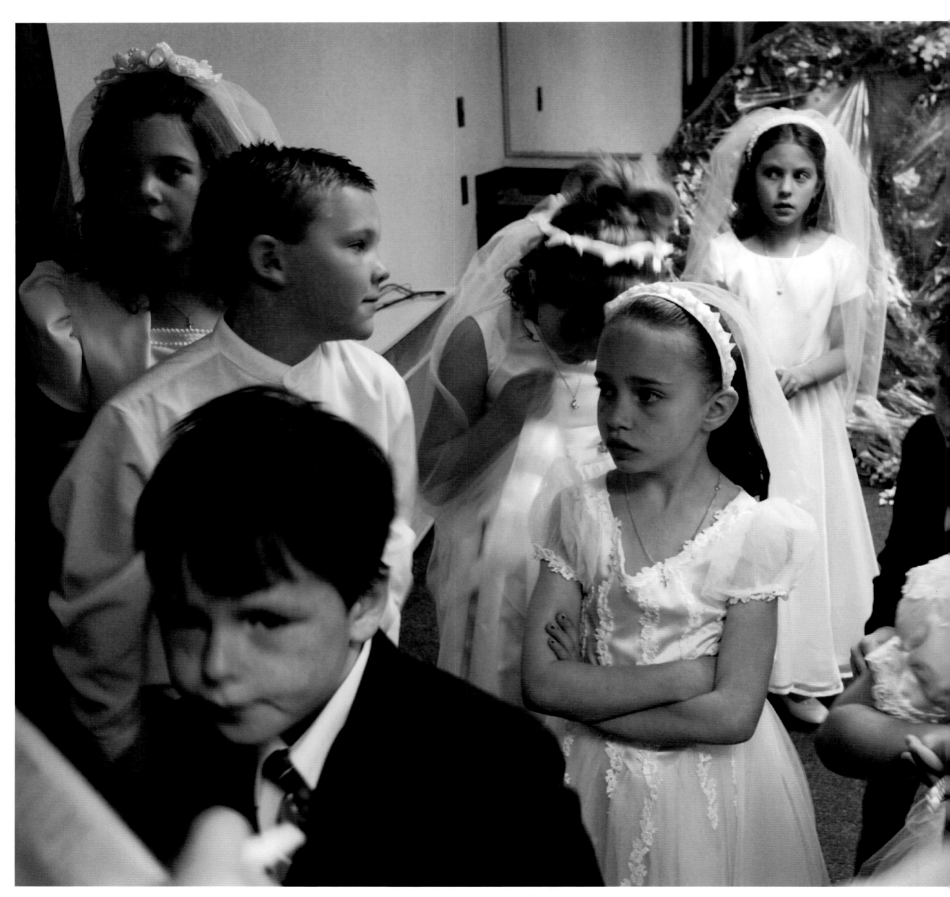

BUTTE

After Sunday mass at St. Ann's Roman Catholic Church, Father Thomas Haffey celebrates with his parish's 2003 class of first communicants. Stephanie Ricky (center), 8, marked the rite of passage with cake for breakfast.

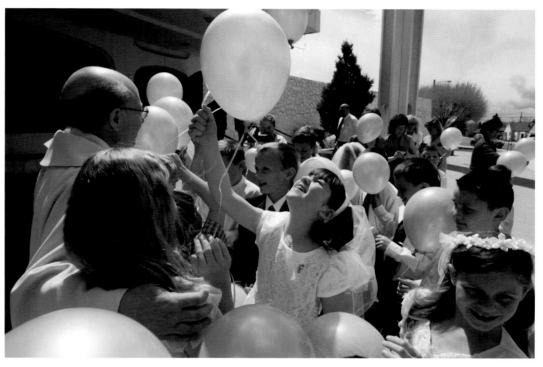

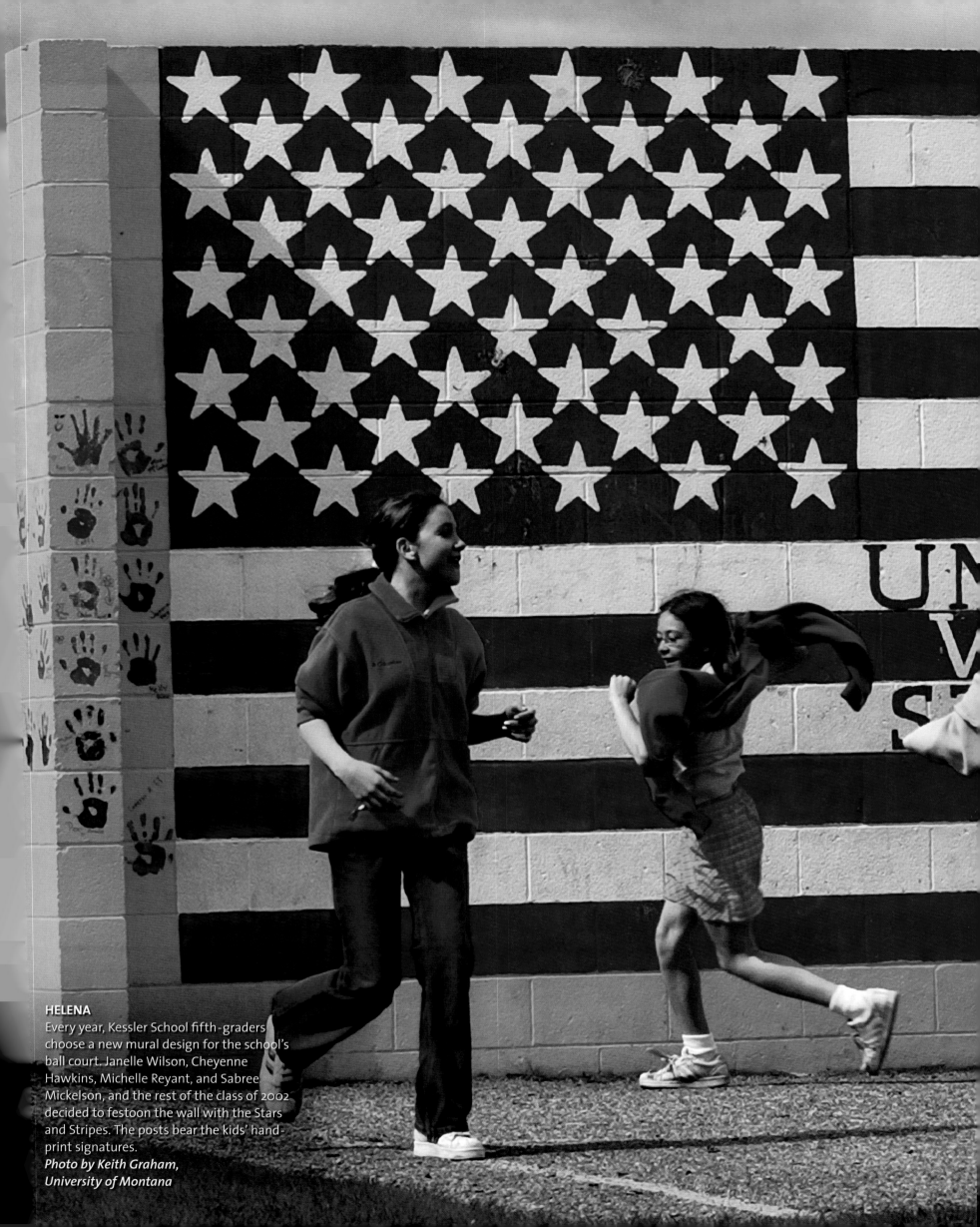

HELENA
Every year, Kessler School fifth-graders choose a new mural design for the school's ball court. Janelle Wilson, Cheyenne Hawkins, Michelle Reyant, and Sabree Mickelson, and the rest of the class of 2002 decided to festoon the wall with the Stars and Stripes. The posts bear the kids' hand-print signatures.
Photo by Keith Graham,
University of Montana

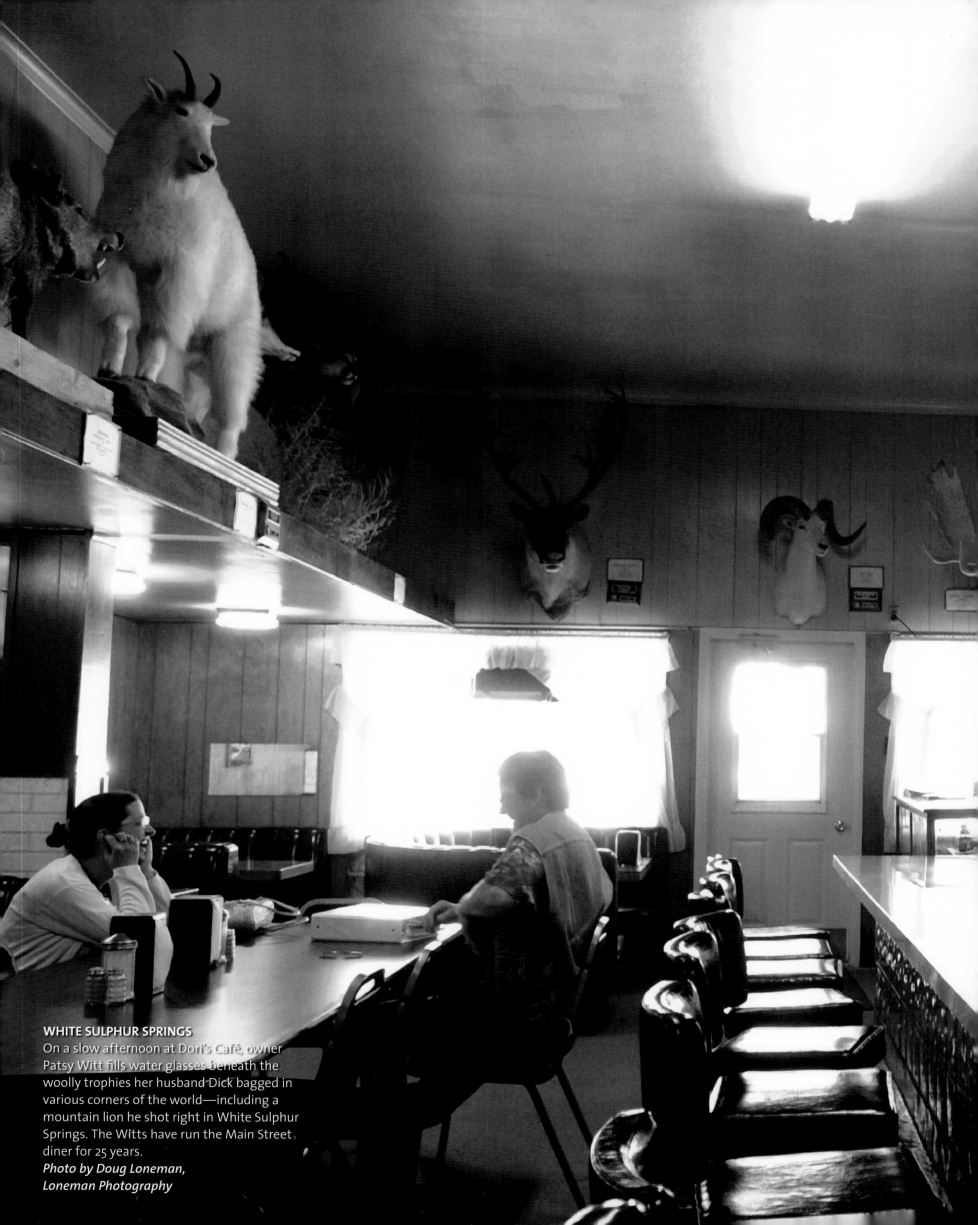

WHITE SULPHUR SPRINGS
On a slow afternoon at Dori's Café, owner Patsy Witt fills water glasses beneath the woolly trophies her husband Dick bagged in various corners of the world—including a mountain lion he shot right in White Sulphur Springs. The Witts have run the Main Street diner for 25 years.
Photo by Doug Loneman,
Loneman Photography

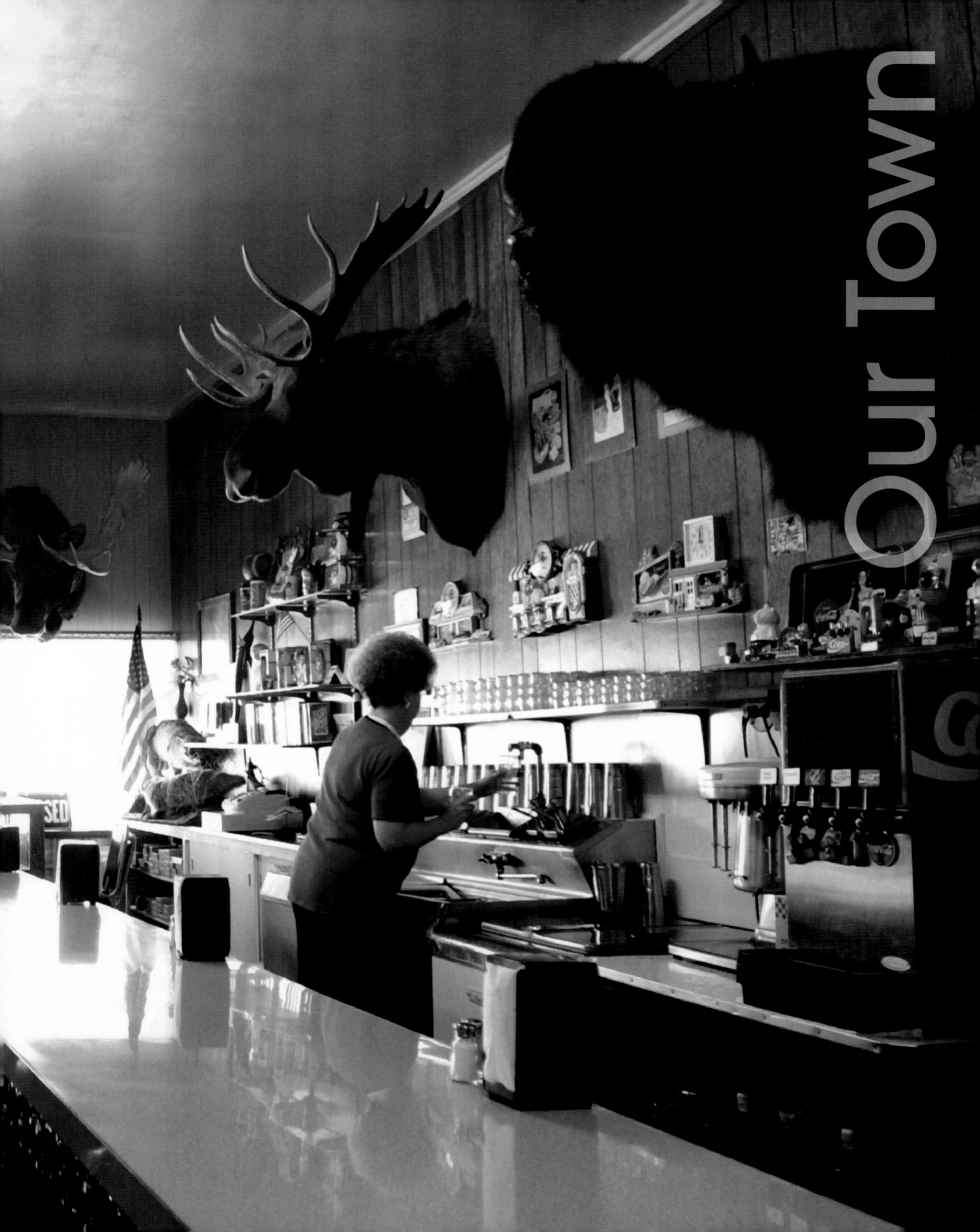

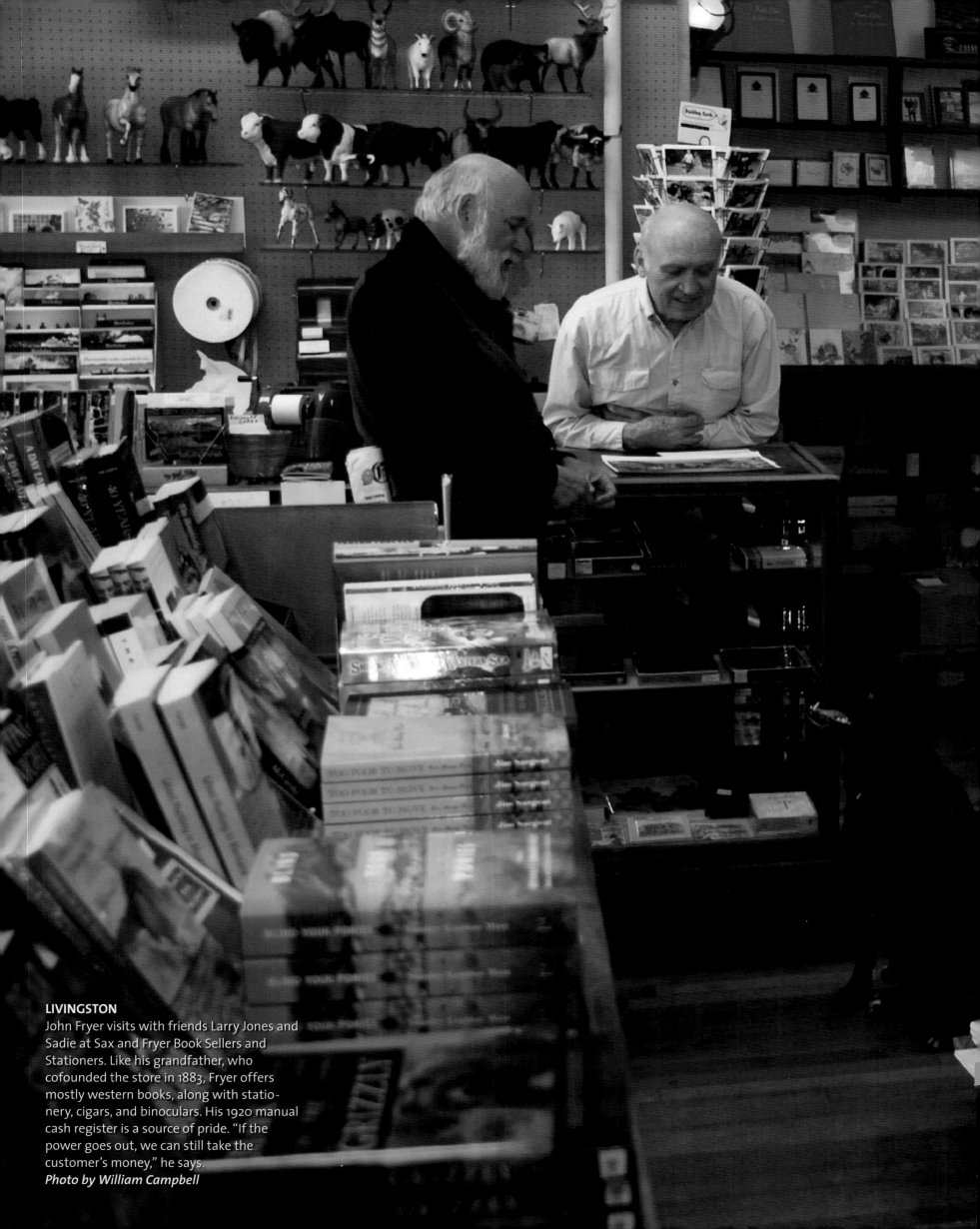

LIVINGSTON
John Fryer visits with friends Larry Jones and Sadie at Sax and Fryer Book Sellers and Stationers. Like his grandfather, who cofounded the store in 1883, Fryer offers mostly western books, along with stationery, cigars, and binoculars. His 1920 manual cash register is a source of pride. "If the power goes out, we can still take the customer's money," he says.
Photo by William Campbell

GREAT FALLS

Make way for goslings: A Canada goose and a gaggle of goslings traverse River Drive on their way to their nests on the banks of the Missouri River. Geese usually lay four to six eggs, so looks like this mama pulled babysitting duty.
Photos by John W. Liston, Great Falls Tribune

GREAT FALLS

A few stragglers hurry to catch up as motorists, who know River Drive is a common goose crossing, wait.

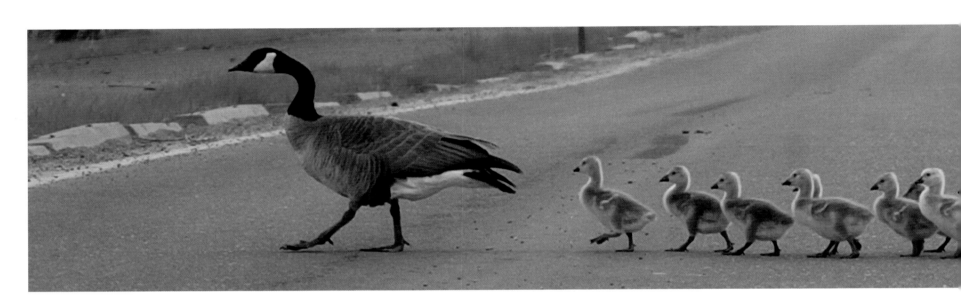

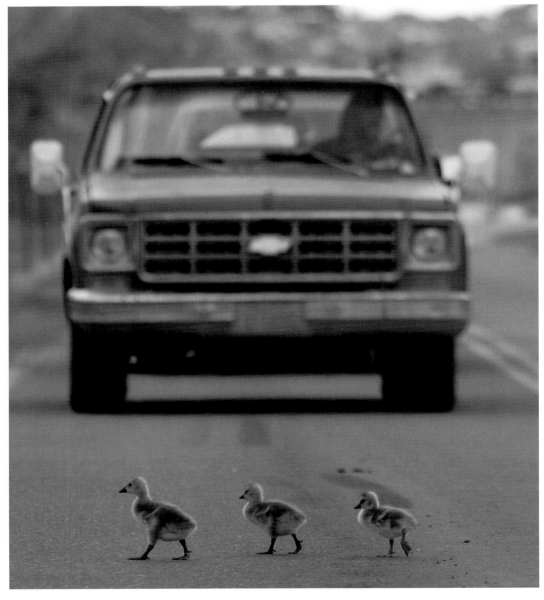

GREAT FALLS

It takes a village: Bundles of fluffy goslings huddle together for warmth and security on the banks of the Missouri River. When several new families hatch in the same area, parents often round up the young into one big nursery school called a crèche and take turns caring for them.

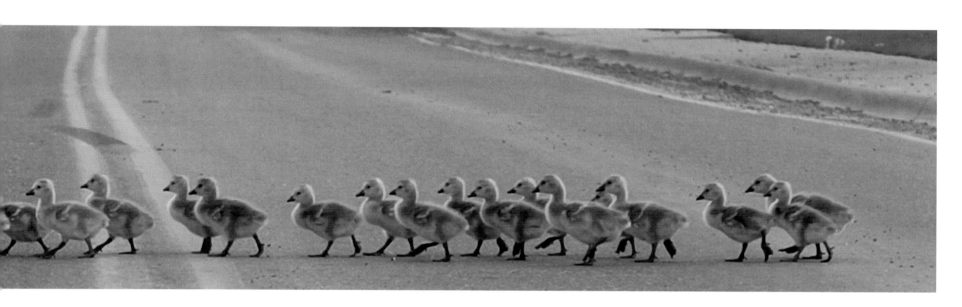

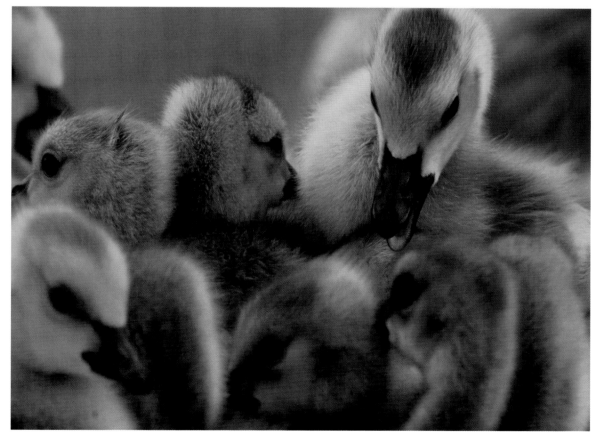

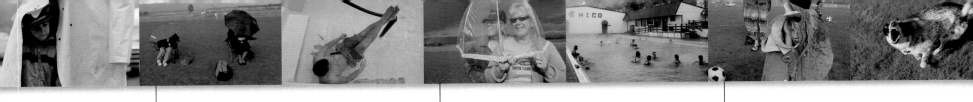

KALISPELL

Halfway through a Kalispell Parks and Recreation League soccer game, the big sky opens up and umbrellas sprout like mushrooms.

Photos by Robin Loznak

KALISPELL

Clear advantage: Bernard and Sharron Griffin catch every play during 6-year-old granddaughter Tia's soccer game.

KALISPELL

Up periscope: While it rains sideways, Kolter Larson, 9, keeps track of his cousin's soccer game from the shelter of grandmother Ingrid's jacket. Grandma (holding the umbrella) gave it to him because, she says, "that's what grandmothers are for."

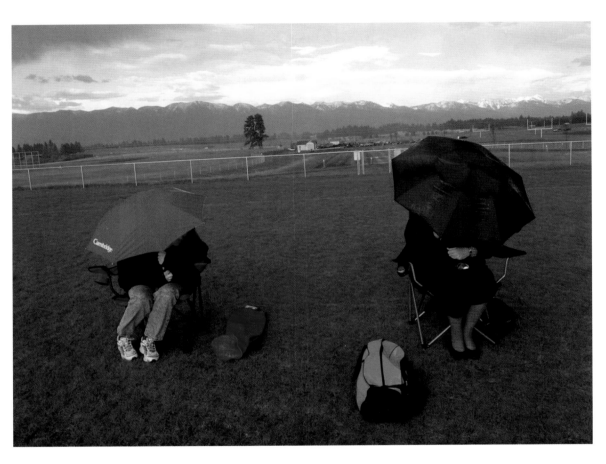

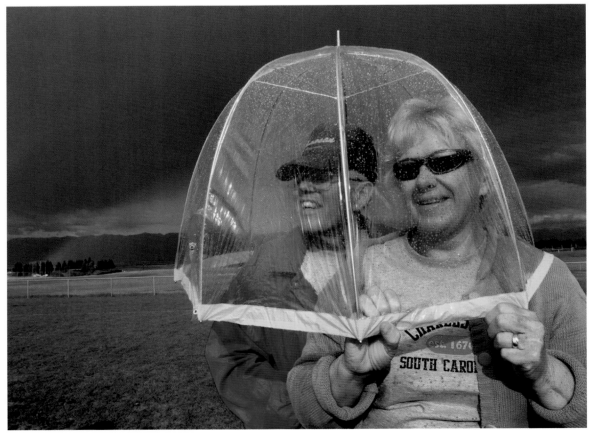

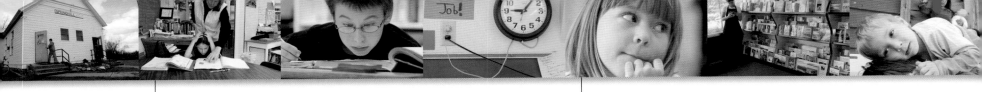

BELGRADE

Springhill Community School teacher Linda Rice instructs 13 students in the first through eighth grades at one of America's 400 one-room schoolhouses. With experience teaching at bigger schools, Price, shown here working with fourth-grader Emma Treut, says she loves teaching the same students throughout their grade school years.

Photos by Doug Loneman, Loneman Photography

BELGRADE

Trying to come up with the answer to an arithmetic problem, first-grader Sarina Myers strikes what her mother calls her "thinking pose."

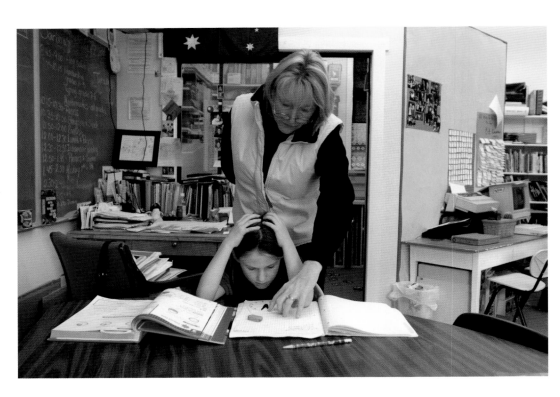

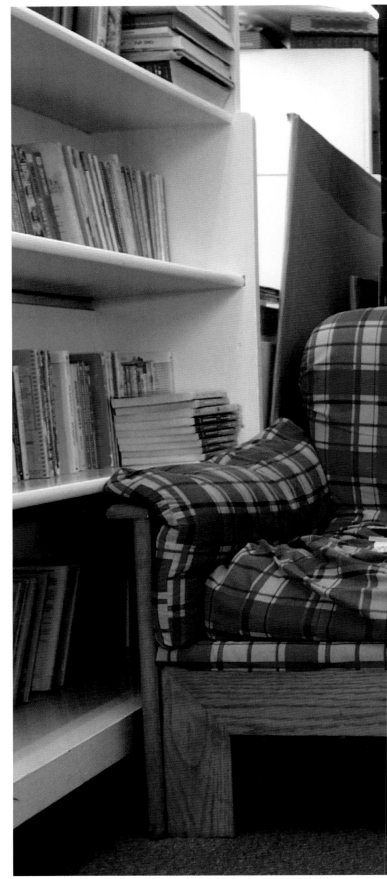

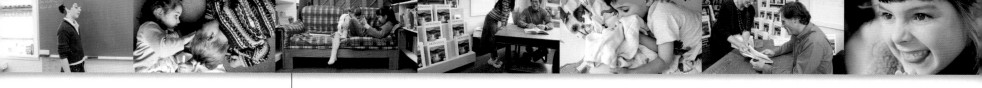

BELGRADE

Rachel Sales haltingly reads a story to Sarina Myers on the Springhill School's reading couch. Students pair up with grade-mates for reading, and older kids are often enlisted to help the younger ones in subjects such as math and social studies.

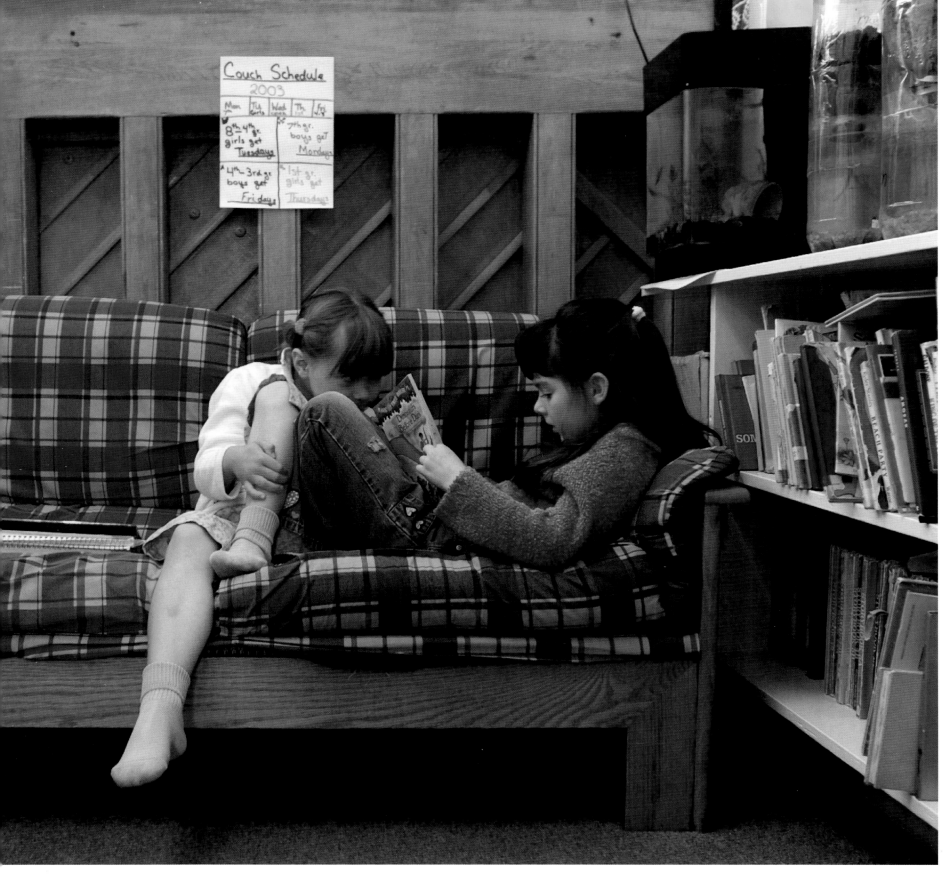

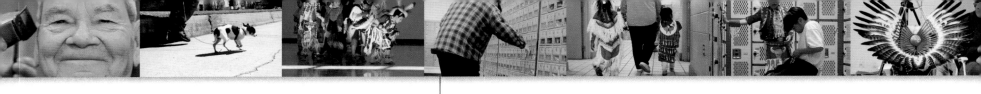

WHITE SULPHUR SPRINGS
In this central Montana ranching town (pop. 1,000), residents who live off the main rural route must pick up their mail at the post office. With 750 people passing through every week to check their P.O. boxes, Roger Hilty's dog Waldo has plenty of friends to greet.
Photo by Doug Loneman, Loneman Photography

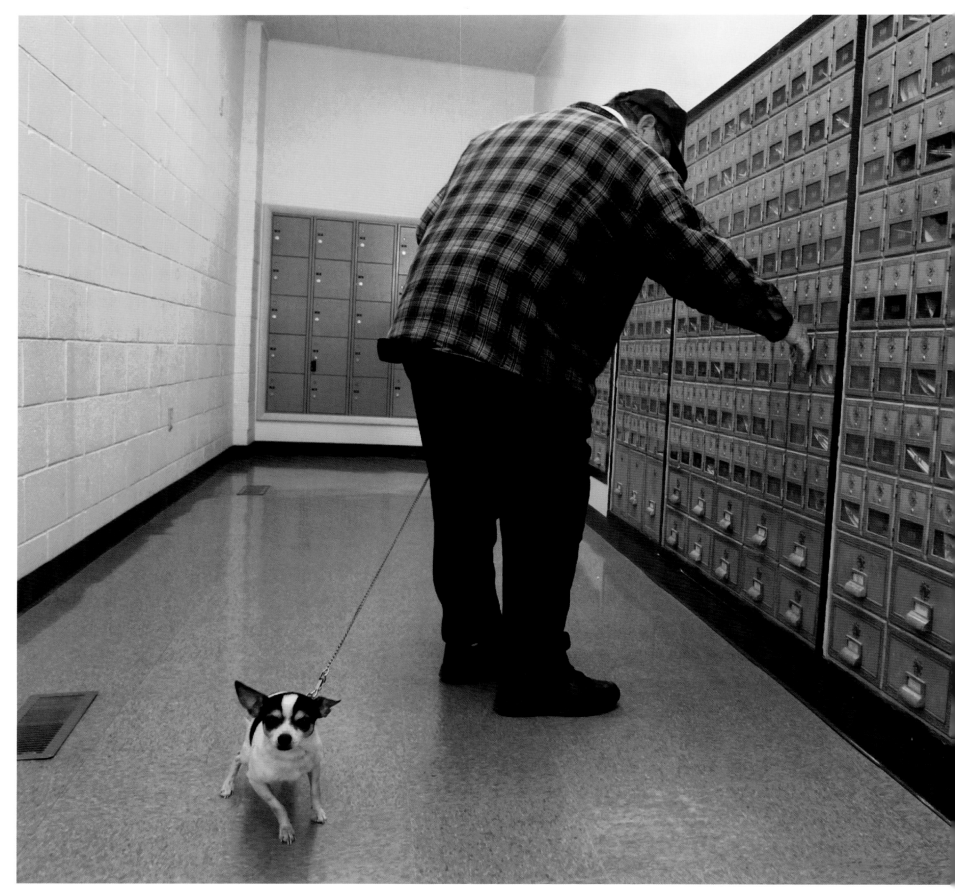

WHITE SULPHUR SPRINGS

On Main Street, a haircut costs $8. Retired machinist Jim Coleman, 88, began life in Michigan and moved west, first to Portland, then to Tacoma, and, 11 years ago, to White Sulphur Springs, where, he says, "there's one movie theater, one bank, one hardware store, one hotel... one of everything, except for bars. There are three of those."

Photo by Doug Loneman, Loneman Photography

POLSON

Aaron Wienke, a 10-year-old Assiniboin Sioux, prepares for the Grand Entry at the Polson Gathering of Families Powwow. The hawk-feather bustle and porcupine-quill head roach are part of his regalia for the Boys Traditional Dance. The Flathead Reservation event honors graduating high school students.

Photo by Kurt Wilson

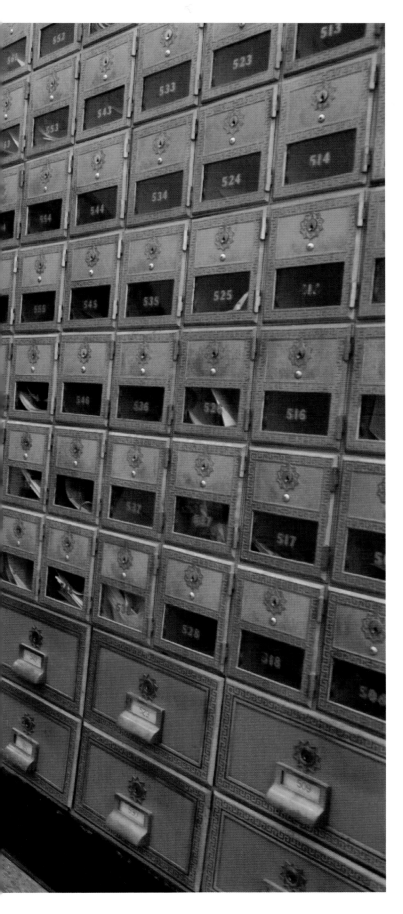

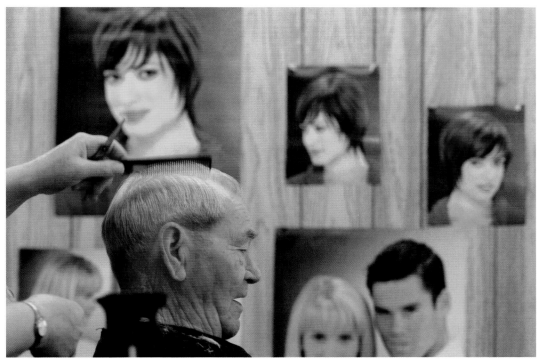

CONRAD

Beau Lindberg holds the flag during opening ceremonies of the Conrad Whoop-Up Trail Days Rodeo. Cowboys can be bought on the auction block, and if they win the bronc riding, roping, or bulldogging event, their "owner" gets part of the prize money.
Photo by Keith Graham, University of Montana

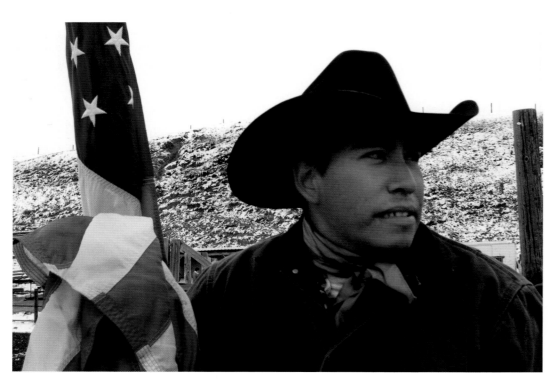

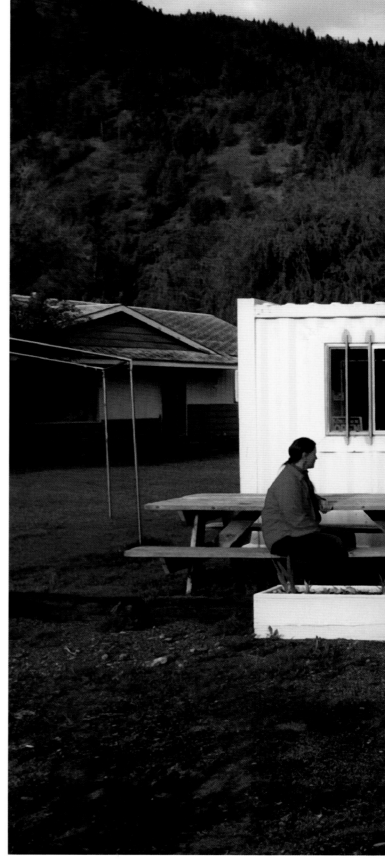

RAVALLI

When Nancy and David Martin won the contract to run the U.S. Post Office's station in Ravalli, they had just nine days to come up with a facility. They found a shipping container in Missoula, moved it to their yard on the road to Glacier National Park, and voilà! Stamps anyone?
Photo by Kurt Wilson

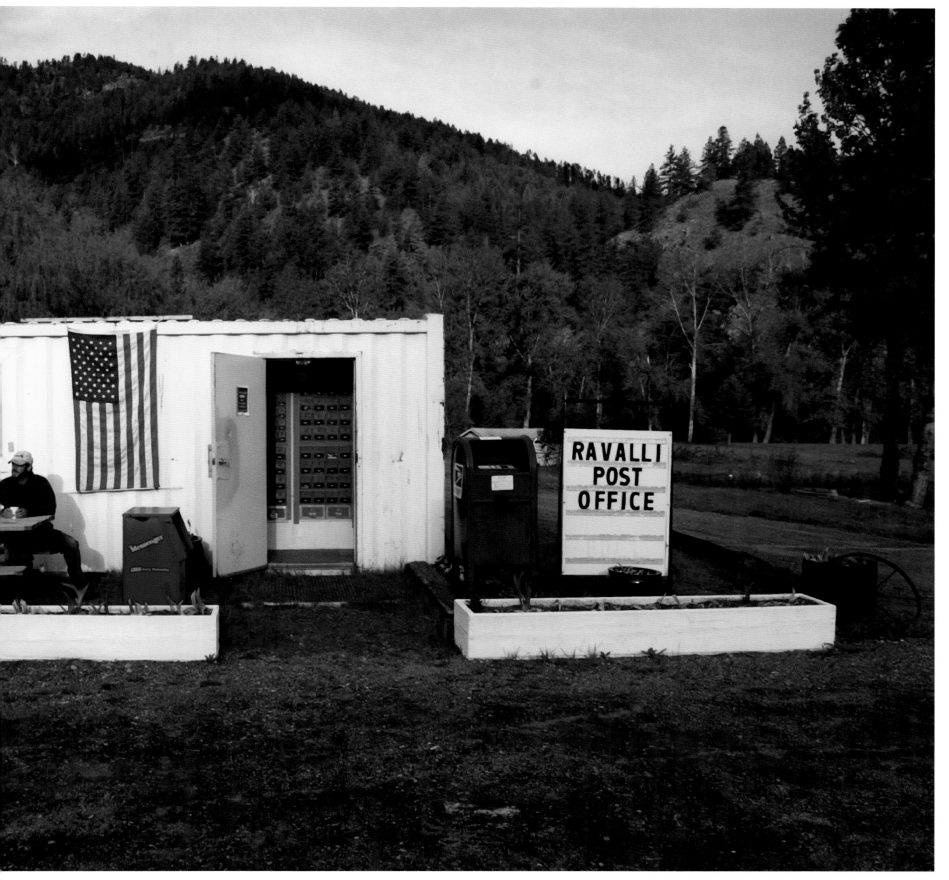

DRUMMOND

Would you buy a used cow from this man? Customers who need cows call Garry Mentzer, who rounds them up from his own and other ranches and ships them out. Just off Interstate 90 in Granite County, the town of Drummond is known far and wide as the "Bullshippers Capital of the World."
Photo by Keith Graham, University of Montana

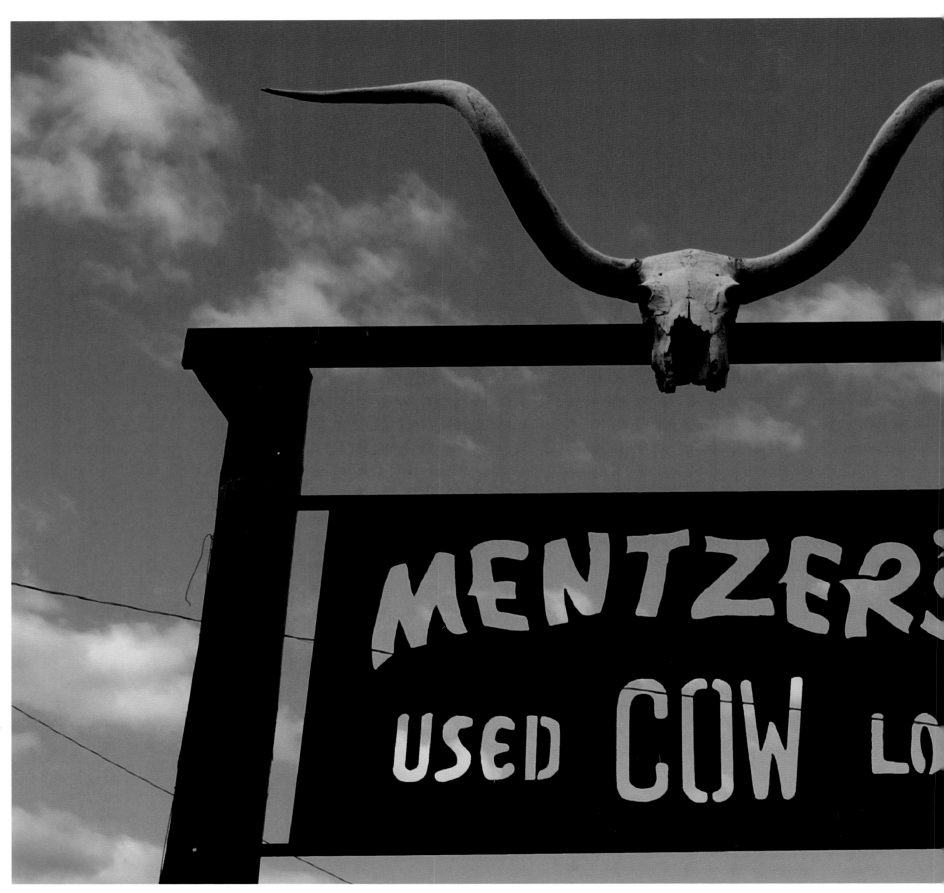

WILSALL

Chuck Dallas's ranch outside Wilsall was just a bend in the road until 1997, when daughter Mardy devised this metal sign. It was her Future Farmers of America graduating project.
Photo by Erik Petersen

HARLOWTON

Spring snow dusts the fir-pole sign at the entrance to a 50,000-acre spread along Highway 191, a home to three generations. The huge ranch has been in the family since the 1920s.
Photo by Keith Graham, University of Montana

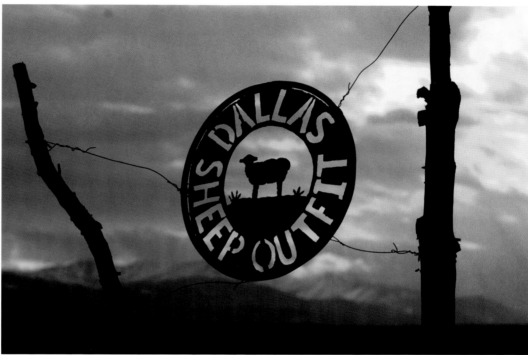

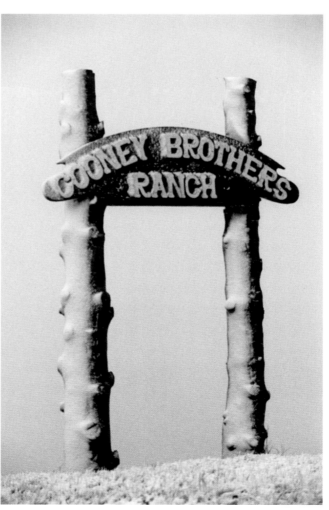

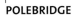

POLEBRIDGE

"They're my kids," says Karin Colby, left, of her wolf hybrids: half dog, half wolf Taswind (bottom) and 7/8 wolf, 1/8 dog Matohota. Detractors call hybrids dangerous, but Colby says that the key is constant socialization, a lot of work, and clear-cut role playing. "I'm the alpha of the pack."
Photo by Karen Nichols

VIRGINIA CITY

Mild, mild West: 70-year-old Virginia City resident Tom Williams relaxes outside one of the former gold-mining town's many original 19th century buildings. When the gold disappeared, there was no money to remodel anything. Locals like to think of their home as a ghost town that's very much alive.

Photos by William Campbell

SHERIDAN

Neighbors organize a yard sale to raise money to send three Sheridan girls to the Family Career and Community Leaders of America national meeting in Philadelphia.

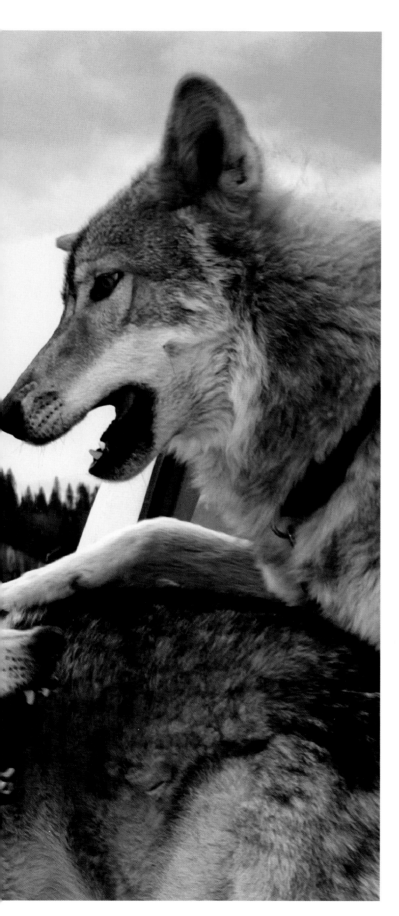

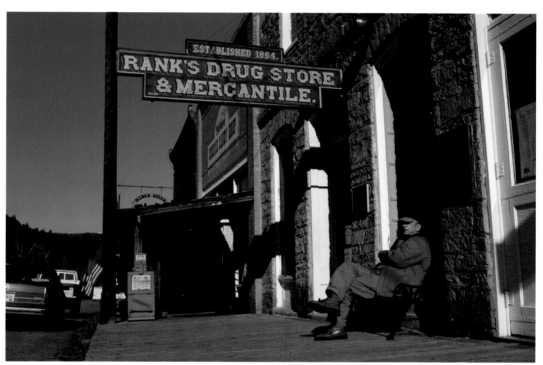

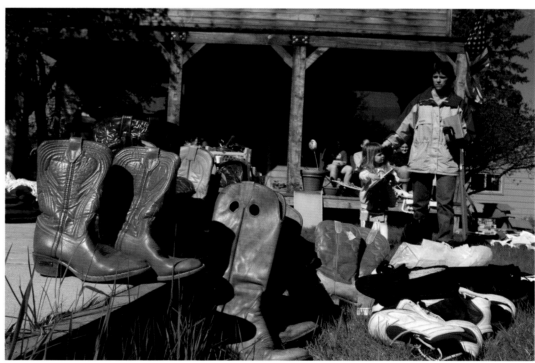

KALISPELL

Salad days: A 10-year-old Angus heiffer munches on a spring carpet of dandelion and grass. Her owner, John Kloeckl, 75, has been ranching in the area for 60 years.

Photo by Robin Loznak

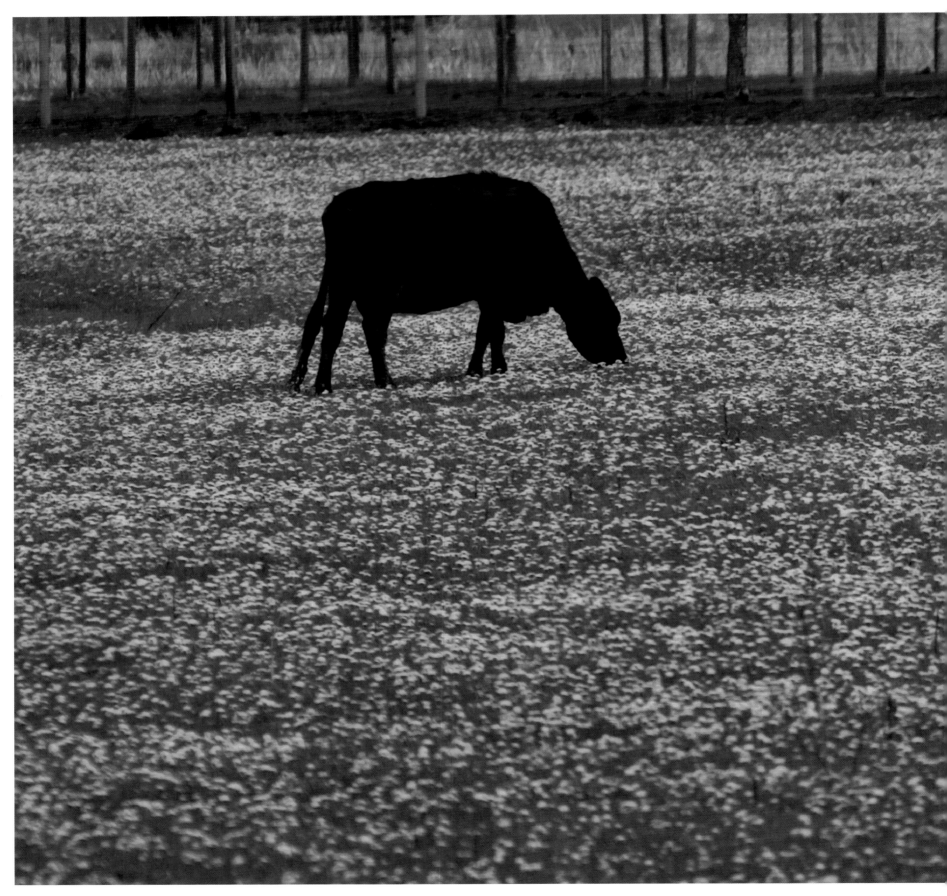

WILSALL

Myrtle homeschools her 3-month-old pups, getting them ready to guard Chuck Dallas's sheep herd. Myrtle is a Maremma; the pups' father is an Akbash. Both breeds, popular with local ranchers, bond strongly to their flocks, are tough on predators, and have coats that withstand harsh weather.

Photo by Erik Petersen

KALISPELL

After wintering in the Southwest and Mexico, this male yellow-headed blackbird has come north a few weeks ahead of the missus to stake out his cattail kingdom in a marsh near Kalispell.

Photo by Robin Loznak

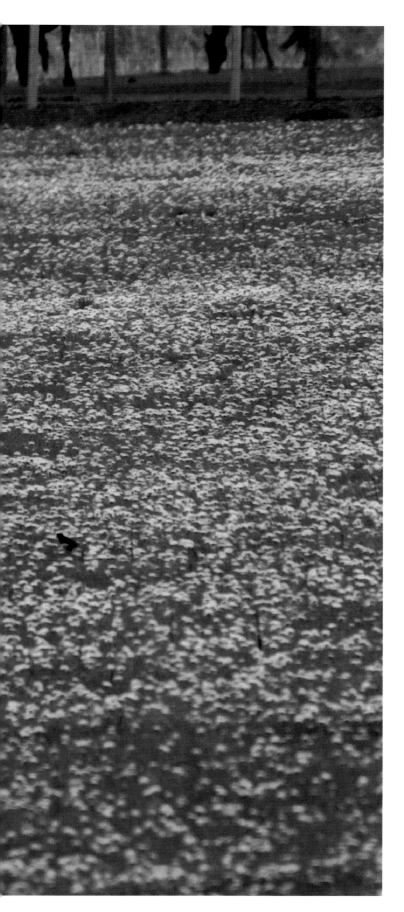

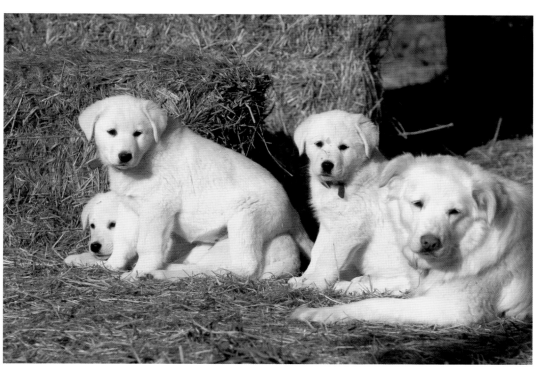

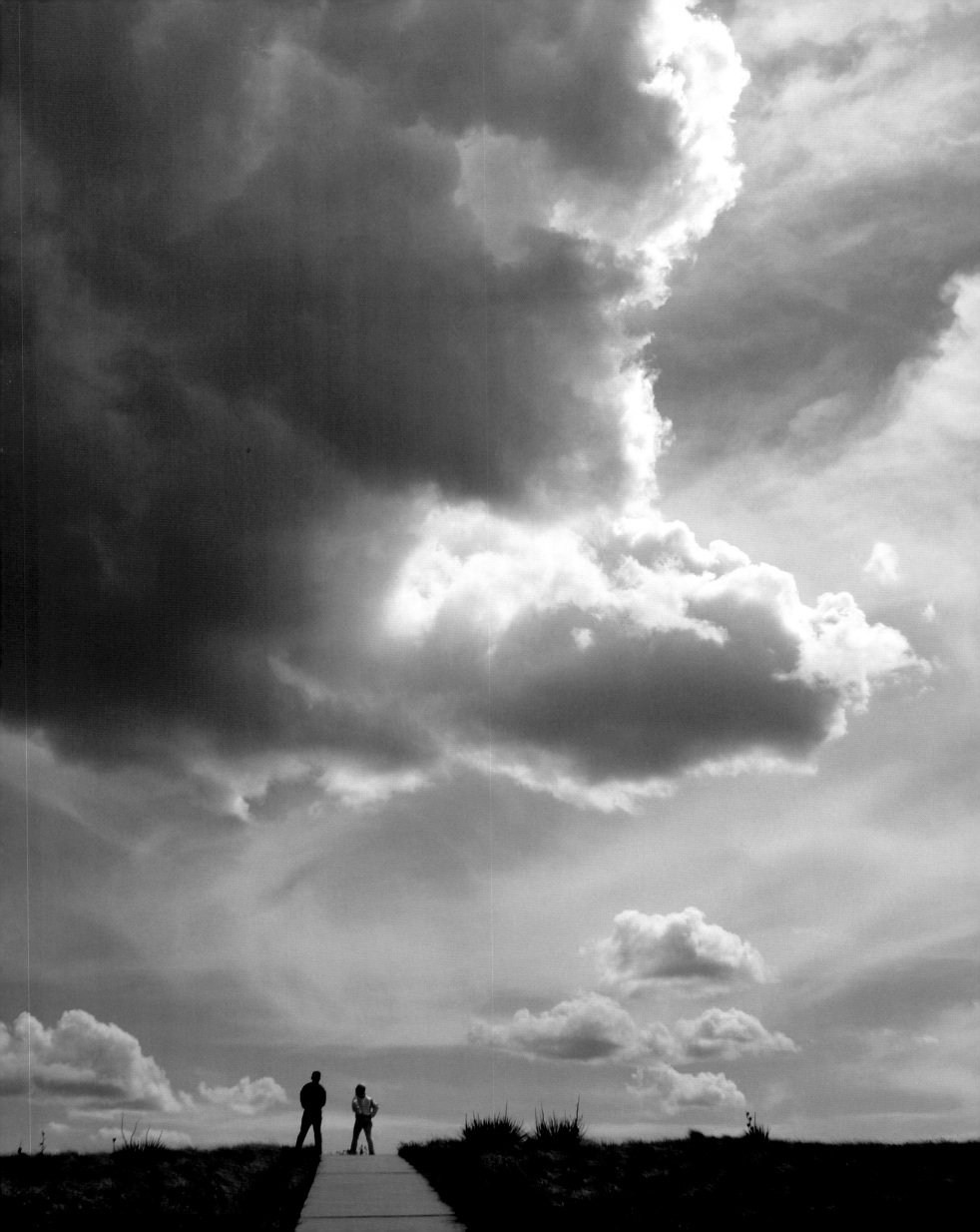

LITTLE BIGHORN
Clouded by years of controversy and myth, Lieutenant Colonel George A. Custer's "last stand" in 1876 is remembered amid the grassy hills of Little Bighorn Battlefield National Monument, 40 miles southeast of Billings.
Photo by Steven G. Smith

MILES CITY
Custer's last band: Brian Kitzmann, decked out as the famous lieutenant colonel, leads the 7th Calvary Drum and Bugle Corps in the Bucking Horse Sale Parade. The Wyoming-based group occasionally faces protests from Native Americans, but it was well received in Miles City. "Around here, Custer is a proud part of Montana history," says Kitzmann.
Photo by David Grubbs

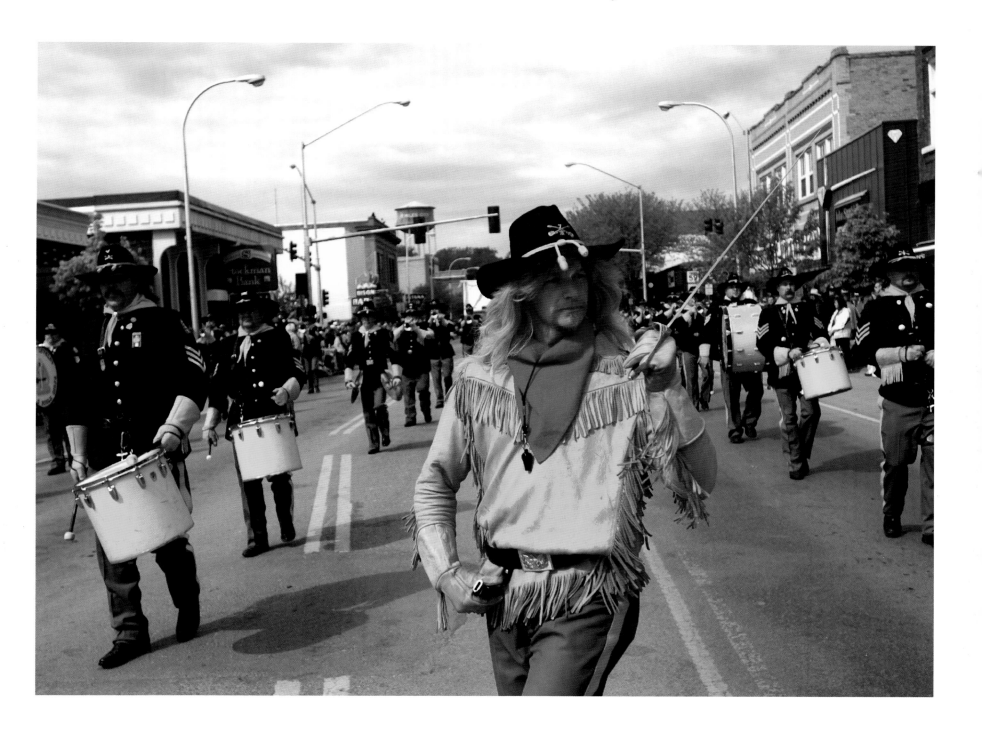

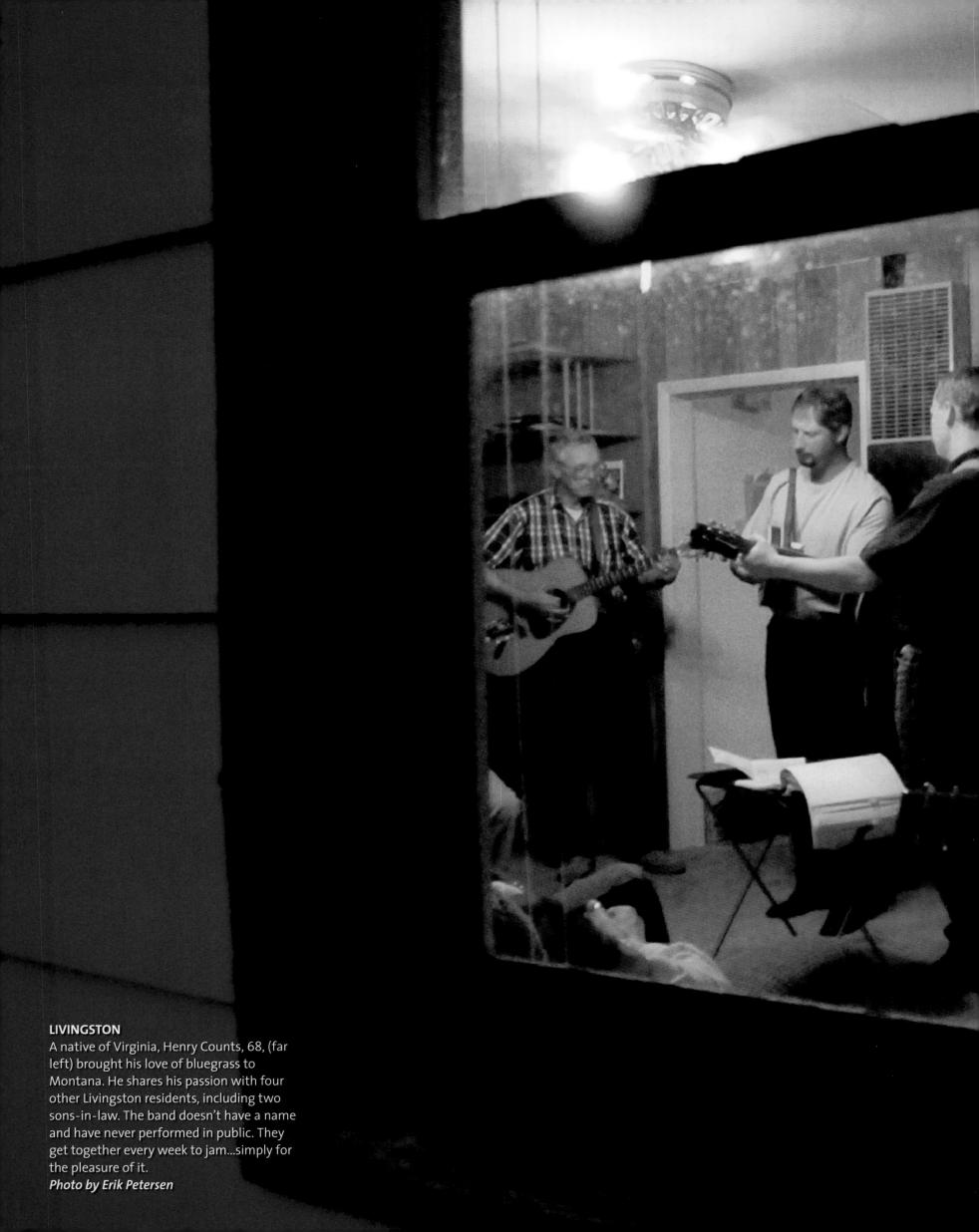

LIVINGSTON
A native of Virginia, Henry Counts, 68, (far left) brought his love of bluegrass to Montana. He shares his passion with four other Livingston residents, including two sons-in-law. The band doesn't have a name and have never performed in public. They get together every week to jam...simply for the pleasure of it.
Photo by Erik Petersen

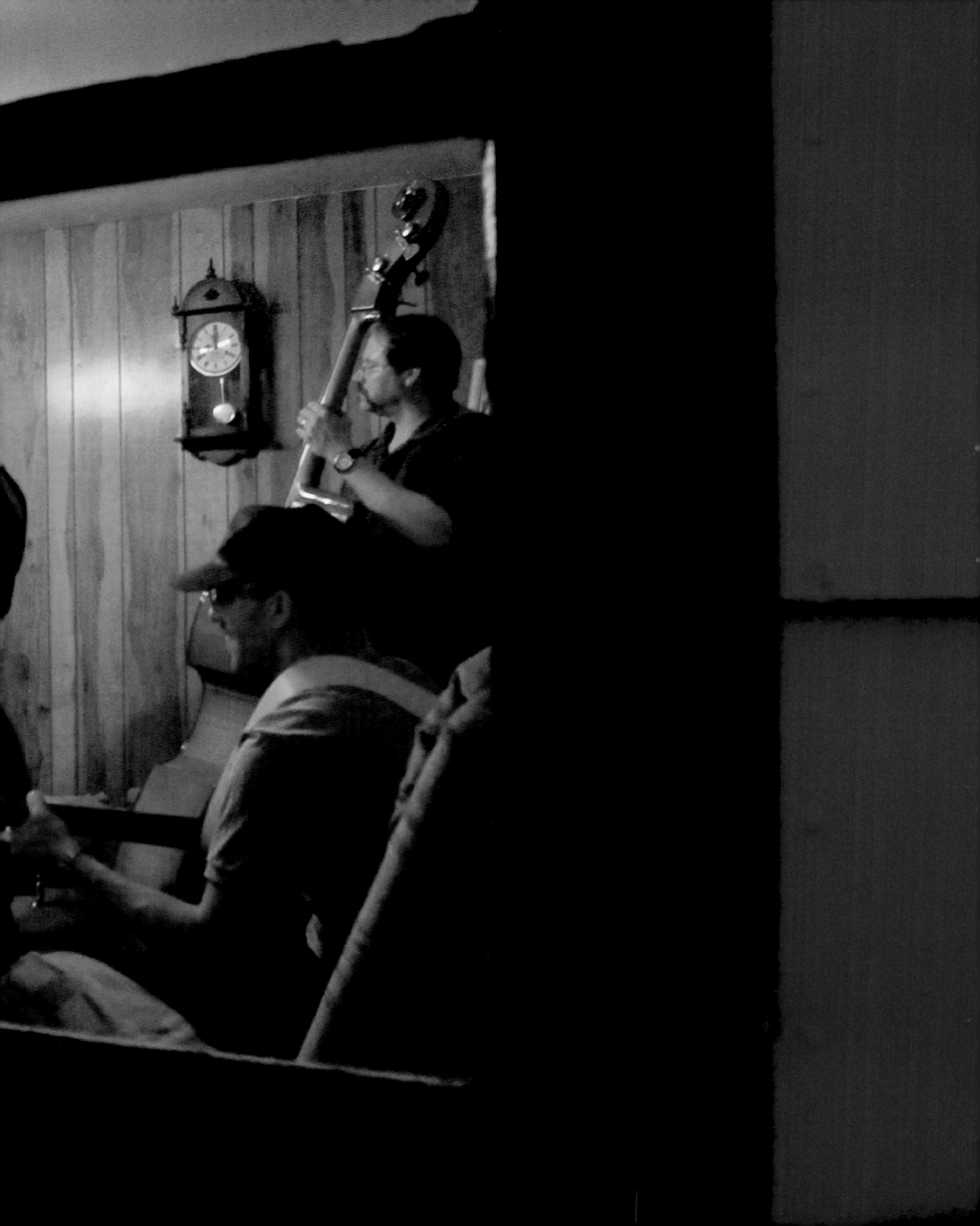

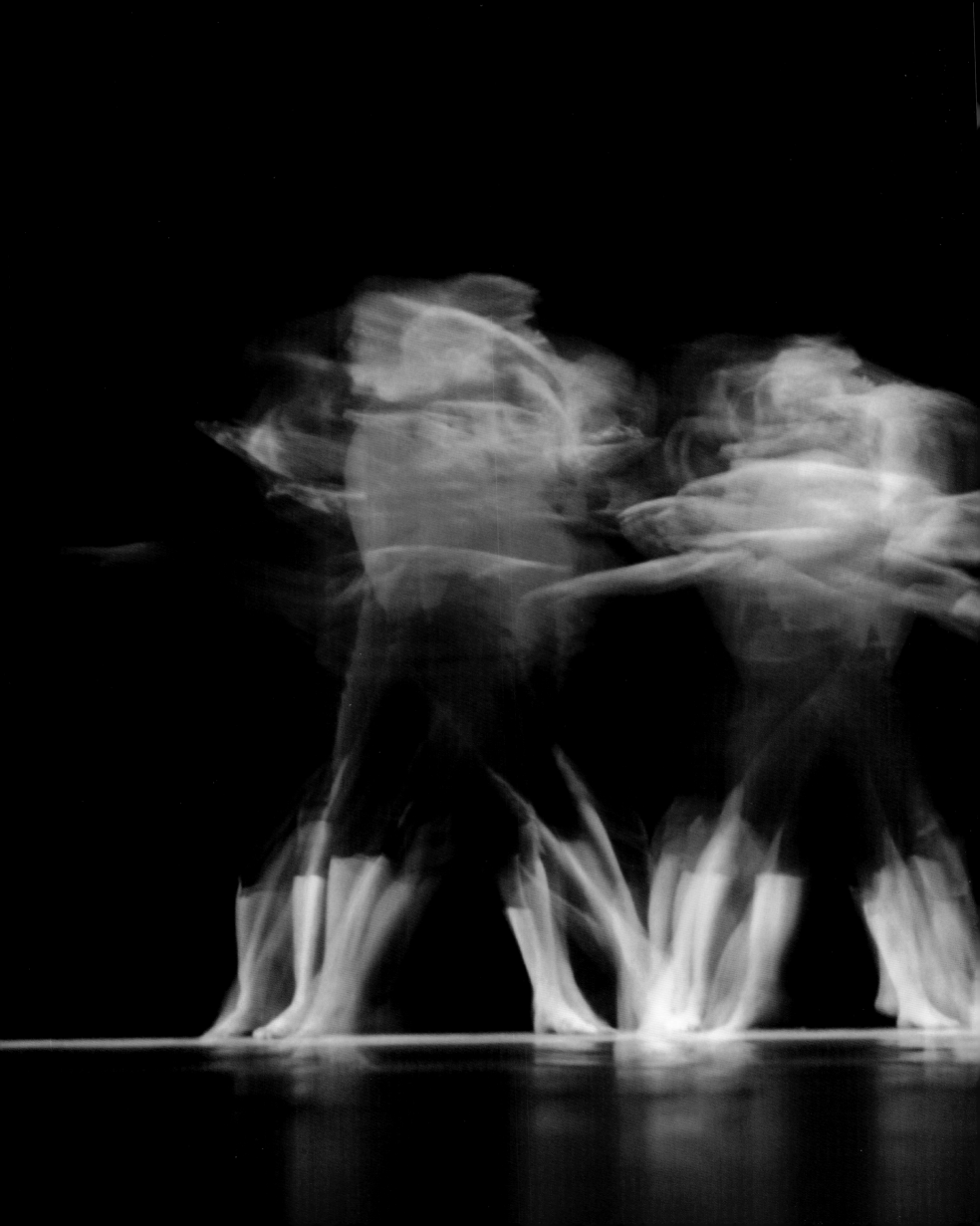

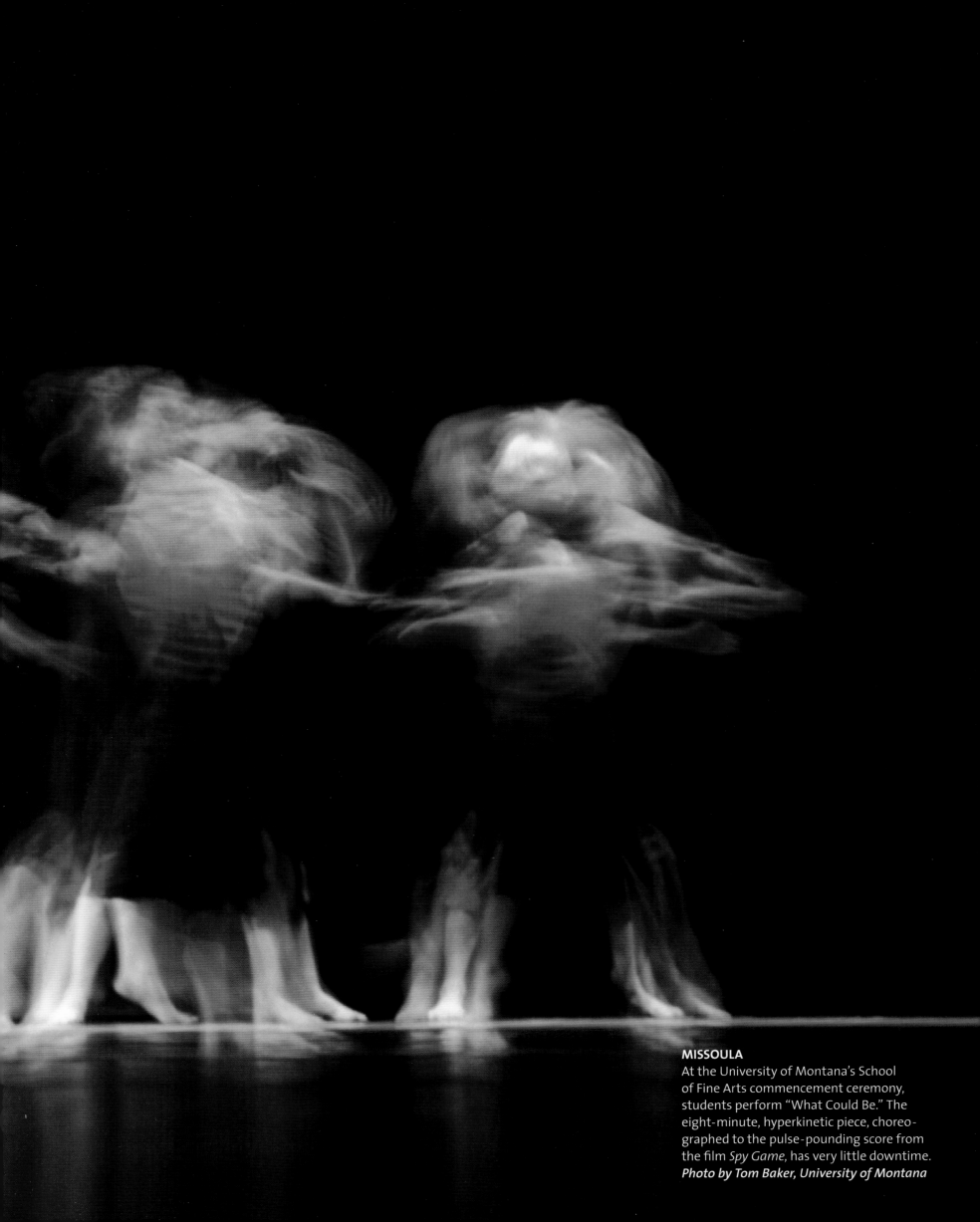

MISSOULA
At the University of Montana's School of Fine Arts commencement ceremony, students perform "What Could Be." The eight-minute, hyperkinetic piece, choreo-graphed to the pulse-pounding score from the film *Spy Game*, has very little downtime.
Photo by Tom Baker, University of Montana

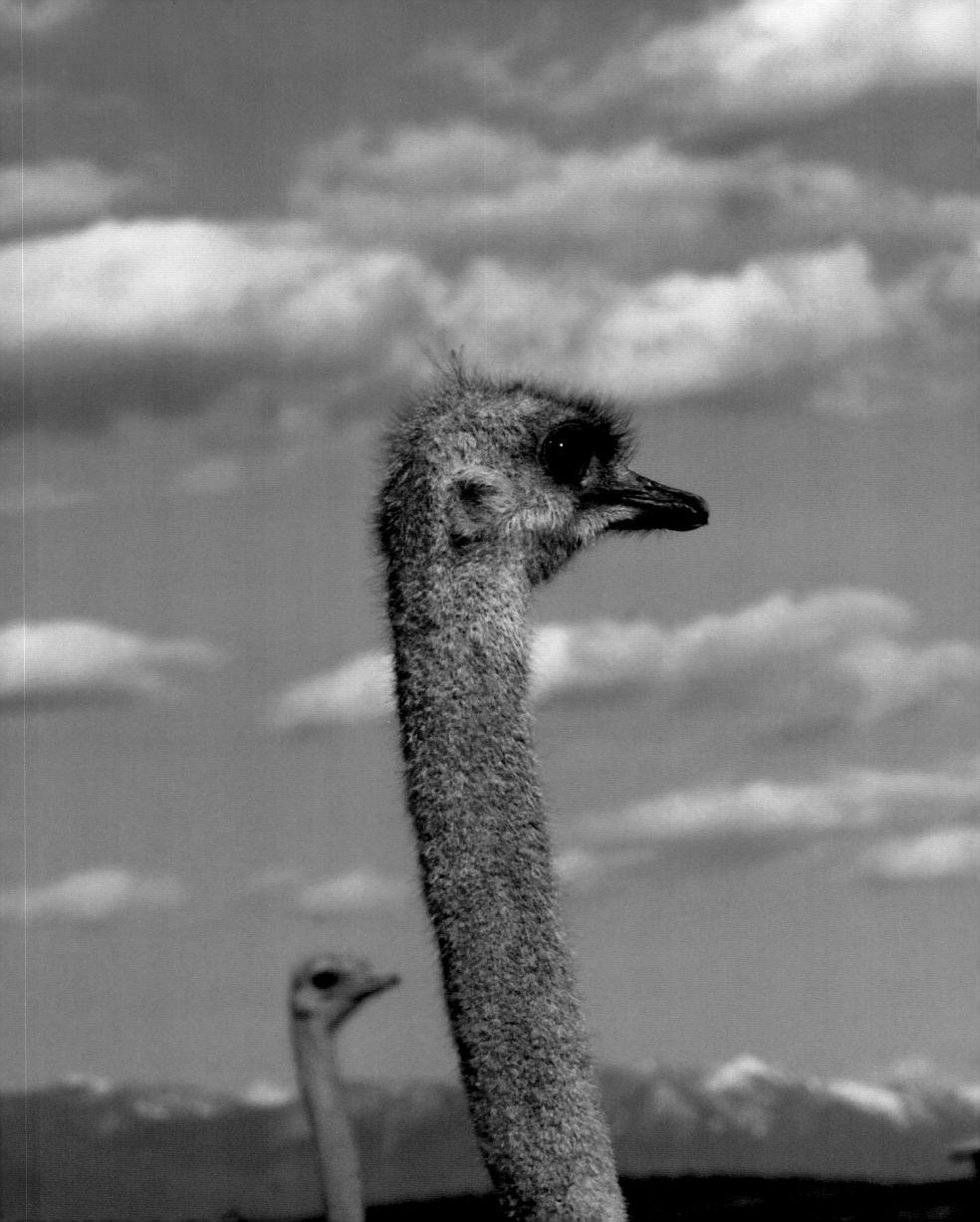

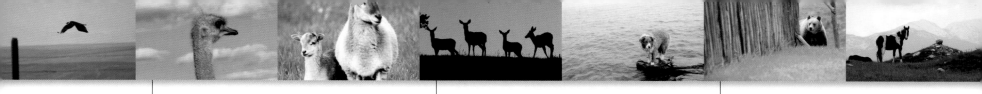

WHITEFISH

Since the ostrich meat craze died out in America in the late 90s, Caroline and Harold Krause sell fertilized eggs from their 11 hens for $25 each to Canadian clients, who hatch, raise, and slaughter the birds for sale to French distributors.
Photo by Jennifer DeMonte

HARLOWTON

A wet Montana spring means lush forage for the mule deer. Tourists, who come to see the wildlife, contribute $207 million annually to the state economy. Hunters spend an additional $189 million, not including license fees and equipment purchases.
Photo by Keith Graham,
University of Montana

POLEBRIDGE

Grizzly bears, listed as threatened under the Endangered Species Act, usually keep to themselves. If they become "food conditioned" by humans, they are considered dangerous and may be killed. Karen Nichols left this subject, ambling though an old homestead just west of Glacier National Park, in peace after taking this shot—from her car.
Photo by Karen Nichols

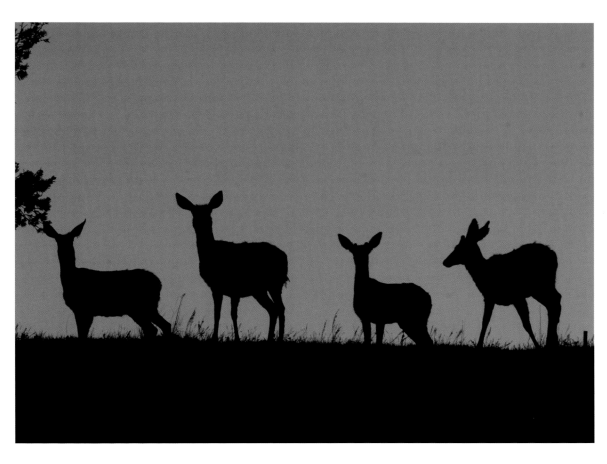

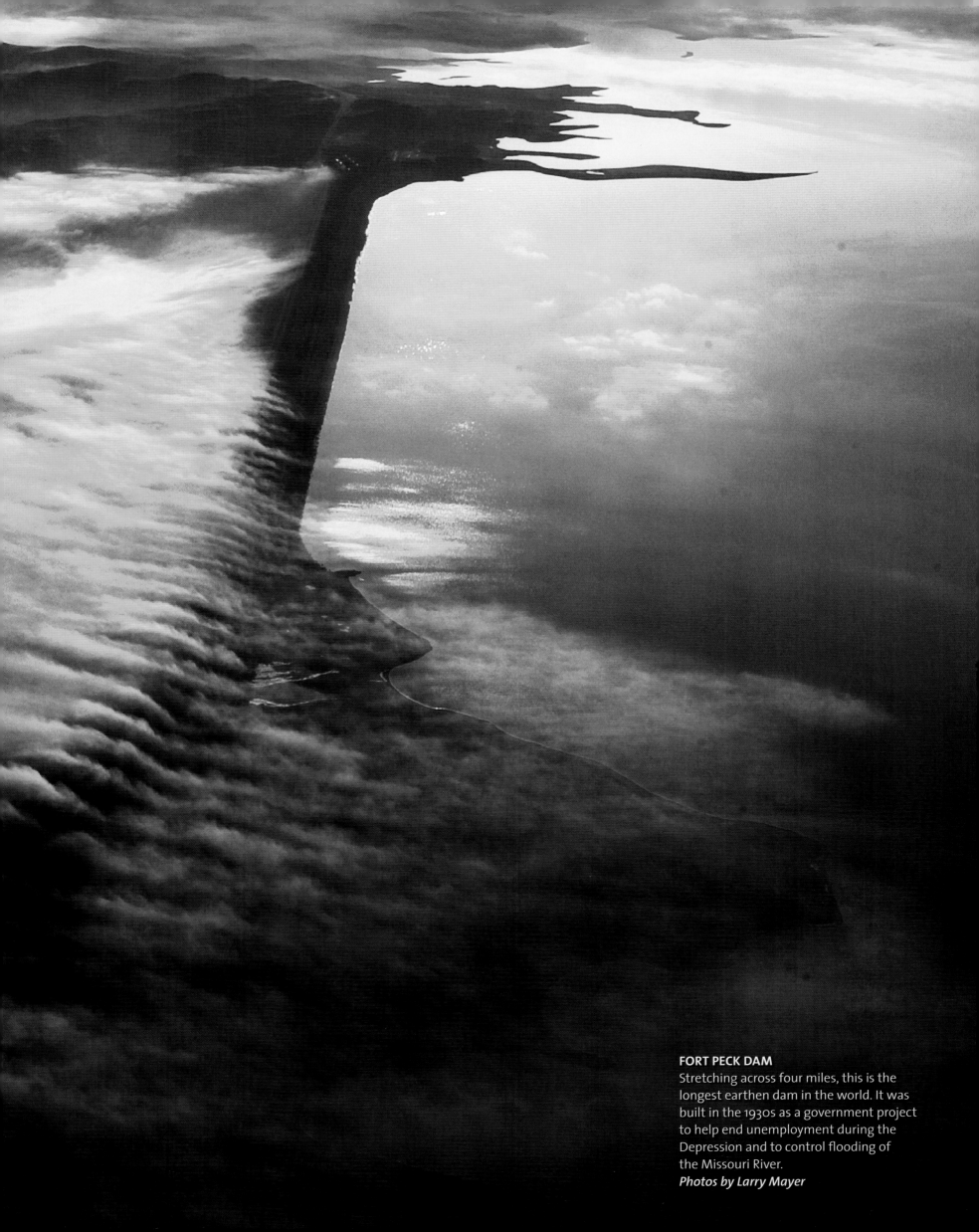

FORT PECK DAM
Stretching across four miles, this is the
longest earthen dam in the world. It was
built in the 1930s as a government project
to help end unemployment during the
Depression and to control flooding of
the Missouri River.
Photos by Larry Mayer

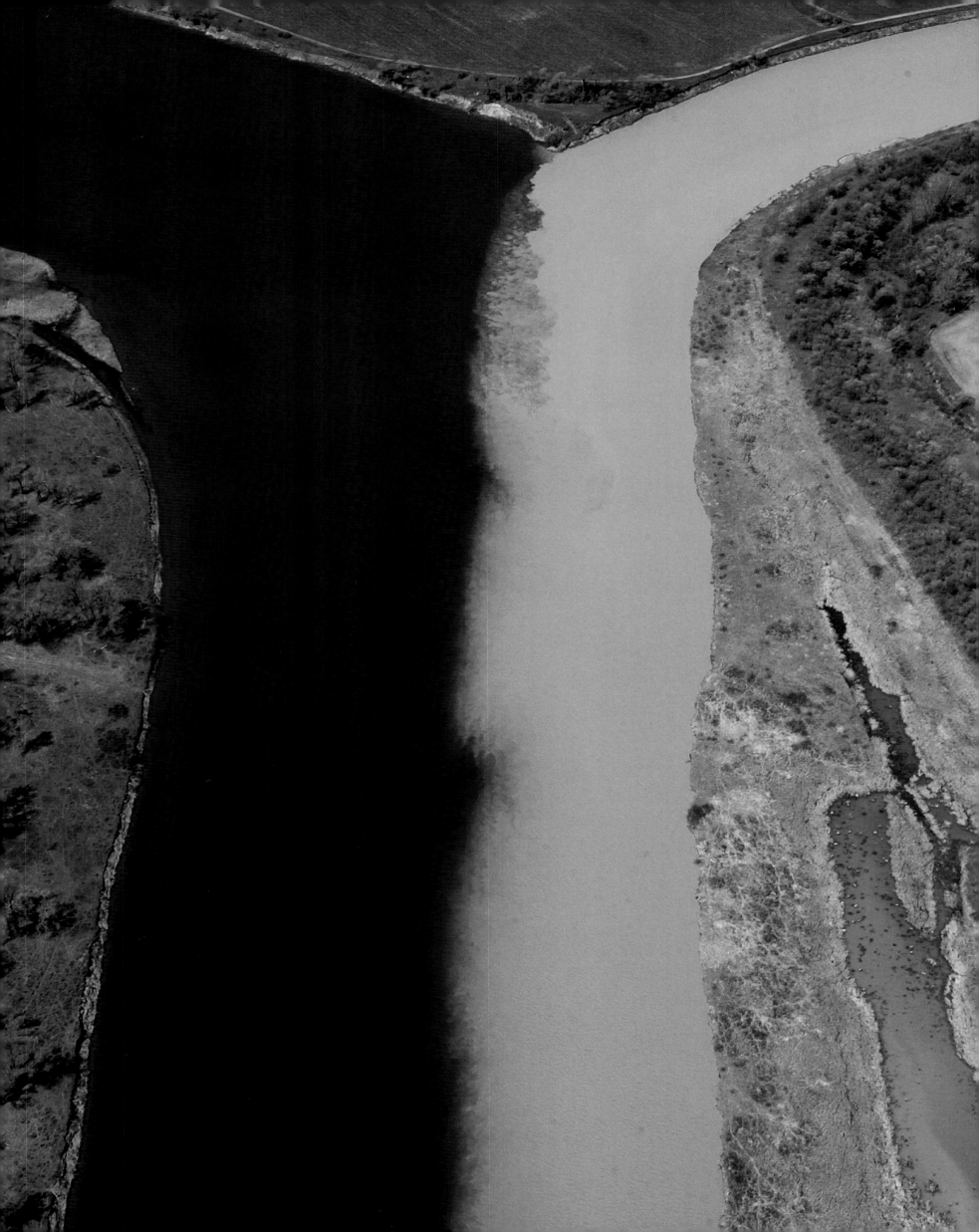

SOUTH OF NASHUA

Pouring in from the left are the clear bottom waters of the Missouri River, released from Fort Peck Reservoir, and from the right, the slow and murky waters of the Milk River. The striking confluence lasts for several miles, until the waters meld completely.

Photos by Larry Mayer

SOUTH OF GLASGOW

"The water of this river possesses a peculiar whiteness, being about the color of a cup of tea with the admixture of a teaspoonful of milk. From the colour of its water we called it the Milk River." Meriwether Lewis, writing in his journal on May 8, 1805, thus named this river in northeast Montana.

SOUTH OF ZORTMAN

As the implacable Missouri River flows east toward the dam, through the million-acre Charles M. Russell National Wildlife Refuge, it narrows and deposits silt. Slowly the river itself is demolishing the reservoir.

GREAT FALLS
An ocean of wheat covers the plains of the 3,800-square-mile "Golden Triangle," north of Great Falls. Although it's still the state's leading agricultural export, the wheat crop has suffered in recent years from a four-year drought.
Photo by John W. Liston, Great Falls Tribune

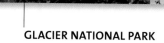

GLACIER NATIONAL PARK

Named for its three-petal, three-leaf formation, the trillium is one of the early spring bloomers at Glacier National Park. As the flower ages, its snow-white petals turn a soft pink. In recent years, its essence has been marketed as a balancing agent for those with overly romantic, intellectual, or escapist tendencies.

Photo by Jennifer DeMonte

MOIESE

Arrowleaf balsamroot thrives on the dry, rocky hillsides of Montana. Native people used all parts of the plant for food, from steaming the leaves and roasting the roots to pounding the sunflower-like seeds to make flour.

Photo by Kurt Wilson

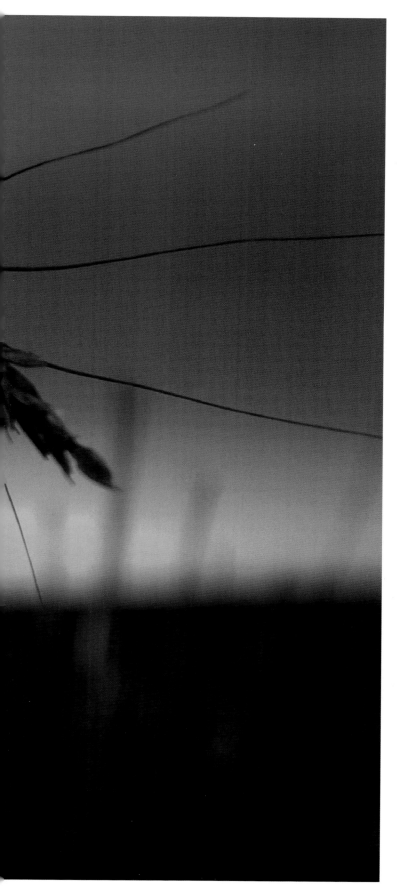

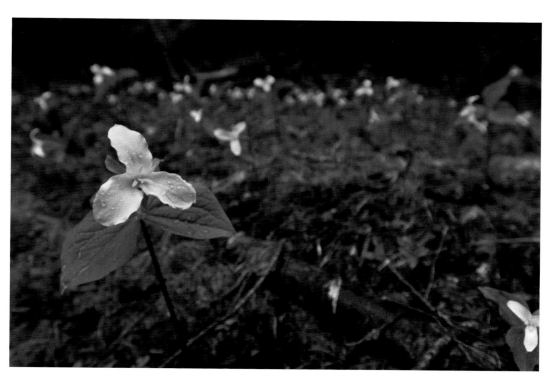

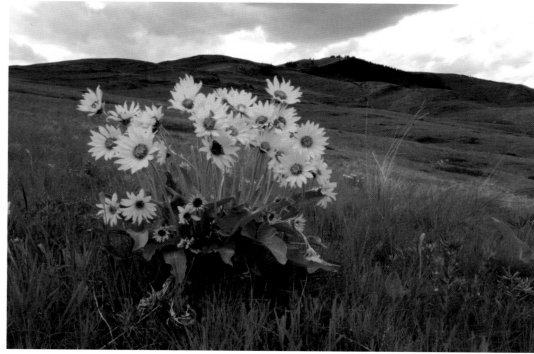

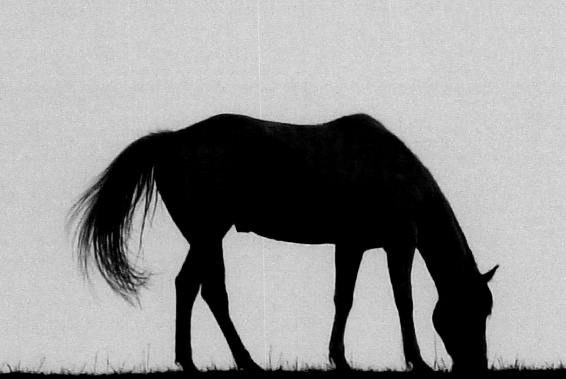

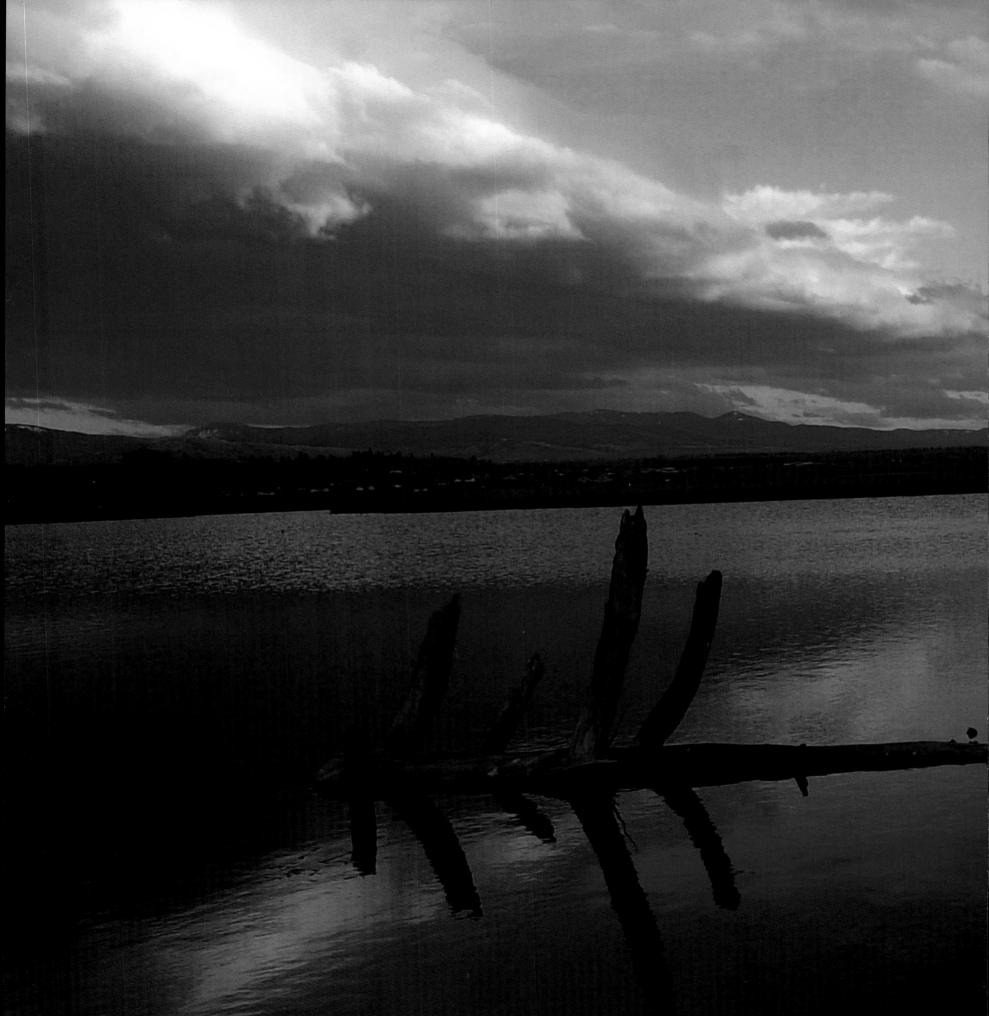

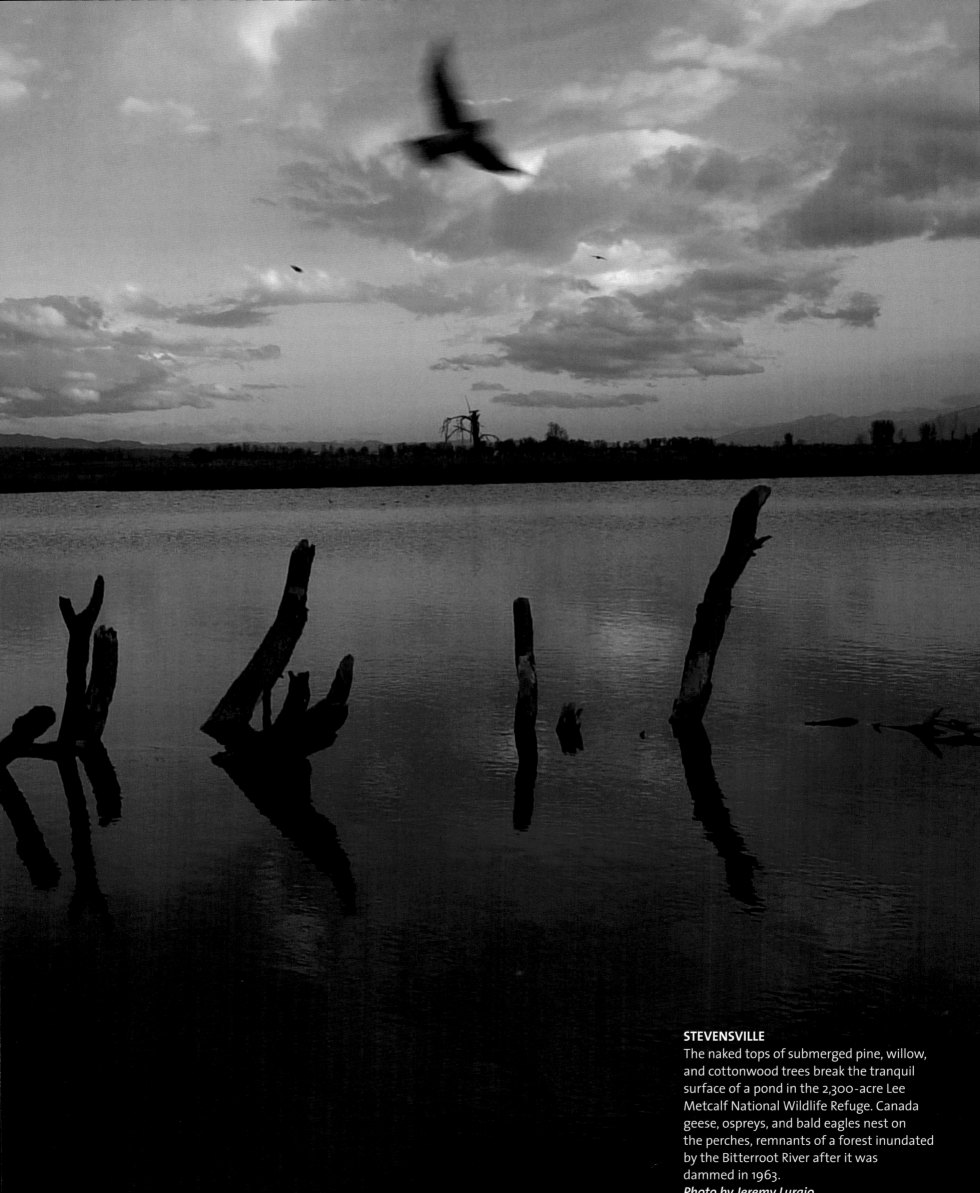

STEVENSVILLE

The naked tops of submerged pine, willow, and cottonwood trees break the tranquil surface of a pond in the 2,300-acre Lee Metcalf National Wildlife Refuge. Canada geese, ospreys, and bald eagles nest on the perches, remnants of a forest inundated by the Bitterroot River after it was dammed in 1963.

Photo by Jeremy Lurgio

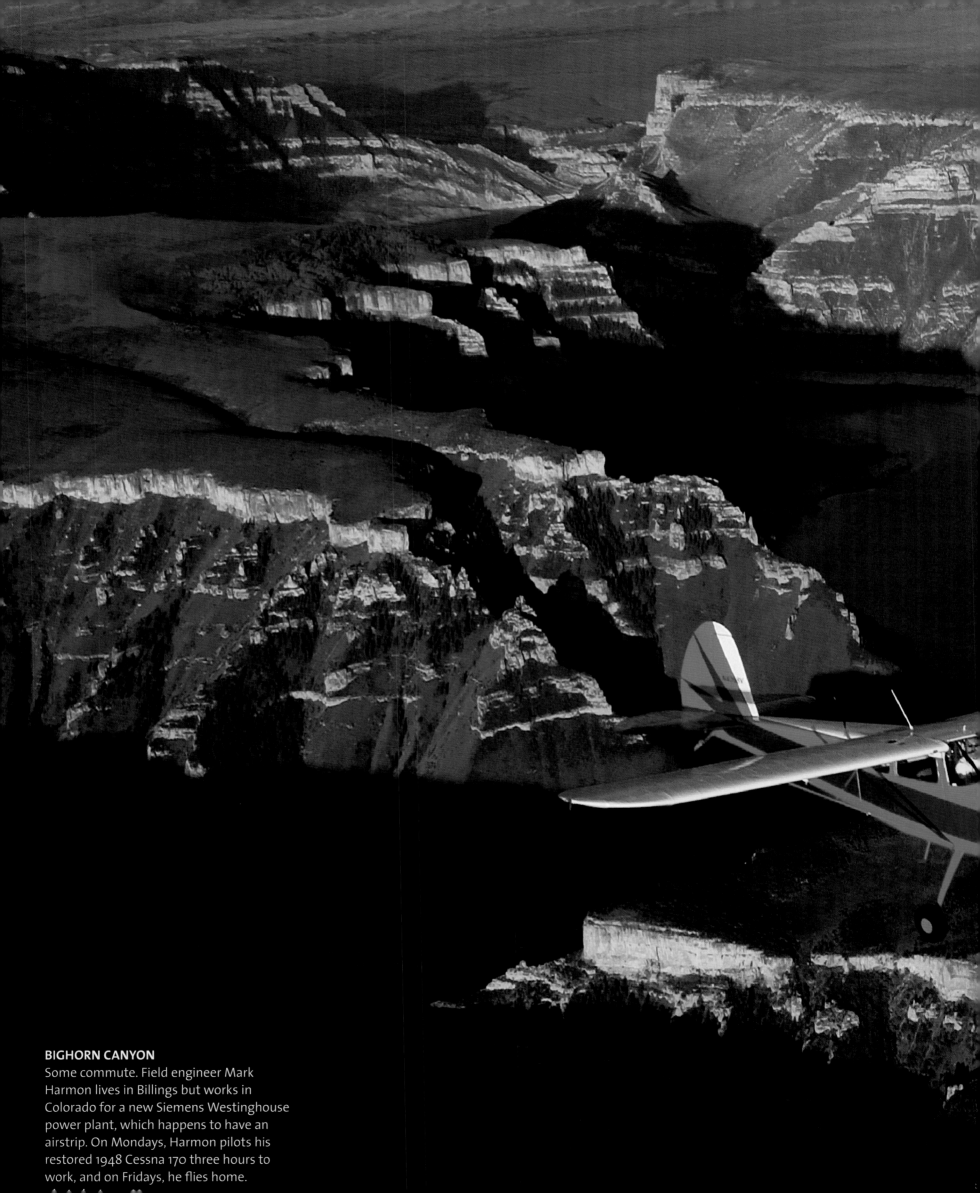

BIGHORN CANYON
Some commute. Field engineer Mark Harmon lives in Billings but works in Colorado for a new Siemens Westinghouse power plant, which happens to have an airstrip. On Mondays, Harmon pilots his restored 1948 Cessna 170 three hours to work, and on Fridays, he flies home.

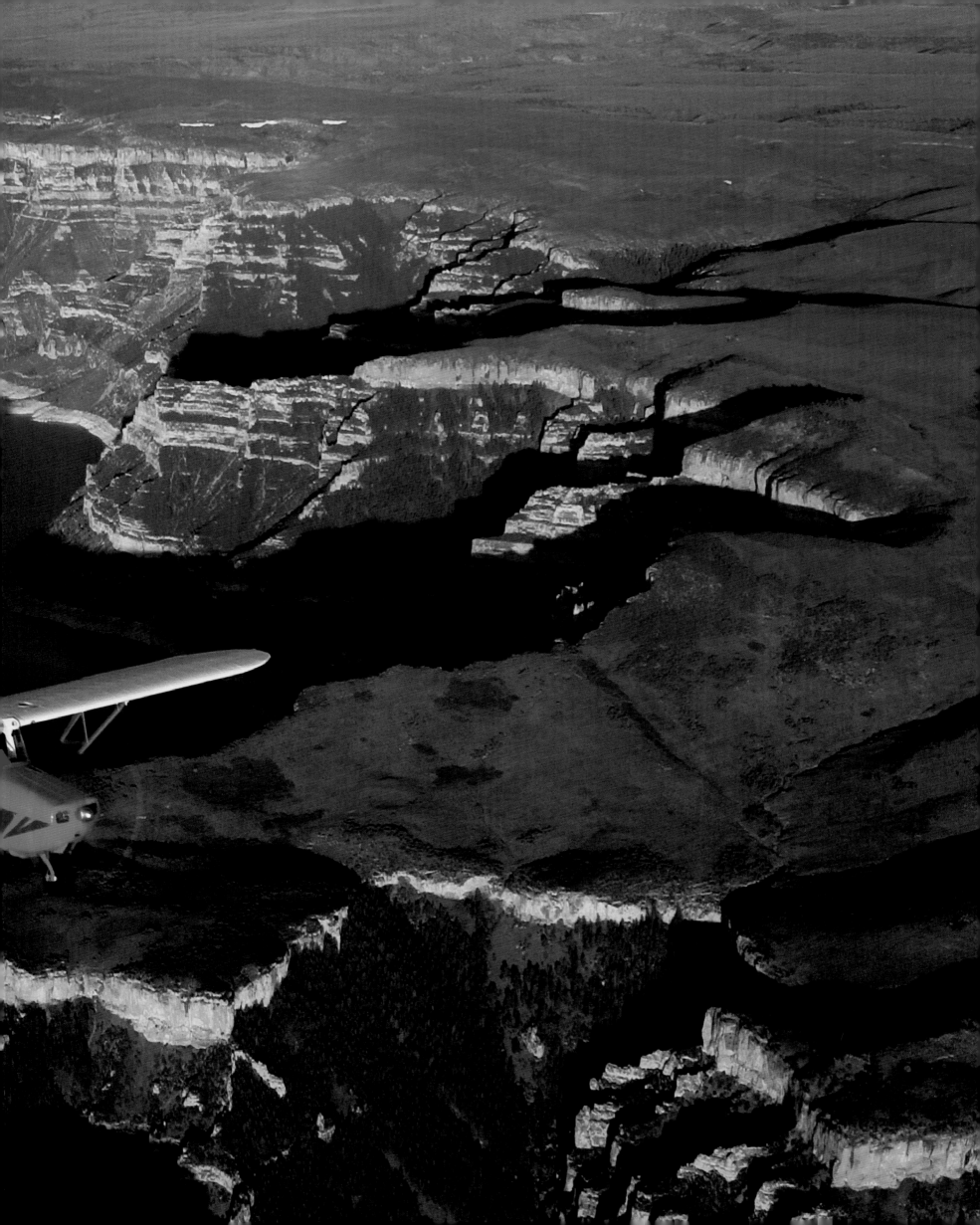

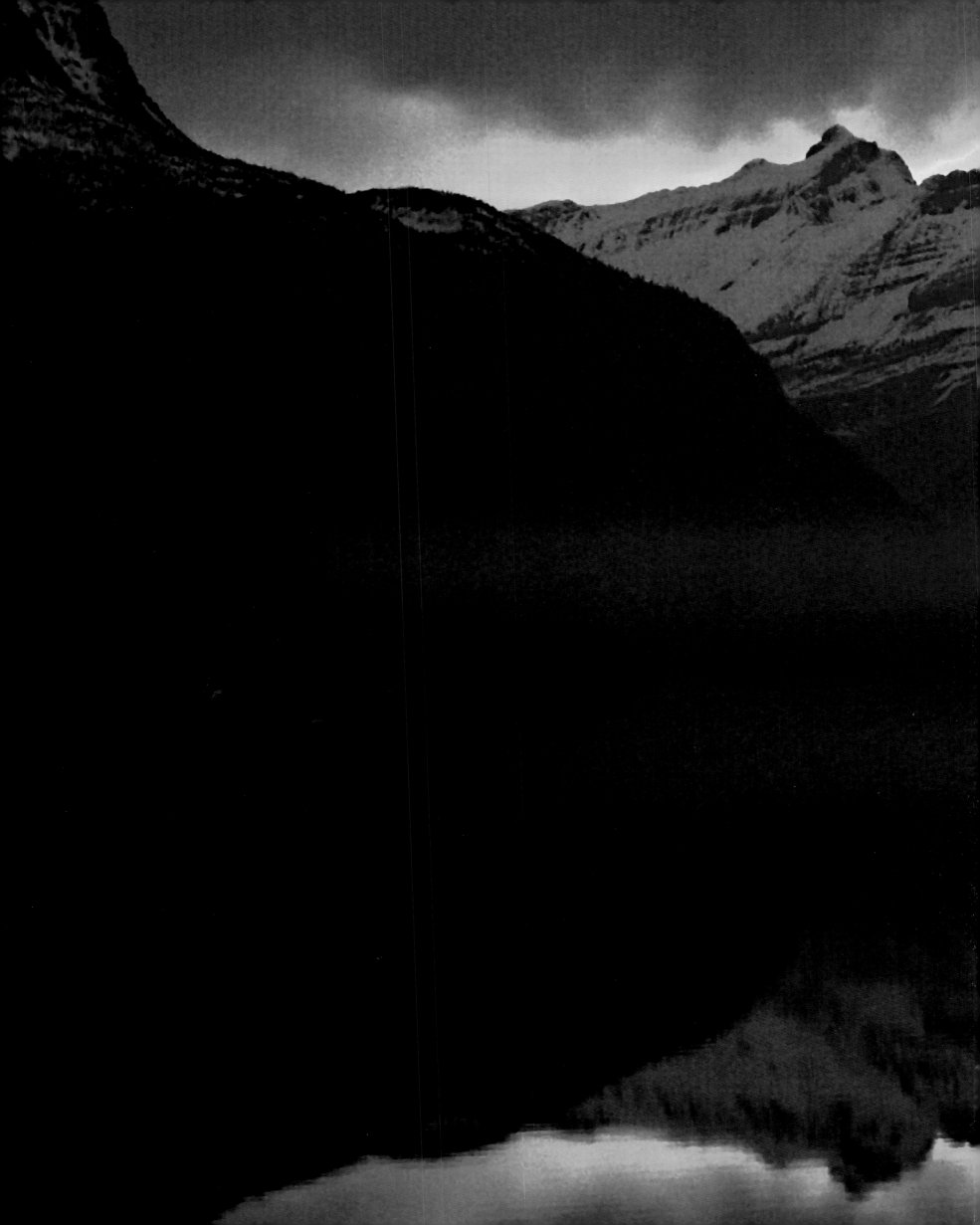

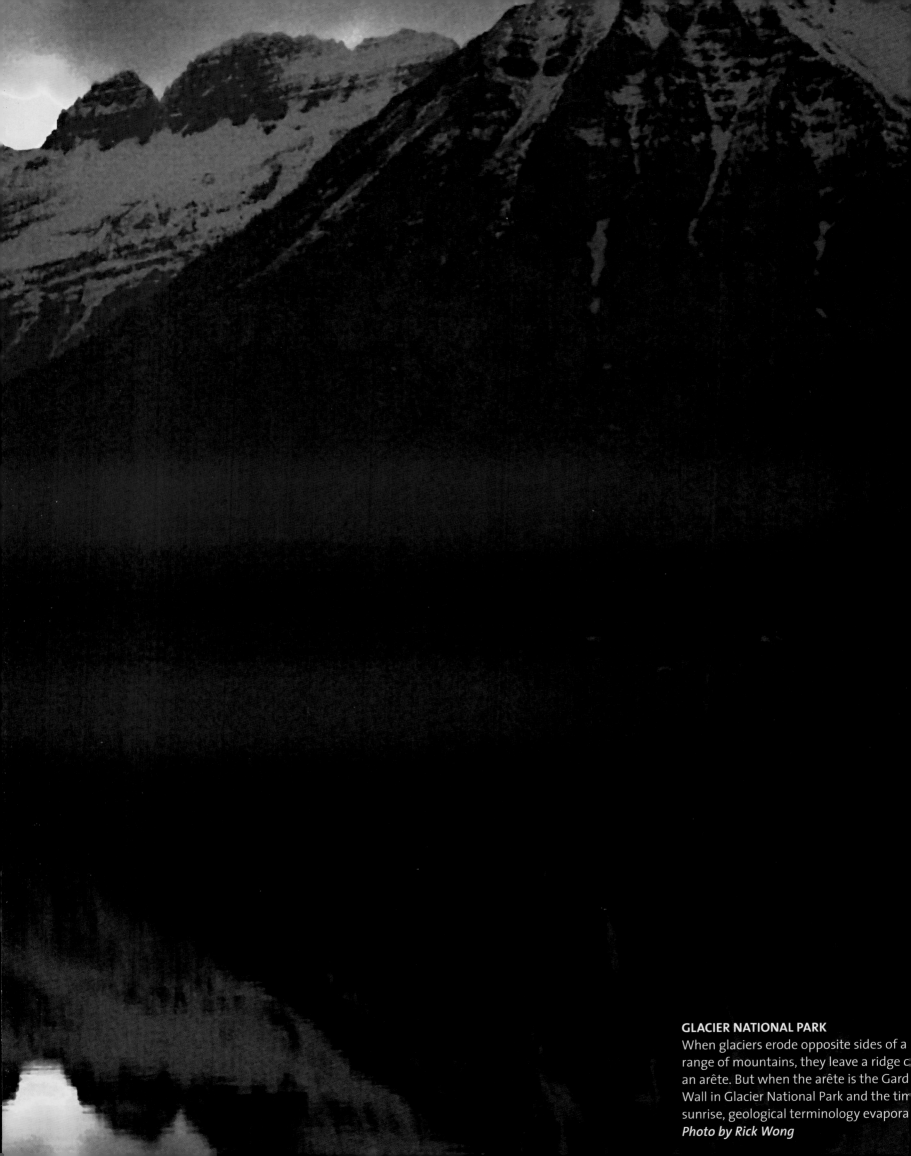

GLACIER NATIONAL PARK
When glaciers erode opposite sides of a
range of mountains, they leave a ridge c
an arête. But when the arête is the Gard
Wall in Glacier National Park and the tim
sunrise, geological terminology evapora
Photo by Rick Wong

ne week of May 12-18, 2003, more than 25,000

professional and amateur photographers spread out

oss the nation to shoot over a million digital photographs

h the goal of capturing the essence of daily life in America.

The professional photographers were equipped with

be Photoshop and Adobe Album software, Olympus

050 digital cameras, and Lexar Media's high-speed

npact flash cards.

The 1,000 professional contract photographers plus

ther 5,000 stringers and students sent their images via

(file transfer protocol) directly to the *America 24/7*

site. Meanwhile, thousands of amateur photographers

paded their images to Snapfish's servers.

At *America 24/7*'s Mission Control headquarters, located

NET in San Francisco, dozens of picture editors from the

on's most prestigious publications culled the images

n to 25,000 of the very best, using Photo Mechanic by

nera Bits. These photos were transferred into Webware's

veMedia Digital Asset Management (DAM) system,

th served as a central image library and enabled the

gners to track, search, distribute, and reformat the images

the creation of the 51 books, foreign language editions,

and magazine syndication, posters, and exhibitions.

Once in the DAM, images were optimized (and in some

s resampled to increase image resolution) using Adobe

toshop. Adobe InDesign and Adobe InCopy were used to

gn and produce the 51 books, which were edited and

ewed in multiple locations around the world in the form

dobe Acrobat PDFs. Epson Stylus printers were used for

to proofing and to produce large-format images for

bitions. The companies providing support for the

rica 24/7 project offer many of the essential components

nyone building a digital darkroom. We encourage you to

SHOOT

7 images maximum uploaded to online Snapfish accounts → **Snapfish** servers

10s of 1,000s of amateurs

1,000 professionals with **Olympus** C-5050 cameras and **Lexar Media** compact flash cards

Photographers use **Adobe Photoshop** to convert RAW images to JPEG, and Photo Mechanic tagging software to add data

1,000s of stringers & students

Toolkit, registration info & password via email to photographers' laptops

Printer ← **InDesign** layouts output via **Acrobat** to PDF format

5 graphic design and production teams

51 books: one national, 50 states

Produced by 24/7 Media, published by DK Publishing

50 state posters designed by 50 AIGA member firms

24/7

DESIGN & PUBLISH

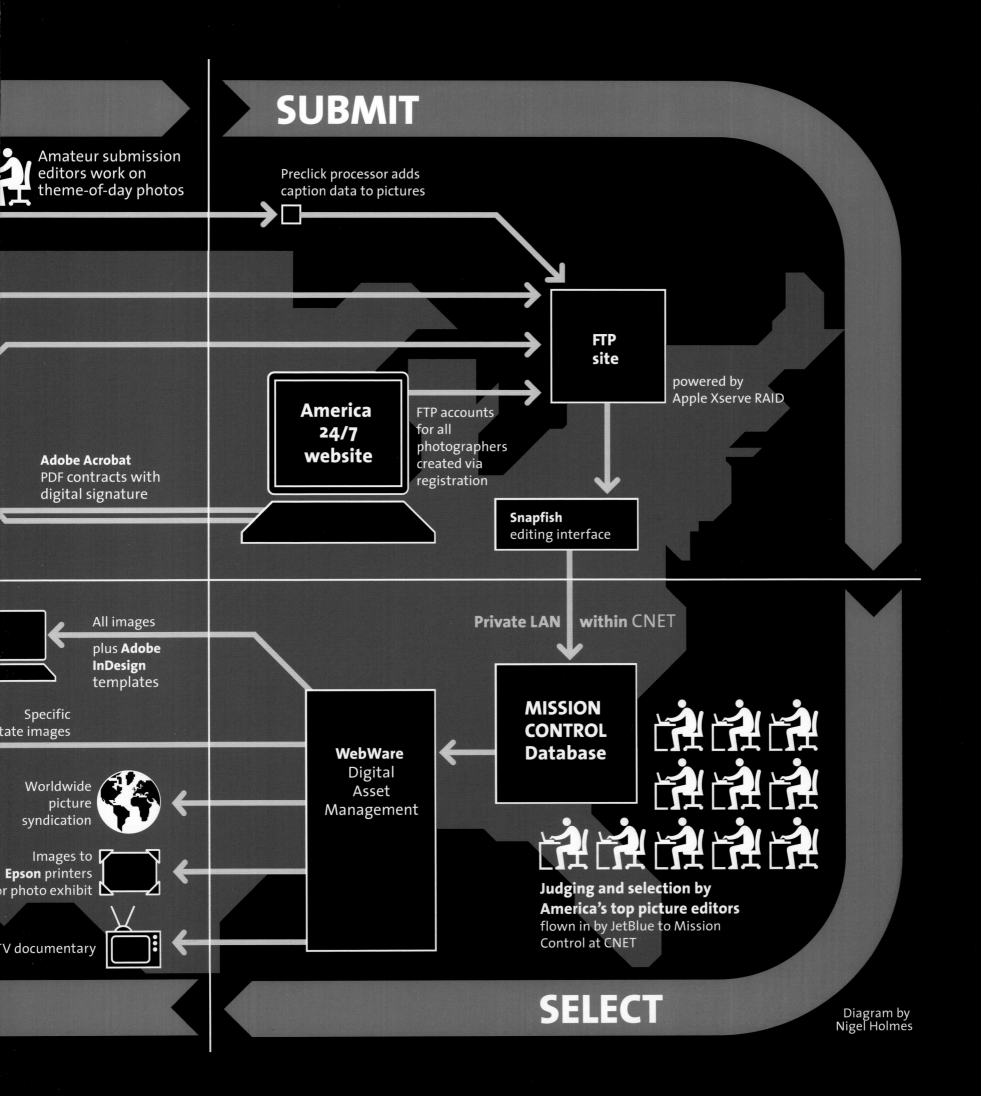

SUBMIT

Amateur submission editors work on theme-of-day photos

Preclick processor adds caption data to pictures

FTP site

powered by Apple Xserve RAID

America 24/7 website

FTP accounts for all photographers created via registration

Adobe Acrobat
PDF contracts with digital signature

Snapfish
editing interface

All images

plus **Adobe InDesign** templates

Private LAN within CNET

Specific
tate images

WebWare
Digital
Asset
Management

MISSION CONTROL Database

Worldwide picture syndication

Images to **Epson** printers or photo exhibit

Judging and selection by America's top picture editors flown in by JetBlue to Mission Control at CNET

V documentary

SELECT

Diagram by Nigel Holmes

About Our Sponsors

America 24/7 gave digital photographers of all levels the opportunity to share their visions of what it means to live in the United States. This project was made possible by a digital photography revolution that is dramatically changing and improving picture-taking for professionals and amateurs alike. And an Adobe product, Photoshop®, has been at the center of this sea change.

Adobe's products reflect our customers' passion for the creative process, be it the photographer, graphic designer, layout artist, or printer. Adobe is the Publishing and Imaging Software Partner for *America 24/7* and products such as Adobe InDesign®, Photoshop, Acrobat®, and Illustrator® were used to produce this stunning book in a matter of weeks. We hope that our software has helped do justice to the mythic images, contributed by well-known photographers and the inspired hobbyist.

Adobe is proud to be a lead sponsor of *America 24/7*, a project that celebrates the vibrancy of the American spirit: the same spirit that helped found Adobe and inspires our employees and customers to deliver the very best.

Bruce Chizen
President and CEO
Adobe Systems Incorporated

Olympus, a global technology leader in designing precision healthcare solutions and innovative consumer electronics, is proud to be the official digital camera sponsor of *America 24/7*. The opportunity to introduce Americans from coast to coast to the thrill, excitement, and possibility of digital photography makes the vision behind this book a perfect fit for Olympus, a leader in digital cameras since 1996.

For most people, the essence of digital photography is best grasped through firsthand experience with the technology, which is precisely what *America 24/7* is about. We understand that direct experience is the pathway to inspiration, and welcome opportunities like this sponsorship to bring the power of the digital experience into the lives of people everywhere. To Olympus, *America 24/7* offers a platform to help realize a core mission: to deliver and make accessible the power of the digital experience to millions of American photographers, amateurs, and professionals alike.

The 1,000 professional photographers contracted to shoot on the America 24/7 project were all equipped with Olympus C-5050 digital cameras. Like all Olympus products, the C-5050 is offered by a company well known for designing, manufacturing, and servicing products used by professionals to perform their work, every day. Olympus is a customer-centric company committed to working one-

to-one with a diverse group of professionals. From biomedical researchers who use our clinical microscopes, to doctors who perform life-saving procedures with our endo-scopes, to professional photographers who use cameras in their daily work, Olympus is a trusted brand.

The digital imaging technology involved with *America 24/7* has enabled the soul of America to be visually conveyed, not just by professional observers, but by the American public who participated in this project—the very people who collectively breath life into this country's existence each day.

We are proud to be enabling so many photographers to capture the pictures on these pages that tell the story of who we are as a nation. From sea to shining sea, digital imagery allows us to connect to one another in ways we never dreamed possible.

At Olympus, our ideas have proliferated as rapidly as technology has evolved. We have channeled these visions into breakthrough products and solutions to meet the demands of our changing world-products like microscopes, endoscopes, and digital voice recorders, supported by the highly regarded training, educational, and consulting services we offer our customers.

Today, 83 years after we introduced our first microscope, we remain as young, as curious, and as committed as ever.

Lexar Media has grown from the digital photography revolution, which is why we are proud to have supplied the digital memory cards used in the America 24/7 project. Lexar Media's high-performance memory cards utilize our unique and patented controller coupled with high-speed flash memory from Samsung, the world's largest flash memory supplier. This powerful combination brings out the ultimate performance of any digital camera.

Photographers who demand the most from their equipment choose our products for their advanced features like write speeds up to 40X, Write Acceleration technology for enabled cameras, and Image Rescue, which recovers previously deleted or lost images. Leading camera manu-facturers bundle Lexar Media digital memory cards with their cameras because they value its performance and reliability.

Lexar Media is at the forefront of digital photography as it transforms picture-taking worldwide, and we will continue to be a leader with new and innovative solutions for profes-sionals and amateurs alike.

Snapfish, which developed the technology behind the *America 24/7* amateur photo event, is a leading online photo service, with more than 5 million members and 100 million photos posted online. Snapfish enables both film and digital camera owners to share, print, and store their most important photo memories, at prices that cannot be equaled. Digital camera users upload photos into a password-protected online album for free. Users can also order film-quality prints on professional photographic paper for as low as 25¢. Film camera users get a full set of prints, plus online sharing and storage, for just $2.99 per roll.

Founded in 1995, eBay created a powerful platform for the sale of goods and services by a passionate community of individuals and businesses. On any given day, there are millions of items across thousands of categories for sale on eBay. eBay enables trade on a local, national and international basis with customized sites in markets around the world.

Through an array of services, such as its payment solution provider PayPal, eBay is enabling global e-commerce for an ever-growing online community.

JetBlue Airways is proud to be *America 24/7*'s preferred carrier, flying photographers, photo editors, and organizers across the United States.

Winner of Condé Nast Traveler's Readers' Choice Awards for Best Domestic Airline 2002, JetBlue provides friendly service and low fares for travelers in 22 cities in nine states across America.

On behalf of JetBlue's 5,000 crew members, we're excited to be involved in this remarkable project, and for the opportunity to serve American travelers each and every day, coast to coast, 24/7.

Digital Pond has been a leading creator of large graphic displays for museums, corporations, trade shows, retail environments and fine art since 1992.

We were proud to bring together our creative, print and display capabilities to produce signage and displays for mission control, critical retouching for numerous key images for the book, and art galleries for the New York Public Library and Bryant Park.

The Pond's team and SplashPic® Online service enabled us to nimbly design, produce and install over 200 large graphic panels in two NYC locations within the truly "24/7" production schedule of less than ten days.

WebWare Corporation is pleased to be a major sponsor of the America 24/7 project. We take pride in being part of a groundbreaking adventure that is stretching the boundaries—and the imagination—in digital photography, digital asset management, publishing, news, and global events.

Our ActiveMedia Enterprise™ digital asset management software is the "nerve center" of *America 24/7*, the central repository for managing, sharing, and collaborating on the project's photographs. From photo editors and book publishers to 24/7's media relations and marketing personnel, ActiveMedia provides the application support that links all facets of the project team to the content worldwide.

WebWare helps Global 2000 firms securely manage, reuse, and distribute media assets locally or globally. Its suite of ActiveMedia software products provide powerful media services platforms for integrating rich media into content management systems marketing and communication portals; web publishing systems; and e-commerce portals.

Google™

Google's mission is to organize the world's information and make it universally accessible and useful.

With our focus on plucking just the right answer from an ocean of data, we were naturally drawn to the America 24/7 project. The book you hold is a compendium of images of American life distilled from thousands of photographs and infinite possibilities. Are you looking for emotion? Narrative? Shadows? Light? It's all here, thanks to a multitude of photographers and writers creating links between you, the reader, and a sea of wonderful stories. We celebrate the connections that constitute the human experience and are pleased to help engender them. And we're pleased to have been a small part of this project, which captures the results of that interaction so vividly, so dynamically, and so dramatically.

Special thanks to additional contributors: FileMaker, Apple, Camera Bits, LaCie, Now Software, Preclick, Outpost Digital, Xerox, Microsoft, WoodWing Software, net-linx Publishing Solutions, and Radical Media. The Savoy Hotel, San Francisco; The Pan Pacific, San Francisco; Four Seasons Hotel, San Francisco; and The Queen Anne Hotel. Photography editing facilities were generously hosted by CNET Networks, Inc.

Participating Photographers

Coordinator: Keith Graham, Professor, University of Montana

Daniel Armstrong, New Rider Print
Tom Baker, University of Montana
Cynthia Baldauf
Tom Bauer
William Campbell
Mary Campbell
Michael Coles
Dudley Dana, Dana Gallery
Jennifer DeMonte
Keith Graham, University of Montana
David Grubbs
Alyssa Hurst
Ronnie James
Kenneth Jarecke, Contact Press Images
Todd Korol
John W. Liston, *Great Falls Tribune*
Doug Loneman, Loneman Photography
Robin Loznak

Jeremy Lurgio
Larry Mayer
JoAn Mayes
Kathy Muskopf
Karen Nichols
Erik Petersen
Elizabeth Powers
Derek Pruitt, *The Montana Standard*
Karen Simonsen
Steven G. Smith*
Teresa L. Tamura, University of Montana
Rob Tweedy
John Warner, *Billings Gazette*
Kurt Wilson
Nick Wolcott
Rick Wong

*Pulitzer Prize winner

Thumbnail Picture Credits

Credits for thumbnail photographs are listed by the page number and are in order from left to right.

20 Jeremy Lurgio
Keith Graham, University of Montana
Kate Medley
Jennifer DeMonte
Kenneth Jarecke, Contact Press Images
Jeremy Lurgio
Jeremy Lurgio

21 Kurt Wilson
Kurt Wilson
Kenneth Jarecke, Contact Press Images
Kenneth Jarecke, Contact Press Images
Derek Pruitt, *The Montana Standard*
Kenneth Jarecke, Contact Press Images
Karen Nichols

24 William Campbell
Cynthia Baldauf
Cynthia Baldauf
Cynthia Baldauf
Cynthia Baldauf
William Campbell
Cynthia Baldauf

25 Jeremy Lurgio
Cynthia Baldauf
William Campbell
William Campbell
Cynthia Baldauf
Cynthia Baldauf
William Campbell

26 Doug Loneman, Loneman Photography
Doug Loneman, Loneman Photography
Jeremy Lurgio
Doug Loneman, Loneman Photography
Derek Pruitt, *The Montana Standard*
Derek Pruitt, *The Montana Standard*
Jeremy Lurgio

27 Teresa L. Tamura, University of Montana
Doug Loneman, Loneman Photography
Steven G. Smith
Robin Loznak
Teresa L. Tamura, University of Montana
Jeremy Lurgio
Doug Loneman, Loneman Photography

28 Jennifer DeMonte
Jennifer DeMonte

Jennifer DeMonte
Jennifer DeMonte
Jennifer DeMonte
Jennifer DeMonte
Jennifer DeMonte

29 Mery Davis Donald
Jennifer DeMonte
Teresa L. Tamura, University of Montana
Karen Nichols
Jennifer DeMonte
Teresa L. Tamura, University of Montana
Jennifer DeMonte

32 Kenneth Jarecke, Contact Press Images
Doug Loneman, Loneman Photography
Jeremy Lurgio
Jeremy Lurgio
Doug Loneman, Loneman Photography
Jeremy Lurgio
Jeremy Lurgio

33 Jeremy Lurgio
Teresa L. Tamura, University of Montana
Kenneth Jarecke, Contact Press Images
Jennifer DeMonte
Jeremy Lurgio
Jeremy Lurgio
Doug Loneman, Loneman Photography

34 Keith Graham, University of Montana
Jennifer DeMonte
Kenneth Jarecke, Contact Press Images
Jennifer DeMonte
Cynthia Baldauf
Keith Graham, University of Montana
Cynthia Baldauf

35 Kenneth Jarecke, Contact Press Images
Teresa L. Tamura, University of Montana
Kenneth Jarecke, Contact Press Images
Steven G. Smith
Kenneth Jarecke, Contact Press Images
Cynthia Baldauf
Teresa L. Tamura, University of Montana

44 Michael Coles
Derek Pruitt, *The Montana Standard*
Michael Coles
Derek Pruitt, University of Montana

Keith Graham, University of Montana
Derek Pruitt, *The Montana Standard*
Teresa L. Tamura, University of Montana

45 Erik Petersen
Derek Pruitt, *The Montana Standard*
Michael Coles
Keith Graham, University of Montana
Derek Pruitt, *The Montana Standard*
Erik Petersen
Michael Coles

46 Annie P. Warren, University of Montana
Teresa L. Tamura, University of Montana
Teresa L. Tamura, University of Montana
Doug Loneman, Loneman Photography
Teresa L. Tamura, University of Montana
Teresa L. Tamura, University of Montana
Teresa L. Tamura, University of Montana

47 Teresa L. Tamura, University of Montana
Teresa L. Tamura, University of Montana
Teresa L. Tamura, University of Montana
Teresa L. Tamura, University of Montana
Doug Loneman, Loneman Photography
Teresa L. Tamura, University of Montana
Tom Baker, University of Montana

48 Cynthia Baldauf
Todd Korol
Derek Pruitt, *The Montana Standard*
Erik Petersen
Derek Pruitt, *The Montana Standard*
Derek Pruitt, *The Montana Standard*
Keith Graham, University of Montana

49 Erik Petersen
William Campbell
Dudley Dana, Dana Gallery
Todd Korol
Todd Korol
Todd Korol
Kurt Wilson

50 Doug Loneman, Loneman Photography
Erik Petersen
Erik Petersen
Keith Graham, University of Montana
Robin Loznak
Robin Loznak
Robin Loznak

51 Robin Loznak
David Grubbs
Teresa L. Tamura, University of Montana
Robin Loznak
Doug Loneman, Loneman Photography
Robin Loznak
Robin Loznak

53 Kurt Wilson
Kurt Wilson
Kurt Wilson
Kurt Wilson
Kurt Wilson
Kurt Wilson

54 Keith Graham, University of Montana
Keith Graham, University of Montana
Erik Petersen
Keith Graham, University of Montana
Erik Petersen
Keith Graham, University of Montana
Cynthia Baldauf

57 Derek Pruitt, *The Montana Standard*
Jeremy Lurgio
Annie P. Warren, University of Montana
Derek Pruitt, *The Montana Standard*
Jeremy Lurgio
Jeremy Lurgio
Annie P. Warren, University of Montana

60 Tom Bauer
Tom Bauer
Tom Bauer

Tom Bauer
Tom Bauer
Tom Bauer
Tom Bauer

61 Tom Bauer
Tom Bauer
Tom Bauer
Tom Bauer
Tom Bauer
Tom Bauer
Tom Bauer

64 Derek Pruitt, *The Montana Standard*
Jennifer DeMonte
John W. Liston, *Great Falls Tribune*
Derek Pruitt, *The Montana Standard*
Jennifer DeMonte
Doug Loneman, Loneman Photography
Keith Graham, University of Montana

65 Robin Loznak
Daniel Armstrong, New Rider Print
John W. Liston, *Great Falls Tribune*
Kurt Wilson
Doug Loneman, Loneman Photography
Mery Davis Donald
Jennifer DeMonte

66 Erik Petersen
Erik Petersen
Derek Pruitt, *The Montana Standard*
Keith Graham, University of Montana
Tom Bauer
Tom Bauer
Erik Petersen

67 Erik Petersen
Erik Petersen
Derek Pruitt, *The Montana Standard*
Keith Graham, University of Montana
Tom Bauer
Tom Bauer
Erik Petersen

72 Jennifer DeMonte
Jennifer DeMonte
Daniel Armstrong, New Rider Print
Jennifer DeMonte
Daniel Armstrong, New Rider Print
Jennifer DeMonte
Jennifer DeMonte

73 Daniel Armstrong, New Rider Print
Daniel Armstrong, New Rider Print
Jennifer DeMonte
Jennifer DeMonte
Daniel Armstrong, New Rider Print
Daniel Armstrong, New Rider Print
Jennifer DeMonte

75 Daniel Armstrong, New Rider Print
Derek Pruitt, *The Montana Standard*
Daniel Armstrong, New Rider Print
Derek Pruitt, *The Montana Standard*
Daniel Armstrong, New Rider Print
Derek Pruitt, *The Montana Standard*
Daniel Armstrong, New Rider Print

76 Keith Graham, University of Montana
Dudley Dana, Dana Gallery
Kurt Wilson
Kurt Wilson
Kurt Wilson
Dudley Dana, Dana Gallery
Teresa L. Tamura, University of Montana

77 Dudley Dana, Dana Gallery
Kurt Wilson
Kurt Wilson
Kurt Wilson
Robin Loznak
Kurt Wilson
Dudley Dana, Dana Gallery

78 Jeremy Lurgio
Daniel Armstrong, New Rider Print

Daniel Armstrong, New Rider Print
Daniel Armstrong, New Rider Print
Daniel Armstrong, New Rider Print
Jeremy Lurgio
Jeremy Lurgio

79 Jennifer DeMonte
Jennifer DeMonte
Daniel Armstrong, New Rider Print
Daniel Armstrong, New Rider Print
Jeremy Lurgio
Jennifer DeMonte
Jeremy Lurgio

80 Robin Loznak
Jeremy Lurgio
Daniel Armstrong, New Rider Print
Jeremy Lurgio
Nick Wolcott
Jeremy Lurgio
Jeremy Lurgio

82 David Grubbs
Erik Petersen
David Grubbs
David Grubbs
David Grubbs
Erik Petersen
David Grubbs

83 Michael Coles
David Grubbs
David Grubbs
Erik Petersen
David Grubbs
David Grubbs
David Grubbs

84 Kurt Wilson
Doug Loneman, Loneman Photography
Doug Loneman, Loneman Photography
Todd Korol
Doug Loneman, Loneman Photography
Derek Pruitt, *The Montana Standard*
Todd Korol

85 Todd Korol
Derek Pruitt, *The Montana Standard*
Todd Korol
Todd Korol
Derek Pruitt, *The Montana Standard*
Todd Korol
William Campbell

86 Doug Loneman, Loneman Photography
Dudley Dana, Dana Gallery
Doug Loneman, Loneman Photography
Doug Loneman, Loneman Photography
Keith Graham, University of Montana
Doug Loneman, Loneman Photography
Jeremy Lurgio

87 Jeremy Lurgio
Doug Loneman, Loneman Photography
Karen Nichols
Doug Loneman, Loneman Photography
Derek Pruitt, *The Montana Standard*
Dudley Dana, Dana Gallery
Kenneth Jarecke, Contact Press Images

88 Keith Graham, University of Montana
David Grubbs
Tom Bauer
Tom Baker, University of Montana
Mary Campbell
Robin Loznak
Robin Loznak

89 Robin Loznak
Tom Bauer
Robin Loznak
Robin Loznak
Mary Campbell
Robin Loznak
Rick Wong

90 Dudley Dana, Dana Gallery
Daniel Armstrong, New Rider Print
Daniel Armstrong, New Rider Print
Derek Pruitt, *The Montana Standard*
Daniel Armstrong, New Rider Print
Jeremy Lurgio
Daniel Armstrong, New Rider Print

91 Derek Pruitt, *The Montana Standard*
Derek Pruitt, *The Montana Standard*
Daniel Armstrong, New Rider Print
Jeremy Lurgio
Jeremy Lurgio
Daniel Armstrong, New Rider Print
Rick Wong

94 Cynthia Baldauf
Keith Graham, University of Montana
Jeremy Lurgio
Jeremy Lurgio
Keith Graham, University of Montana
Jeremy Lurgio
Keith Graham, University of Montana

95 Kurt Wilson
Kurt Wilson
Kurt Wilson
Robin Loznak
Jeremy Lurgio
Jennifer DeMonte

97 Dudley Dana, Dana Gallery
Jennifer DeMonte
John W. Liston, *Great Falls Tribune*
Tom Bauer
Jennifer DeMonte
Steven G. Smith
Teresa L. Tamura, University of Montana

103 Kurt Wilson
Kurt Wilson
Todd Korol
Kurt Wilson
Kurt Wilson
Kurt Wilson
Todd Korol

104 Kurt Wilson
Kurt Wilson
Kurt Wilson
Kurt Wilson
Kurt Wilson
Kurt Wilson

105 Kurt Wilson
Kurt Wilson
Kurt Wilson
Kurt Wilson
Kurt Wilson
Kurt Wilson
Kurt Wilson

106 Cynthia Baldauf
Robin Loznak
Annie P. Warren, University of Montana
Cynthia Baldauf
Robin Loznak
Annie P. Warren, University of Montana
Dudley Dana, Dana Gallery

107 Cynthia Baldauf
Robin Loznak
Annie P. Warren, University of Montana
Cynthia Baldauf
Robin Loznak
Dudley Dana, Dana Gallery
Annie P. Warren, University of Montana

108 Doug Loneman, Loneman Photography
Derek Pruitt, *The Montana Standard*
John W. Liston, *Great Falls Tribune*
Derek Pruitt, *The Montana Standard*

Mery Davis Donald
John W. Liston, *Great Falls Tribune*
Derek Pruitt, *The Montana Standard*

109 Mery Davis Donald
Derek Pruitt, *The Montana Standard*
John W. Liston, *Great Falls Tribune*
Derek Pruitt, *The Montana Standard*
Derek Pruitt, *The Montana Standard*
David Grubbs
John W. Liston, *Great Falls Tribune*

116 Keith Graham, University of Montana
John W. Liston, *Great Falls Tribune*
Doug Loneman, Loneman Photography
John W. Liston, *Great Falls Tribune*
Cynthia Baldauf
Erik Petersen
Keith Graham, University of Montana

117 Erik Petersen
Teresa L. Tamura, University of Montana
William Campbell
John W. Liston, *Great Falls Tribune*
Keith Graham, University of Montana
Doug Loneman, Loneman Photography
Kurt Wilson

118 Keith Graham, University of Montana
Robin Loznak
Teresa L. Tamura, University of Montana
Robin Loznak
William Campbell
Robin Loznak
Robin Loznak

120 Doug Loneman, Loneman Photography
Doug Loneman, Loneman Photography
Doug Loneman, Loneman Photography
Doug Loneman, Loneman Photography
Doug Loneman, Loneman Photography
Teresa L. Tamura, University of Montana
Karen Nichols

121 Doug Loneman, Loneman Photography
Kenneth Jarecke, Contact Press Images
Doug Loneman, Loneman Photography
Teresa L. Tamura, University of Montana
Kenneth Jarecke, Contact Press Images
Teresa L. Tamura, University of Montana
Doug Loneman, Loneman Photography

122 Doug Loneman, Loneman Photography
Doug Loneman, Loneman Photography
Kurt Wilson
Doug Loneman, Loneman Photography
Kurt Wilson
Kurt Wilson
Kurt Wilson

123 Kurt Wilson
Doug Loneman, Loneman Photography
Kurt Wilson
Kurt Wilson
Kurt Wilson
Kurt Wilson
Kurt Wilson

124 Robin Loznak
Keith Graham, University of Montana
David Grubbs
Kurt Wilson
David Grubbs
David Grubbs
Erik Petersen

125 Erik Petersen
Keith Graham, University of Montana
Kurt Wilson
Keith Graham, University of Montana
Keith Graham, University of Montana
Keith Graham, University of Montana
William Campbell

126 Todd Korol
Keith Graham, University of Montana
Cynthia Baldauf

Keith Graham, University of Montana
William Campbell
Keith Graham, University of Montana
Erik Petersen

127 Teresa L. Tamura, University of Montana
Erik Petersen
Cynthia Baldauf
Jeremy Lurgio
Keith Graham, University of Montana
Kurt Wilson
William Campbell

128 Annie P. Warren, University of Montana
Mery Davis Donald
Karen Nichols
David Grubbs
Jeremy Lurgio
Cynthia Baldauf
William Campbell

129 William Campbell
William Campbell
William Campbell
William Campbell
William Campbell
William Campbell
William Campbell

130 Robin Loznak
Jennifer DeMonte
Robin Loznak
Robin Loznak
Robin Loznak
Jennifer DeMonte
Erik Petersen

131 Robin Loznak
Robin Loznak
Robin Loznak
Erik Petersen
John W. Liston, *Great Falls Tribune*
Robin Loznak
Robin Loznak

133 David Grubbs
Steven G. Smith
David Grubbs
David Grubbs
David Grubbs
David Grubbs
David Grubbs

139 Doug Loneman, Loneman Photography
Jennifer DeMonte
Keith Graham, University of Montana
Keith Graham, University of Montana
Robin Loznak
Karen Nichols
Robin Loznak

143 Larry Mayer
Larry Mayer
Larry Mayer
Larry Mayer
Larry Mayer
Larry Mayer
Larry Mayer

144 Dudley Dana, Dana Gallery
Doug Loneman, Loneman Photography
Keith Graham, University of Montana
John W. Liston, *Great Falls Tribune*
John W. Liston, *Great Falls Tribune*
Kurt Wilson
John W. Liston, *Great Falls Tribune*

145 Kurt Wilson
Steven G. Smith
Kurt Wilson
Jennifer DeMonte
Robin Loznak
Kurt Wilson
Robin Loznak

Staff

The *America 24/7* series was imagined years ago by our friend Oscar Dystel, a publishing legend whose vision and enthusiasm have been a source of great inspiration.

We also wish to express our gratitude to our truly visionary publisher, DK.

Rick Smolan, Project Director
David Elliot Cohen, Project Director

Administrative
Katya Able, Operations Director
Gina Privitere, Communications Director
Chuck Gathard, Technology Director
Kim Shannon, Photographer Relations Director
Erin O'Connor, Photographer Relations Intern
Leslie Hunter, Partnership Director
Annie Polk, Publicity Manager
John McAlester, Website Manager
Alex Notides, Office Manager
C. Thomas Hardin, State Photography Coordinator

Design
Brad Zucroff, Creative Director
Karen Mullarkey, Photography Director
Judy Zimola, Production Manager
David Simoni, Production Designer
Mary Dias, Production Designer
Heidi Madison, Associate Picture Editor
Don McCartney, Production Designer
Diane Dempsey Murray, Production Designer
Jan Rogers, Associate Picture Editor
Bill Shore, Production Designer and Image Artist
Larry Nighswander, Senior Picture Editor
Bill Marr, Sarah Leen, Senior Picture Editors
Peter Truskier, Workflow Consultant
Jim Birkenseer, Workflow Consultant

Editorial
Maggie Canon, Managing Editor
Curt Sanburn, Senior Editor
Teresa L. Trego, Production Editor
Lea Aschkenas, Writer
Olivia Boler, Writer
Korey Capozza, Writer
Beverly Hanly, Writer
Bridgett Novak, Writer
Alison Owings, Writer
Fred Raker, Writer
Joe Wolff, Writer
Elise O'Keefe, Copy Chief
Daisy Hernández, Copy Editor
Jennifer Wolfe, Copy Editor

Infographic Design
Nigel Holmes

Literary Agent
Carol Mann, The Carol Mann Agency

Legal Counsel
Barry Reder, Coblentz, Patch, Duffy & Bass, LLP
Phil Feldman, Coblentz, Patch, Duffy & Bass, LLP
Gabe Perle, Ohlandt, Greeley, Ruggiero & Perle, LLP
Jon Hart, Dow, Lohnes & Albertson, PLLC
Mike Hays, Dow, Lohnes & Albertson, PLLC
Stephen Pollen, Warshaw Burstein, Cohen, Schlesinger & Kuh, LLP
Rick Pappas

Accounting and Finance
Rita Dulebohn, Accountant
Robert Powers, Calegari, Morris & Co. Accountants
Eugene Blumberg, Blumberg & Associates
Arthur Langhaus, KLS Professional Advisors Group, Inc.

Picture Editors
J. David Ake, Associated Press
Caren Alpert, formerly *Health* magazine
Simon Barnett, *Newsweek*
Caroline Couig, *San Jose Mercury News*
Mike Davis, formerly *National Geographic*
Michel duCille, *Washington Post*
Deborah Dragon, *Rolling Stone*
Victor Fisher, formerly Associated Press
Frank Folwell, *USA Today*
MaryAnne Golon, *Time*
Liz Grady, formerly *National Geographic*
Randall Greenwell, *San Francisco Chronicle*
C. Thomas Hardin, formerly *Louisville Courier-Journal*
Kathleen Hennessy, *San Francisco Chronicle*
Scot Jahn, *U.S. News & World Report*
Steve Jessmore, *Flint Journal*
John Kaplan, University of Florida
Kim Komenich, *San Francisco Chronicle*
Eliane Laffont, *Hachette Filipacchi Media*
Jean-Pierre Laffont, *Hachette Filipacchi Media*
Andrew Locke, MSNBC
Jose Lopez, *The New York Times*
Maria Mann, formerly AFP
Bill Marr, formerly *National Geographic*
Michele McNally, *Fortune*
James Merithew, *San Francisco Chronicle*
Eric Meskauskas, *New York Daily News*
Maddy Miller, *People* magazine
Michelle Molloy, *Newsweek*
Dolores Morrison, *New York Daily News*
Karen Mullarkey, formerly *Newsweek, Rolling Stone, Sports Illustrated*
Larry Nighswander, Ohio University School of Visual Communication
Jim Preston, *Baltimore Sun*
Sarah Rozen, formerly *Entertainment Weekly*
Mike Smith, *The New York Times*
Neal Ulevich, formerly Associated Press

Website and Digital Systems
Jeff Burchell, Applications Engineer

Television Documentary
Sandy Smolan, Producer/Director
Rick King, Producer/Director
Bill Medsker, Producer

Video News Release
Mike Cerre, Producer/Director

Digital Pond
Peter Hogg
Kris Knight
Roger Graham
Philip Bond
Frank De Pace
Lisa Li

Senior Advisors
Jennifer Erwitt, Strategic Advisor
Tom Walker, Creative Advisor
Megan Smith, Technology Advisor
Jon Kamen, Media and Partnership Advisor
Mark Greenberg, Partnership Advisor
Patti Richards, Publicity Advisor
Cotton Coulson, Mission Control Advisor

Executive Advisors
Sonia Land
George Craig
Carole Bidnick

Advisors
Chris Anderson
Samir Arora
Russell Brown
Craig Cline
Gayle Cline
Harlan Felt
George Fisher
Phillip Moffitt
Clement Mok
Laureen Seeger
Richard Saul Wurman

DK Publishing
Bill Barry
Joanna Bull
Therese Burke
Sarah Coltman
Christopher Davis
Todd Fries
Dick Heffernan
Jay Henry
Stuart Jackman
Stephanie Jackson
Chuck Lang
Sharon Lucas
Cathy Melnicki
Nicola Munro
Eunice Paterson
Andrew Welham

Colourscan
Jimmy Tsao
Eddie Chia
Richard Law
Josephine Yam
Paul Koh
Chee Cheng Yeong
Dan Kang

Chief Morale Officer
Goose, the dog

ALABAMA 24/7

ALASKA 24/7

ARIZONA 24/7

ARKANSAS 24/7

CALIFORNIA 24/7

HAWAII 24/7

IDAHO 24/7

ILLINOIS 24/7

INDIANA 24/7

IOWA 24/7

MASSACHUSETTS 24/7

MICHIGAN 24/7

MINNESOTA 24/7

MISSISSIPPI 24/7

MISSOURI 24/7

NEW MEXICO 24/7

NEW YORK 24/7

NORTH CAROLINA 24/7

NORTH DAKOTA 24/7

OHIO 24/7

SOUTH DAKOTA 24/7

TENNESSEE 24/7

TEXAS 24/7

UTAH 24/7

VERMONT 24/7

24/7 books available for every state. Collect the entire series of 50 books. Go to www.america24-7.com/store